LENNON

THE NEW YORK
YEARS

STEWART, TABORI & CHANG

NEW YORK

Published in 2005 by
Stewart, Tabori & Chang
115 West 18th Street
New York, NY 10011
www.abramsbooks.com

Canadian Distribution:
Canadian Manda Group
165 Dufferin Street
Toronto, Ontario M6K 3H6
Canada

Produced by becker&mayer!, Ltd., Bellevue, Washington
www.beckermayer.com

Design: Joanna Price and Kasey Clark • Editorial: Adrienne Wiley
Image Research: Shayna Ian • Production Coordination: Sheila Hackler
Text Editor: Jenna Free • Scans: Picturehouse, New York

Library of Congress Cataloging-in-Publication Data
Gruen, Bob.
 John Lennon : the New York years / text & images by Bob Gruen.
 p. cm.
 ISBN 1-58479-432-1
 1. Lennon, John, 1940-1980–Pictorial works. I. Title.

ML420.L38G76 2005
782.42166'092–dc22
[B]
 2005042607

Printed in China

10 9 8 7 6 5 4 3 2 1

First Printing

Stewart, Tabori & Chang is a subsidiary of

LA MARTINIÈRE
GROUPE

Dedicated to John Lennon and Yoko Ono, and to my mom, who taught me photography.

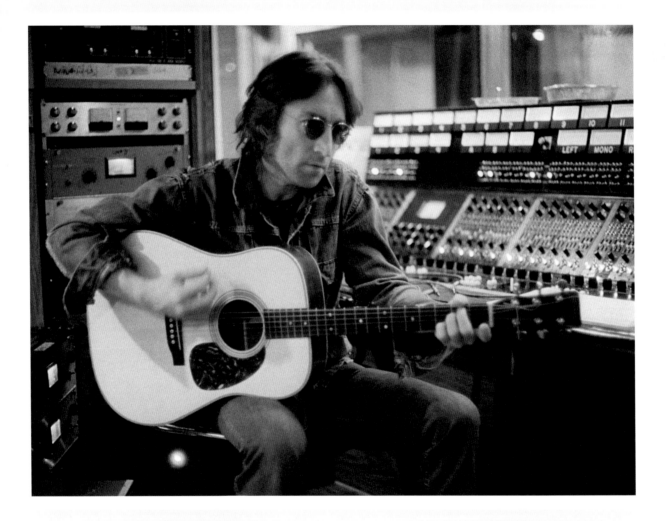

CONTENTS

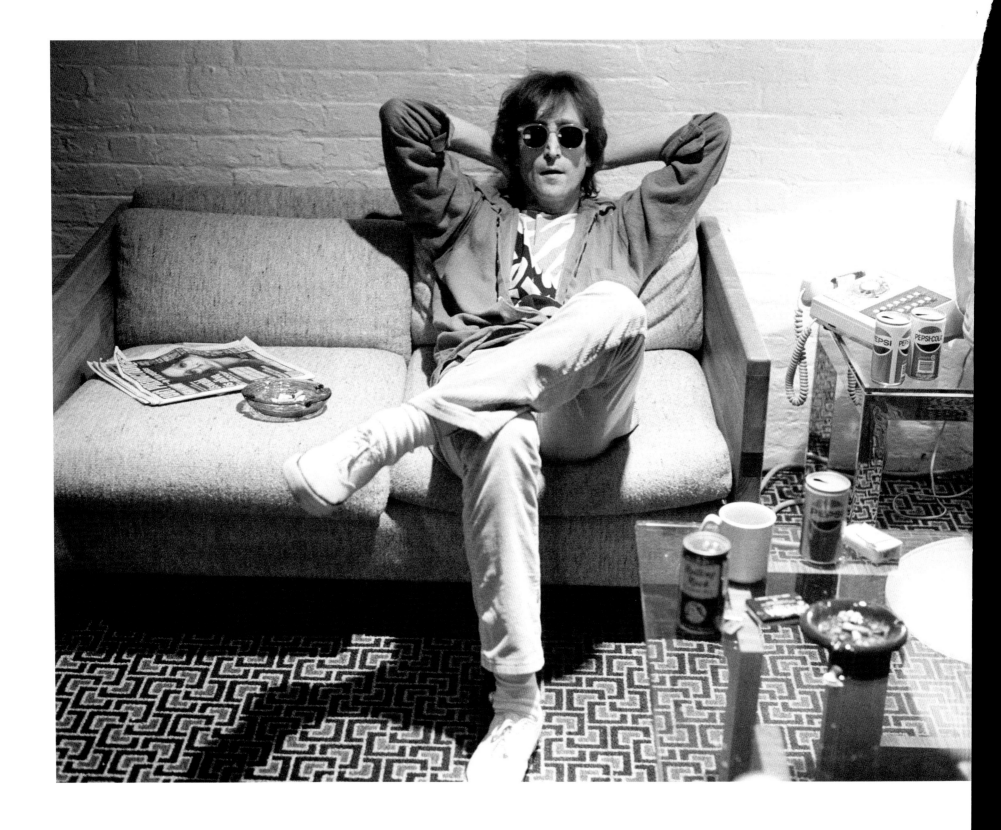

INTRODUCTION

WHEN YOU FEEL you have forever to take pictures, you don't worry about the little moments. You don't rush for the camera to get a photo of someone drinking coffee, because you see him drinking coffee every day. You can always take the picture tomorrow, when the light's better, or when you have more time. That's how it was for me with John Lennon.

I met John in 1971, shortly after he moved to New York City. We were friends and neighbors, and for nine years I was his personal photographer when he needed pictures for his family, for an article, or for an album cover. Our relationship moved quickly outside the realm of business and into the personal, and so I often intentionally refrained from taking photographs when I felt it would be too intrusive. Some moments I let pass because we were just sitting around, watching television or drinking coffee, and I didn't know how limited our time together would be.

John Lennon and Yoko Ono both had a strong sense of history, and the knowledge that the work they were doing was significant. They wanted a personal photographer because they understood the importance of chronicling their lives themselves. They knew the world was watching, and they wanted to be able to retain some control of the image they presented. Through their music and in the numerous interviews they gave, they were expressing ideas that were important to them; they wanted the accompanying photographs to be true to the spirit of their message. They trusted that the work I did was in their best interest, and it was a trust I never gave them cause to question.

Pictures of John were always popular—maybe because he shared so much of himself through them. He was open and expressive, and whatever he was feeling at the moment when the picture was taken, you saw it. Looking back on it now, the pictures seem to chart his evolution over the years.

By the late 1970s, I had so many pictures of John that people suggested I put them together in a book. But it felt incomplete. Before John died, he was planning a worldwide tour to promote the *Double Fantasy* record, and I was to travel with him. I knew that on the tour there would be memorable conversations and hilarious moments with John and Yoko. I thought all the photos I'd taken up to that point amounted to just a few compared to all the pictures I'd take in the months and years to come.

Of course, those photos were never taken. Fortunately, however, I do have nine years of photographs of John, years during which he underwent enormous change and growth. I saw him at his most political and watched him face professional criticism and failure. At times he drank heavily—and I often drank with him. He separated from Yoko, and returned. He emerged from his "lost weekend" of partying and public humiliation, to reinvent himself as a responsible father, husband, and artist. He fell in love with New York City. I was there during recording sessions, concerts, press conferences, court appearances, and fundraisers. I was also there during more personal moments—reflective walks with Yoko; the first photos of their son, Sean; dinners; birthday parties. Though my photos don't capture every moment we spent together, I like to think that by putting my camera down sometimes, it helped the real John show through when the camera was clicking. I like to think my pictures tell a lot about John and his life in New York.

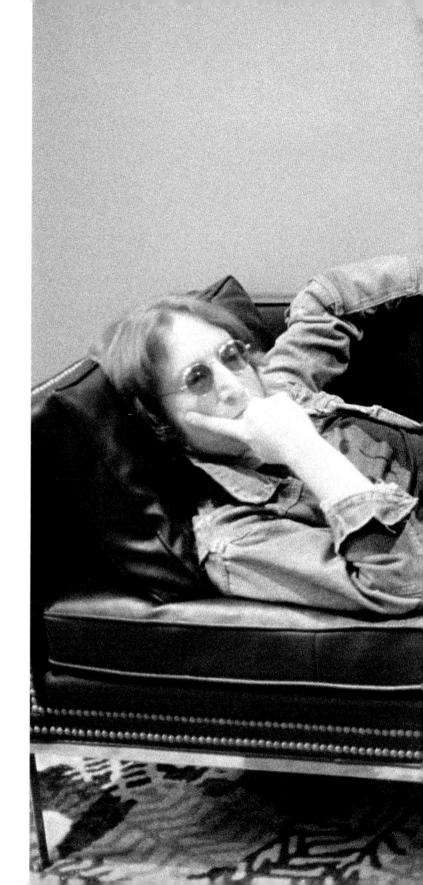

I DIDN'T KNOW John personally when he moved to Bank Street in my neighborhood, Greenwich Village. But, like the rest of New York, I knew that he'd arrived. There was a buzz on the street, everyone saying, "John Lennon moved in," or spotting John and Yoko casually riding their bikes down Bleecker Street. Everyone had an "I spotted John Lennon" story, but no one hassled him. That was the way of New York, where Jackie Kennedy could hail a cab, entrusting her life to an unknown driver. In New York, people are full of self-importance. *Maybe that was John Lennon I just bumped into*, they'll say, *but hey—I've got places to go, things to do. I'm not going to make a big deal of it.* And people like John live in New York because you can have that kind of privacy, even in public. Years later, when John stood on the steps of the New York City courthouse after his immigration hearing, a reporter asked, "Why do you want to live in New York?" He answered simply, "Why do you?"

THE FIRST TIME I saw John and Yoko was certainly a surprise. That night, I'd been at the Beacon Theatre for the early show before swinging by the Apollo Theater to see Aretha Franklin at eleven. She was performing at a benefit for the families of the victims of the Attica prison uprising. A few months earlier, the uprising had left more than forty people dead, and many New Yorkers blamed Governor Nelson Rockefeller for refusing to become involved when the state failed in its negotiations with the hostage-takers. People felt unsettled and aggrieved, and the benefit concert was part of the healing process. I was just walking up the theater aisle when the emcee announced, "John Lennon and the Plastic Ono Band!" Though I knew John and Yoko had moved to town, I was still surprised to see them—they hadn't been listed on any of the official lineups for the show. I hadn't even gotten a good look at the stage yet, but I swung into action and ran up the aisle to the front to shoot photos.

John and Yoko played a few songs, including one they'd written about the uprising called "Attica State." Yoko sang "Sisters, O Sisters" and John sang "Imagine" to the accompaniment of only his acoustic guitar. After they'd left the stage, a small crowd gathered around John and Yoko as they waited in an alcove at the back of the theater for their car. Most of them were fans who would hand a camera to someone, stand next to John and Yoko and say, "Take a picture of us." John joked to the group, "People are always taking our picture—but what happens to all these pictures? We never see them."

So I answered, "I live right around the corner from you. *I'll* show you my pictures." "You live around the corner?" he said. "Well, slip them under the door then!" That was the first time I spoke to John, and I was taken by what a neighborly, casual exchange it was. I never would have thought to show him my pictures if he hadn't said that—and said it so warmly. I was just starting out in the business and thought, "What do they need my pictures for? They're John Lennon and Yoko Ono."

A few days later, I walked over to John and Yoko's place and knocked on the door of their brownstone. The access was that easy—which would become a problem for them as more and more people learned where they lived. They didn't have a twenty-four-hour staff, but they did have people over during the day to help them if they needed something. No security guards were present, just one efficient female secretary and a male personal assistant.

When I knocked on the door, antiwar activist and Yippie movement cofounder Jerry Rubin answered, catching me a little off guard. I'd never seen him in person before, though of course I recognized him. When Jerry answered the door, he asked if he could help me. I said I had photos for John and Yoko. He asked if they were expecting me, and I said no and left the photos with him. Later, when John, Yoko, and I were first becoming acquainted, Yoko remembered the gesture, the fact that I hadn't pushed too hard. I wasn't trying to hassle them, I was just doing what I'd told John I would. They appreciated that respect, and it helped our professional relationship develop. I'm sure it helped that they liked the pictures, too.

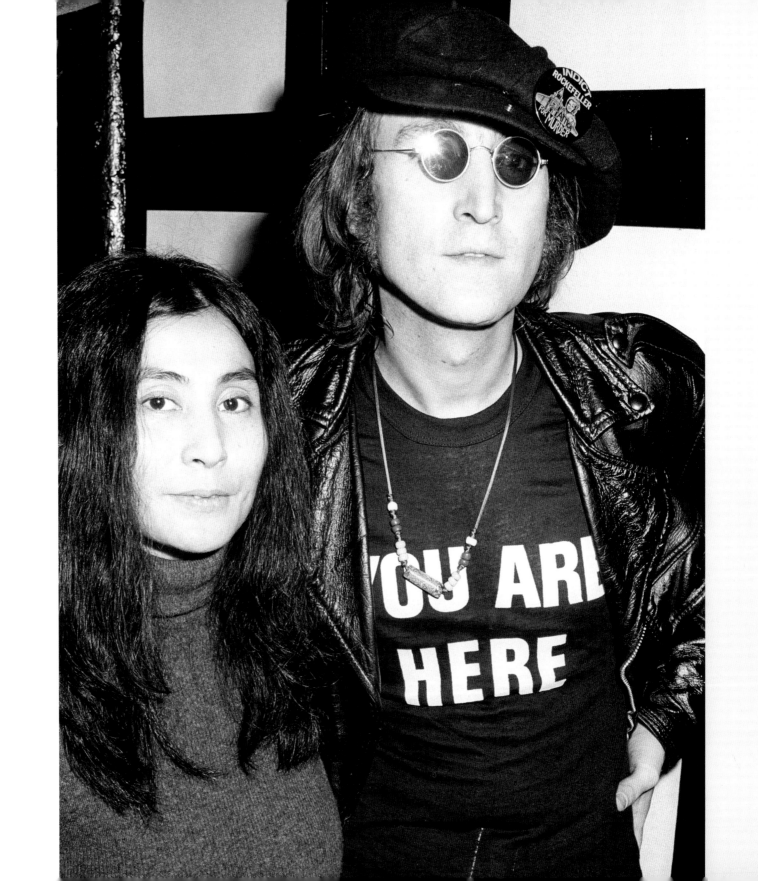

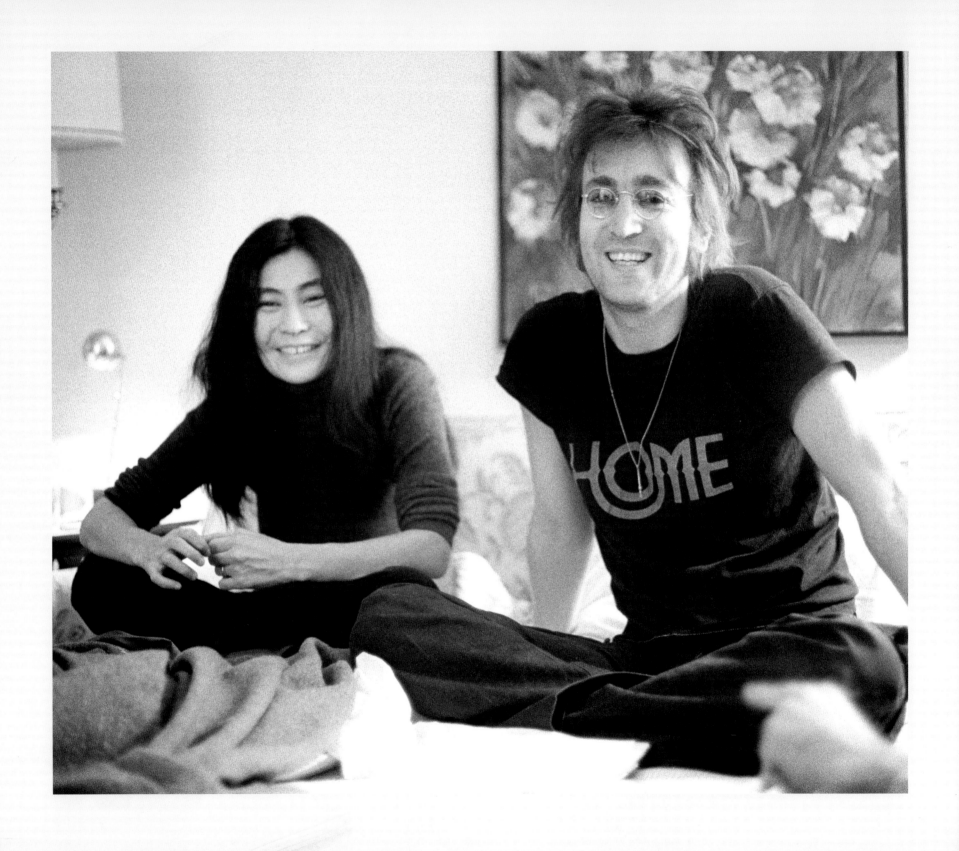

A FEW MONTHS LATER, journalist Henry Edwards asked me to work with him on an *After Dark* magazine article about the New York band Elephant's Memory. Elephant's Memory was John and Yoko's backup band for the new album they were recording, which would become *Some Time in New York City*. Henry asked me to come with him when he interviewed John and Yoko.

Just as I arrived at the hotel where the interview was to take place, Henry came out of the elevator. He told me that John and Yoko had just woken up, were a little cranky, and didn't want to be photographed. He said I should wait a while before coming up to the room. They'd feel better soon, he thought, and then they'd let me come up and take pictures. They'd probably like my pictures, he said, and like me. We'd become friends, and I'd take lots of pictures for them, probably even album covers. "Because that's the way they are," he concluded.

I knew this shoot was a very big deal for me, as a lot of the people I'd photographed I ended up working with repeatedly, and I was hoping as much as anyone that I'd get to build a real working relationship with John and Yoko. John Lennon was a former Beatle, after all, and everyone was watching to see how he would fare in America. It was exciting to have him living in New York, and everyone wanted to be a part of his life here. As I walked toward their door a little while later, I began to feel very nervous, but I knew I couldn't go in there so self-conscious. If I walked in shaking, I wouldn't be able to take quality photos, and that would end all possibilities of working with them. So I took a deep breath and decided to just be myself.

Henry introduced me to John and Yoko as I walked in, but we hardly spoke during the shoot. I just moved around, tried not to be distracting, and whenever I saw a good moment, tried to capture it. John wore a T-shirt that read, "Home," the name of a restaurant and bar on 91st Street and 1st Avenue that John frequented after recording sessions. It's a place I would come to know well during my friendship with John, as a whole group of us would often pop in at three in the morning. Without fail, Ritchie, the owner, would open the kitchen for us, and we'd eat steaks and drink cognac until five.

I always like to simplify images as much as possible, to sum things up in one picture when I can. During that first shoot, it seemed to me that instead of having photos of Elephant's Memory and photos of John and Yoko, it would make the most sense to photograph everyone together. I knew they'd all be at the recording studio together after the interview, so I decided to ask if I could come along.

I noticed that Yoko was the one talking to their assistant, working out all the plans of the evening. So toward the end of the shoot, I approached her and said, "This story is about you working with the Elephants. Can I take a picture of you working with the Elephants?" She said that would be fine, but warned me that they weren't going to stop what they were doing. I'd have to wait around until they were done recording before I'd be able to take any posed photos. But if I didn't mind waiting, I could come. She added a warning about their infamous co-producer: "And you'd better watch out for Phil Spector. He'll be there, and he hates photographers."

I FELL RIGHT IN with them as they piled into their big 1972 Chrysler station wagon. Though it was well known that John had a psychedelic Rolls Royce in England for when he felt like showing off, he preferred nondescript cars for anonymity. In fact, John and Yoko rode in that station wagon across the country to Los Angeles in early 1973, enjoying its sheer normalcy.

By the time we arrived at the studio, the engineers were ready to record a vocal for John. We walked down a hallway, and John motioned for me to follow him as he went into the recording booth. I had no idea why I was being invited into such an intimate space with John, but later suspected he just wanted someone there to sing to. I'm a good observer—I tend to take things as they come without freaking out or asking questions, and perhaps John sensed that. We stood in this close space, and the engineers said, "Okay, John. We're ready."

John turned to me and put a finger to his lips, motioning silence—so clearly I couldn't take photos. He started singing "Woman is the Nigger of the World," a song pointing out how women are often mistreated, which ended up being one of his most controversial works.

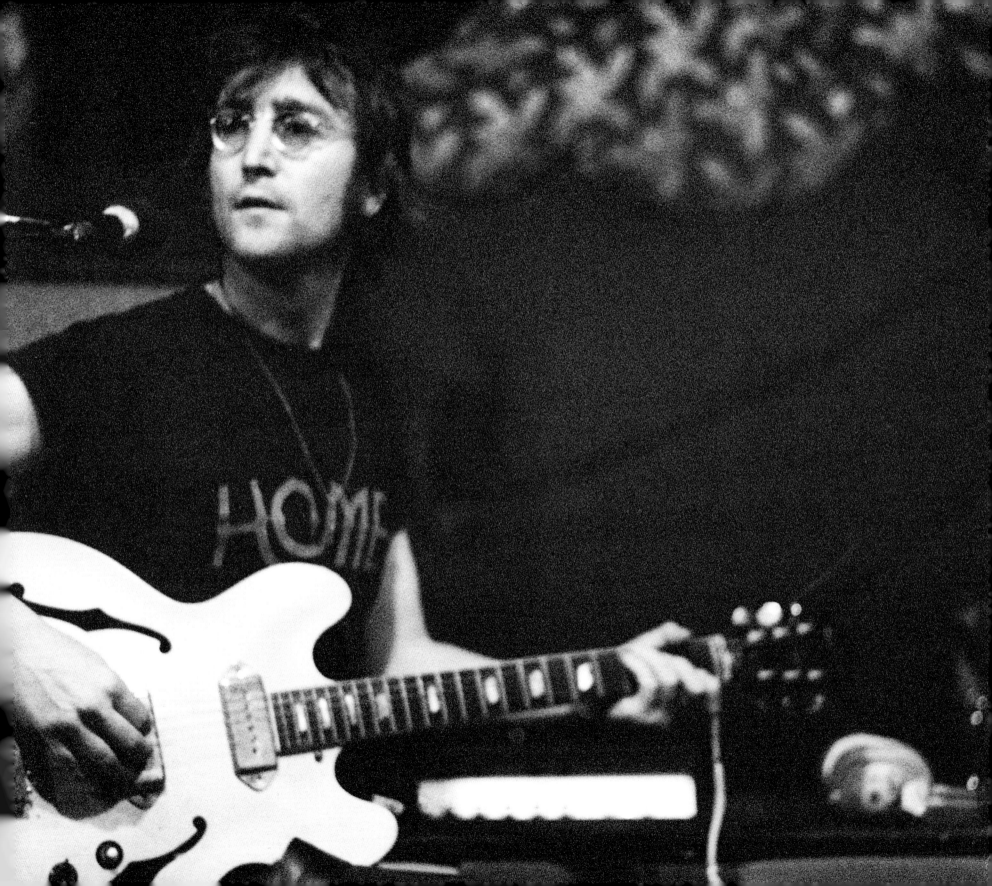

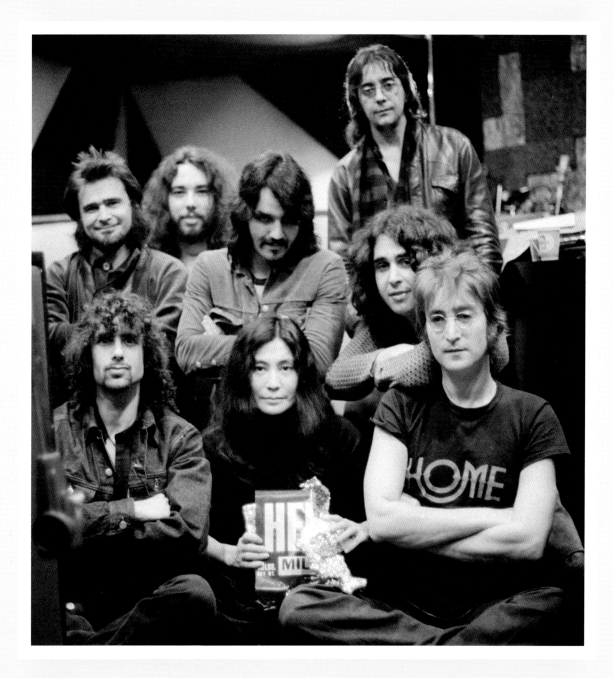

I think there's a good chance he wanted to try it on someone, to gauge an outsider's response. I might have seemed like a tough audience, since I was pretty macho-looking in my cowboy boots, but I was very open to his message, as I'd had many conversations with my wife and other friends about the growing women's liberation movement. I thought John's song was a brilliant way to express it. When the song was released in June 1972, no radio station would play it. But the song and the message behind it were too important to John to leave it at that. He had an idea for people to call a special phone line to hear it. The set-up was extremely simple by today's standards—literally a room in Apple headquarters with multiple phones hooked up to playback machines. That was the only way to hear John's song unless you had the record.

My moment with John was overshadowed by the rest of the night, though, which I spent taking photos of Elephant's Memory. I found I had free reign, as long as I wasn't intruding. I also tried very hard to avoid Phil Spector. I knew if he yelled at me, I'd be thrown out, so I didn't want him to even see me. For the most part I was successful, until at one point in the night I was standing near John at the piano, and Phil came in and stood on the other side of him. I froze and imagined myself as a fly on the wall. There was a mike stand there, and I was trying to *be* that mike stand.

I noticed Phil had a bottle of Remy Martin cognac, a very expensive brand. I'd recently started drinking cognac myself, and noticed the bottle had an interesting top made of cork. In a moment of daring, I asked him, "So, where did you get that bottle with the cork?" He looked at me, surprised, and told me where he got the bottle, and that was that. We're still friends today. It's not that I caught him in a good mood; later I saw him talking on a pay phone, screaming at whoever was on the other end. He ended up smashing the phone booth's glass.

When Phil left and the work was winding down, I reminded Yoko that she'd said I could take some photos with her and the band. They started off posing in the studio with a giant Hershey bar Yoko happened to find. It struck me how Yoko sat there, this small woman surrounded by all these big, macho men, and the only two letters visible on the candy wrapper were "H-E."

After shooting in the studio, John started playing old rock songs on his guitar. Everyone joined in, singing along, as I took pictures of them in the lobby and then out on 44th Street in front of the studio. I kept shooting and everyone was singing, prolonging the spirit of the session in the open air. When we said good-bye, I didn't know if I'd work with them again.

Stan Bronstein, Jim Keltner, Adam Ippolito, Rick Frank,

Wayne (Tex) Gabriel, Gary Van Seyoc, John, and Yoko, all

singing on 44th Street.

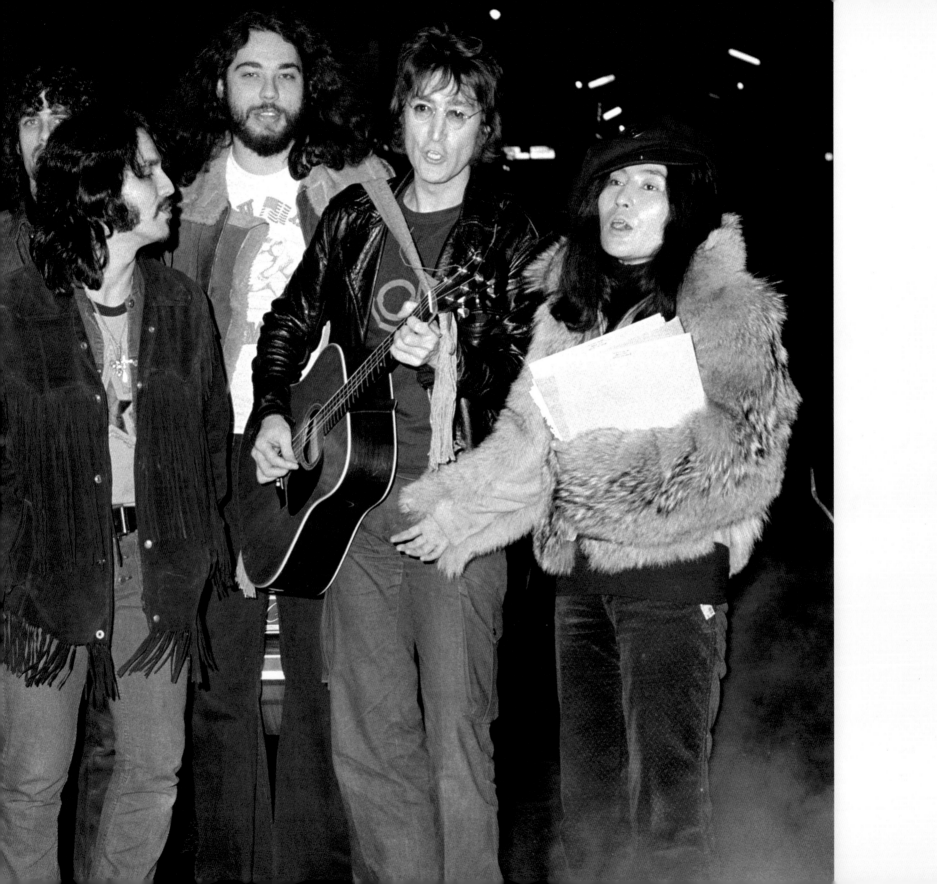

John, Yoko, and Lisa Robinson in the Bank Street apartment.

THE NEXT DAY, I sent my photos to *After Dark* magazine and left New York for a few weeks to work with Ike and Tina Turner, only returning for a brief two-day break. As luck would have it, during my quick return to New York I ran into the Elephants' drummer, Rick Frank.

"Man, we've been trying to reach you," he said. "We want to use your picture on the album cover." He asked if I would go over to John and Yoko's with him the next day to show them the pictures I'd taken.

That visit was the first time I went inside John and Yoko's Bank Street home. Since we'd already been formally introduced and spent some time together, it was a pretty relaxed visit. We just sat around, watching TV and smoking. The front room was long and low, with an office, a kitchen, and a seating area. Their bedroom, in contrast, was completely open with a tall ceiling, and painted entirely in white. It had a massive bed, which was actually an oversized mattress between two wooden church pews. They often held court with friends and assistants as they lounged on that huge bed. Their bedroom also had the largest television screen I'd ever seen.

John loved TV. To my great annoyance over the course of our friendship, the television was constantly on, even when we were having a serious conversation. I found it very distracting and complained to him about it once, asking why we always had to have it on.

"If you have the window open," John replied, "you can still have a conversation. And the TV is like my window, except it shows the whole world."

John was fascinated by the use of media, the way people reacted to it and the way advertisers chose to combine words to send out a message. He loved to watch TV and focus on how all the images meshed to communicate the big picture. John was, above all, a communicator.

When I went to leave at the end of that first afternoon, Yoko—who was very much in charge of the couple's business affairs—said, very directly, "We want you to keep coming back, to hang out and take any pictures you want. We're not hiring you or paying you because you'll sell pictures to magazines and make money for your photos. But we'll give you access as long as you show us what you do and let us choose which ones you use." Yoko told me she really liked my work, and she liked me. She said they always had people working for them whose job it was to keep people away, but I shouldn't be afraid of them. "If they don't let you in," she said, "try again in a few hours or a few days." She asked me to always be in touch with them.

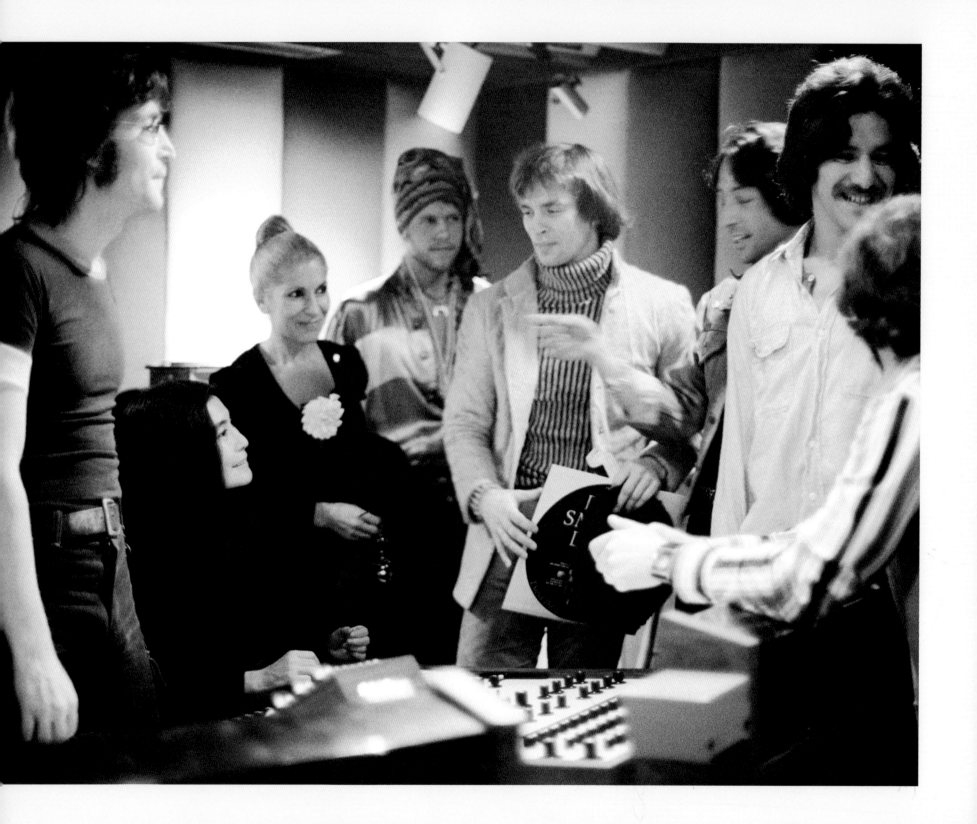

I STARTED SPENDING more and more time at the studio with John, Yoko, and Elephant's Memory. It was a really politically charged environment; the *Some Time in New York City* album was to become pretty controversial upon its release. Fueling that vibe, people like Jerry Rubin and Abbie Hoffman would frequently attend sessions. Even Tom Hayden, who went on to become a senator, was there one night.

Though John was extremely political, his views differed significantly from those of the infamous Yippie founders, who were much more radical and talked more about destruction than peace. There was a lot of talk, specifically, about disrupting the Republican Convention that year. But John and Yoko were peaceful; they always made a point of saying they weren't against anything, but rather were in favor of things. They weren't against war, but in favor of peace; they weren't against the Republican Convention, but were in favor of supporting a candidate who made sense—and clearly, that candidate was not Richard Nixon.

Though the government was as distrustful of John as it was of Rubin and Hoffman, John made it clear that he was not in total agreement with his revolutionary friends. Despite the radicals drawn to John, in interviews and in everyday conversations he stuck to his view that the only way to change the system was to do so nonviolently.

In fact, disrupting the Republican Convention was the furthest thing from John's mind. In addition to opposing destruction of any kind, John was also an Englishman. He didn't feel it was his role to endorse any American political candidates, or to tell anyone how the U.S. should be run. He not only had British citizenship, he also sometimes exercised very British restraint.

The dynamics of the period—and the people—were interesting to watch. Hayden was solid and serious, much more of a politician-type, while Hoffman was more of an actor or street performer, always eager to stir things up. There were constant debates and clowning, and sessions where Rubin and Hoffman would talk about revolution, while Allen Ginsberg would sit in the corner with his Tibetan finger chimes and chant, "Ommmmm . . . Ommmmm." John thought Ginsberg was the only one making any sense. In the midst of all the furor inside and outside the studio, there was still recording going on.

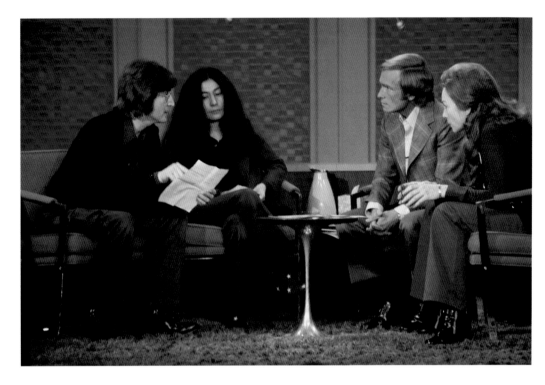

On the *Dick Cavett Show* with Shirley MacLaine.

THE NEXT TIME I saw John and Yoko perform in public was on the

Dick Cavett Show. They were starting to promote *Some Time in New York City* and performed several songs from that album on the show. Yoko sang "Sisters, O Sisters," and the shots I captured were used often afterwards for publicity—I think because they show Yoko in such a strong role. She appears as the lead singer, with John in a supporting role on guitar. John put Yoko out there, front and center, to get people to realize what she was doing with her music. A lot of people felt Yoko forced John into that supporting role, but that's not true. He was proud of her. John's relationship with Yoko had also really opened his eyes to the way women are treated.

Many people got very upset about Yoko during this period. Her art conjures a lot of feelings, not all of them pleasant. While some art makes you *think*, Yoko's art makes you *feel*. Some of her pieces were really shocking. Many people—instead of realizing that Yoko was evoking feelings and that her ability to do that was in itself impressive—resented her for making them feel so bad. Through it all—or perhaps because of it all—Yoko was always very strong. The fact that she already had her own one-person show when she met John was an incredible accomplishment. To be included in a show of many would have been impressive for a woman at the time; for a woman to have her own show was almost unheard of.

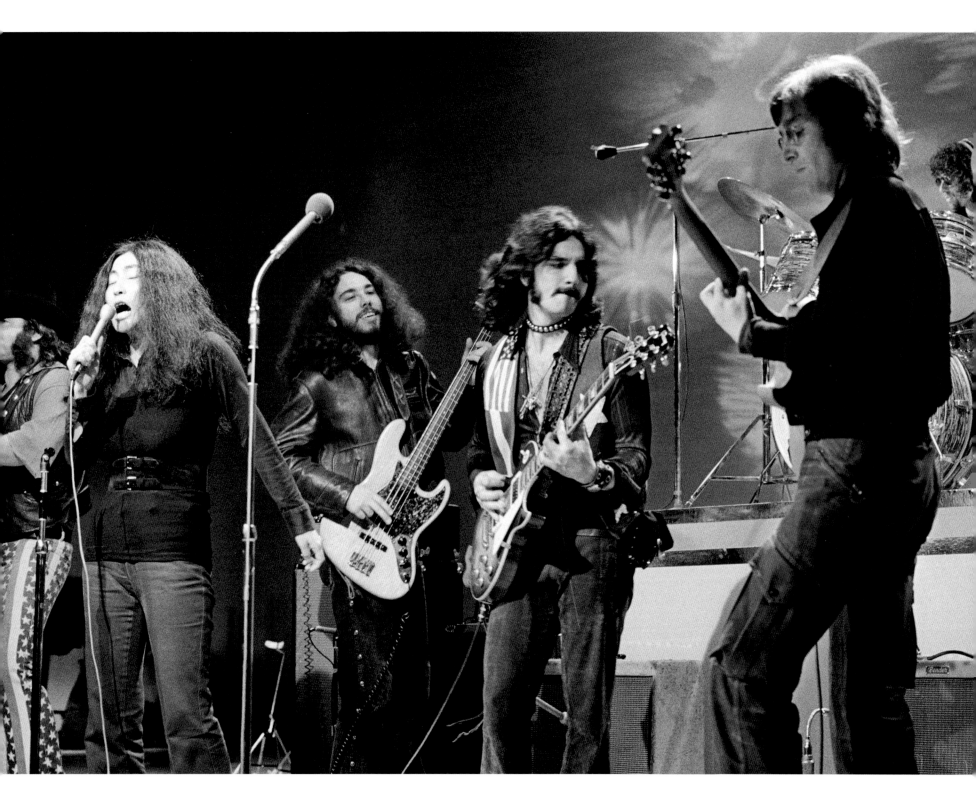

Music, too, was a tough environment for a woman in the early 1970s. When Yoko was working in the studio, she was constantly undermined, even though she was trained as a classical musician and is very knowledgeable about music. It wasn't unusual for her to tell the sound engineer at a recording that she needed more bass, only to have him respond with, "What's that? What do you think we need, John?" Invariably, John would say, "I think Yoko said we need more bass." The tech guys would have to hear it from John; they couldn't follow her. It was awkward for them to have a woman telling them what to do, to be around a woman with so much authority.

All of us guys who had formed a group around John and Yoko thought we were pretty tough. Interestingly, in spite of all the strutting, all of us had chosen really strong women to date and marry. We might have bragged about our manliness, but the truth is, everyone who was in the studio during this time learned a lot from Yoko and her ideas, and she knew it. She once wrote, "Elephant's Memory were very macho people . . . but my songs were about women—very feminist. Their girlfriends and wives who sat in on the sessions picked up on it."

Many times I've run into people who say to me that they don't like Yoko; they just like John. Well, *John* liked Yoko. Often she comes off in photographs as very imperial, aloof, a very strong kind of character, and she doesn't look like she even has a sense of humor. But that persona is deceiving. John was a comedian, and you couldn't hang out with John Lennon and be a humorless person. And when people ask me, as they often do, "What kind of a woman is Yoko?," my first answer is, "She's the kind of girl that John Lennon would marry."

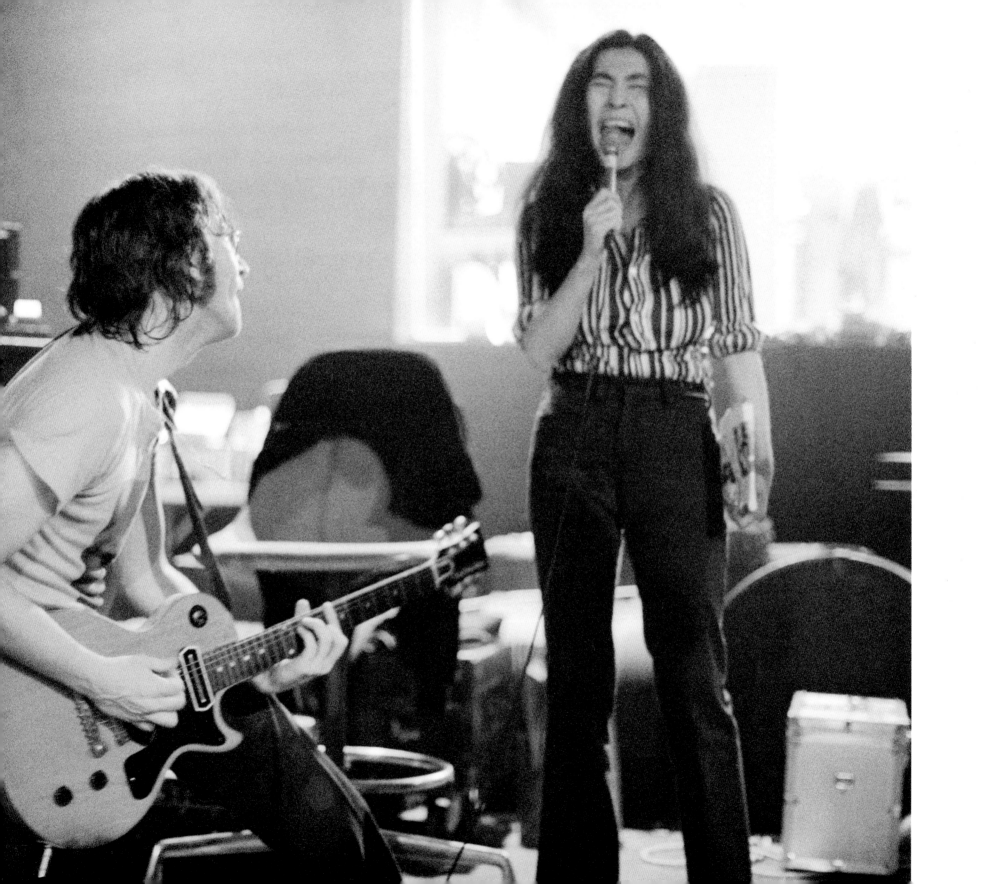

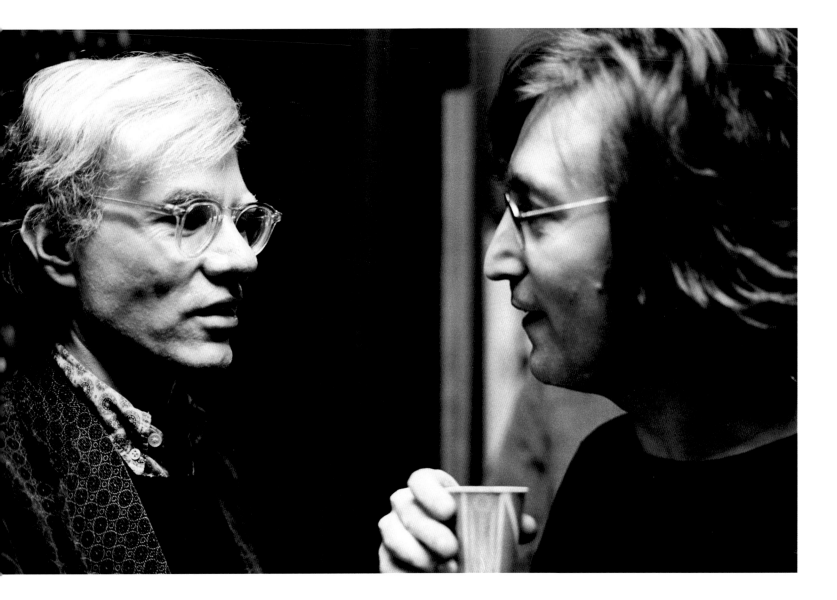

I WAS HAVING a great time hanging around the studio, which was becoming more and more lively the closer we came to the album release. Famous faces appeared frequently, as did various girlfriends, friends, and on one occasion, a random group of filmmakers from Canada. Right in front of the producer's panel there was a row of theater seating, couches, and chairs. Spectators could wander in, sit down, and face the performers without much disruption. Still, each day it seemed like the work was getting looser and the hanging out was getting more intense. Since most everyone was drunk, it took at least twice as long as it should have to accomplish even the smallest task.

On one occasion, Andy Warhol stopped by for a visit. On another night, Rudolf Nureyev was there along with Geraldo Rivera. It was kind of like a block party of who's who in the New York celebrity scene.

A studio regular was the late Barry Groupp, sound engineer for Elephant's Memory and a genius when it came to inventing electronic gadgets. He was forever trying to respond to singers' complaints about sound when they were on stage. He invented a helmet that was individually adjustable; you could fine-tune all these dials on the back so that it was suited to the sound you wanted, and it had a built-in microphone. So instead of hearing clear sound only by wearing earphones in a studio, a vocalist could wear this odd-looking helmet on stage and sing and hear and move around. Also during this time, Barry developed a microphone for the saxophone. It clipped on the horn, allowing the saxophonist to move around instead of standing in front of a microphone. John and the Elephants were on the cutting edge of music technology, always looking for the newest things.

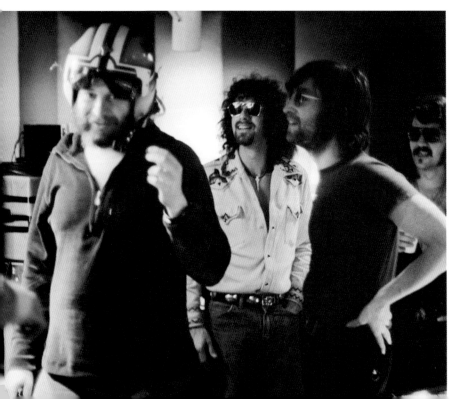

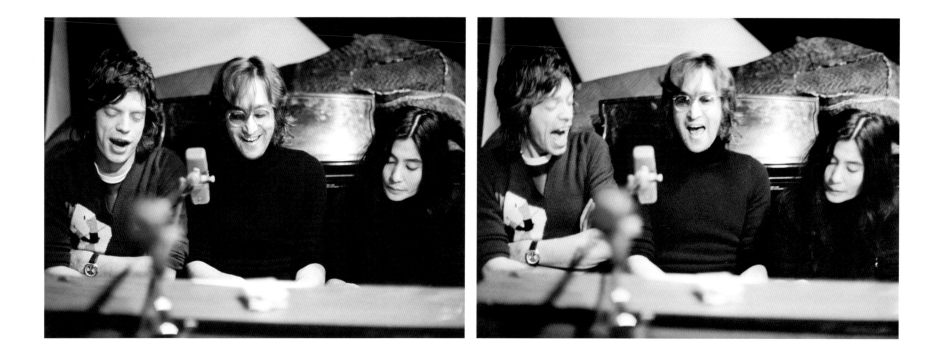

I WASN'T USUALLY on a specific assignment for photographs of John and I didn't have to be at the studio constantly. Often, I wouldn't arrive until midnight or later. One night I came home from the studio around three in the morning, and had just crawled into bed when the Elephant's Memory's road manager called. "Bob," he said, "I think you should come back to the studio. Mick Jagger's on his way over." I got dressed, and was back at the studio by four.

Mick and John seemed like old schoolmates. They had the kind of rapport you'd have with a good friend you haven't seen in a while. John asked Tex to show Mick some chords he was working on, and they all sat and played together for a while. As they played, Yoko sat separately and spontaneously wrote a song. Later, she, Mick, and John sat at the piano and tried it out. As you can see, they were having a great time.

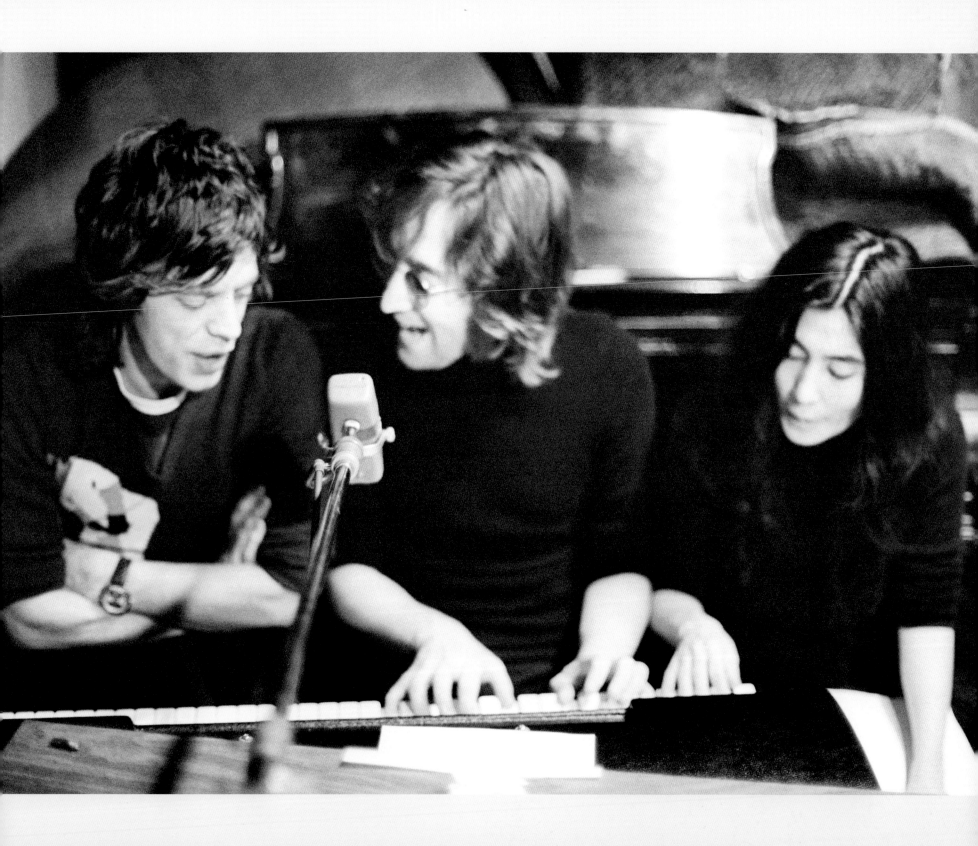

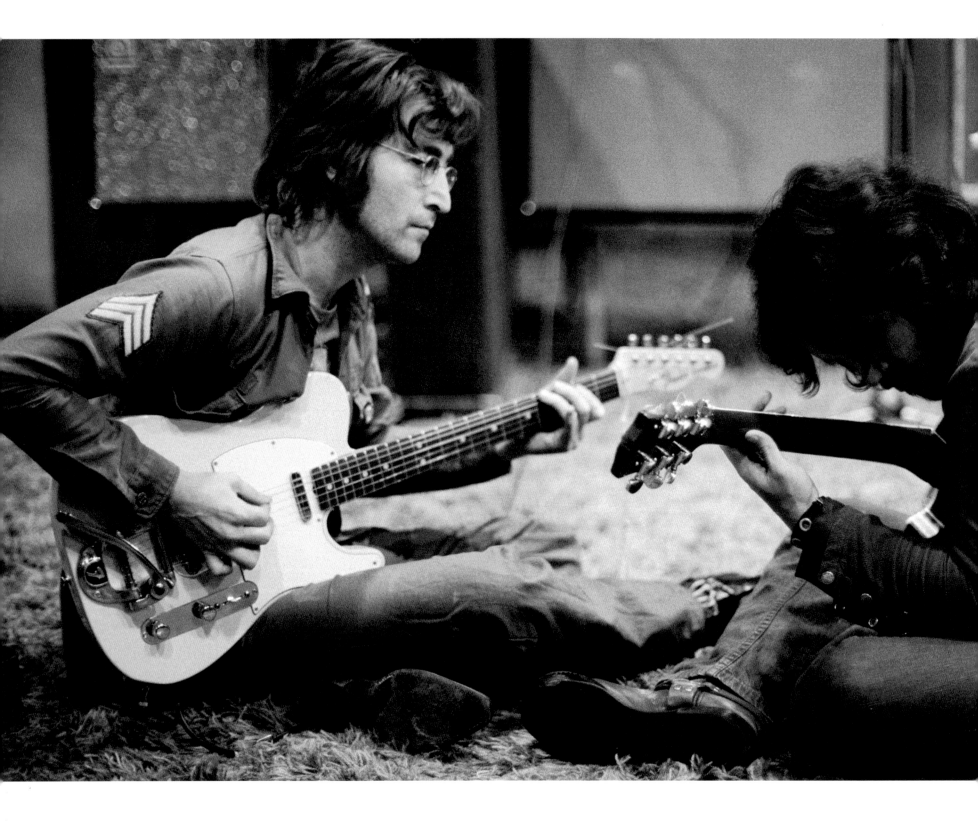

JOHN WAS AN INCREDIBLY patient teacher both in and out of the studio. I watched him give countless interviews and was always impressed with the way he would explain his ideas to others in a way that was non-judgmental. He was also very modest about his influence. I remember in one interview in particular, he emphasized that he couldn't tell people what to do, that no one would listen if he tried to encourage fans to buy a specific toothpaste. Instead, he said, he felt his role as an artist was to express what people were already feeling, whether they fully recognized it or not.

I also had opportunities to watch John as he discussed his songs with Elephant's Memory. He was very much a songwriter, always with a vision of how he wanted the final product to sound.

Once he gave everyone in the studio a lesson on reggae music. In England, there was a large Jamaican population and reggae music was popular. In New York, on the other hand, our island music came from Puerto Rico. There wasn't much reggae in New York yet, and Elephant's Memory, being New Yorkers, couldn't grasp the reggae beat, and kept returning to a very salsa kind of sound. But John insisted, "The reggae beat is different." As he tried to explain the actual beat, he pulled in the world's greatest drummer, Jim Keltner, to show them the beat. John was such a fan of reggae music that his enthusiasm was infectious. That conversation kindled my own interest in reggae. I went to Jamaica a few months later to explore reggae more deeply.

John and Wayne (Tex) Gabriel.

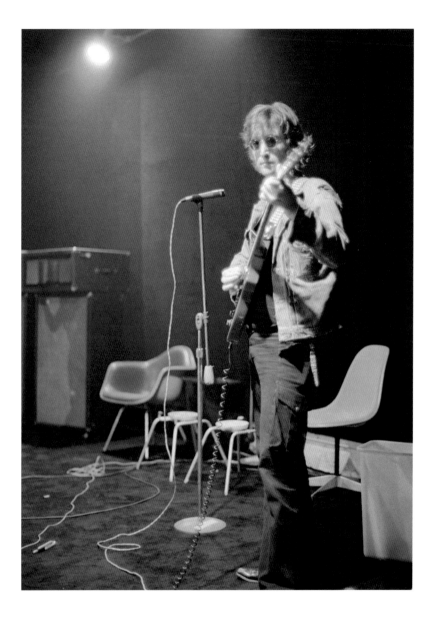

IN THE SUMMER, the frequency of rehearsals increased in preparation for their upcoming Madison Square Garden benefit concert that they hoped would lead to a *Some Time in New York City* tour. John and Yoko had rented a space on West 10th Street, four blocks from their apartment, and christened it Butterfly Studio. John planned to start his own recording studio there, so he could just walk down the block and record whenever he wanted. He had purchased a recording panel in Ascot, England, and had it dismantled and shipped to New York City. Unfortunately, the panel worked on a 220-volt system with English plugs, and they couldn't plug it in in America without significant and costly rewiring. The project became quite complex and was never completed. But even though John, Yoko, and the Elephant's Memory couldn't *record* at the Butterfly Studio, they had soundproofed the back room, so it made for a great rehearsal space.

It was a lot of fun to watch the rehearsals at Butterfly, a spirit of rock 'n' roll really permeated the space. One thing John and the Elephants bonded over was their love for 1950s rock, and often in the Butterfly Studio they'd perform rock 'n' roll songs along with the *Some Time in New York City* songs. Then they'd play a few songs from John's repertoire. John would play something like "Come Together" and you'd realize, wow—that's a Beatle. I had gotten used to thinking of him as just a New York guy, part of a team with Yoko. But when he started singing Beatles' songs in his incredibly distinctive voice, I remembered the John that was part of Paul, George, and Ringo.

The nightly partying after the rehearsals was every bit as long and raucous as the rehearsals had been. Most often we went uptown to the Home restaurant, but on one occasion, the Elephants' horn player Stan suggested a restaurant in Chinatown that was outfitted with a full bar—an essential feature, as far as we were concerned. John and Yoko always paid for everyone, but on that night, they didn't have cash with them. None of the rest of us had money—either with us or in the bank—and ultimately they had to call and wake up an assistant to come to the restaurant with cash. It could have been an awkward wait, but John and Yoko's graciousness—and the fact we ordered another round to tide us over until the assistant arrived—turned the uncomfortable situation into a welcome extension of our party.

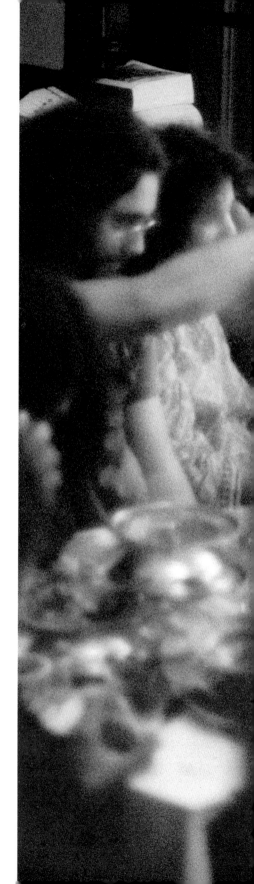

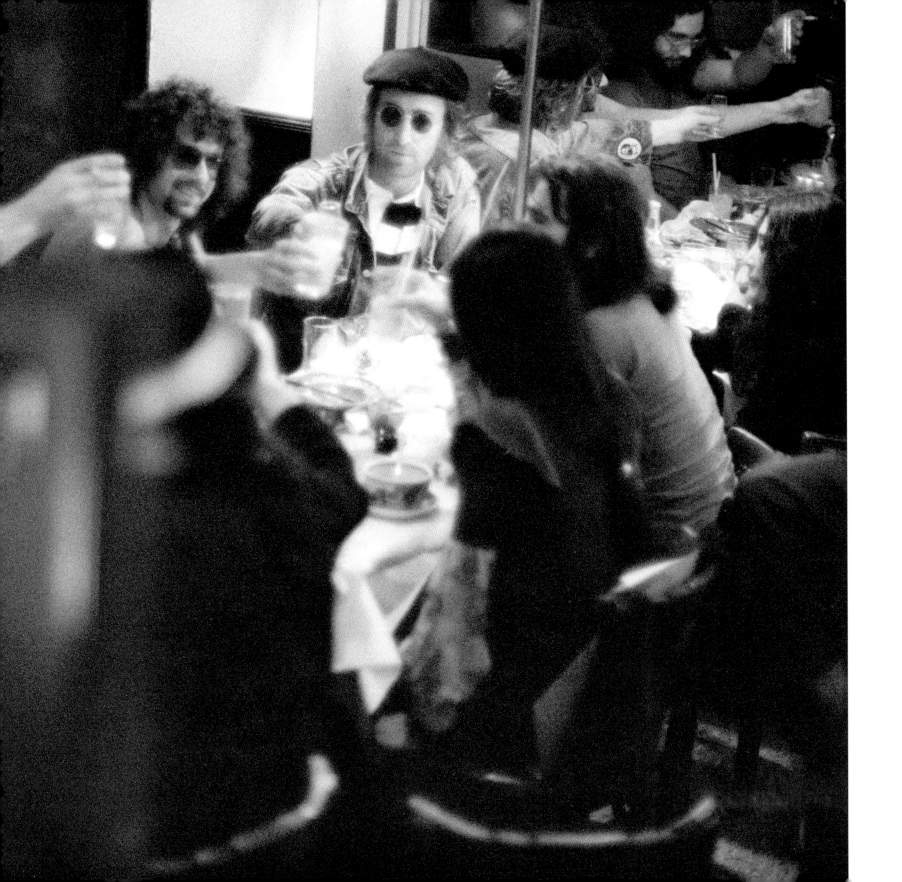

LEADING UP TO the Madison Square Garden concert, rehearsals moved to the Filmore East, an old, retired theater. The theater was officially closed, but could be rented out for rehearsals in its grand space. Empty and cavernous, it was an exciting place to play—you could imagine the enormous audiences that once filled it, and the acoustics were great. John and Yoko had asked a film crew to record the rehearsals, and there was enormous energy and meaning invested in the rehearsals there.

In the frenzy leading up to the concert, however, John and Yoko stood solidly in the middle, very much in touch with each other, conducting everything around them as a team. It was always very important to John that they be represented not as "John" and "Yoko" but as "JohnandYoko." He often said Yoko was his partner, his equal, and his friend.

I always called this photo "John and Yoko in love" because they are so physically in touch with each other. You can tell just by the way they're looking at each other that they have a strong connection.

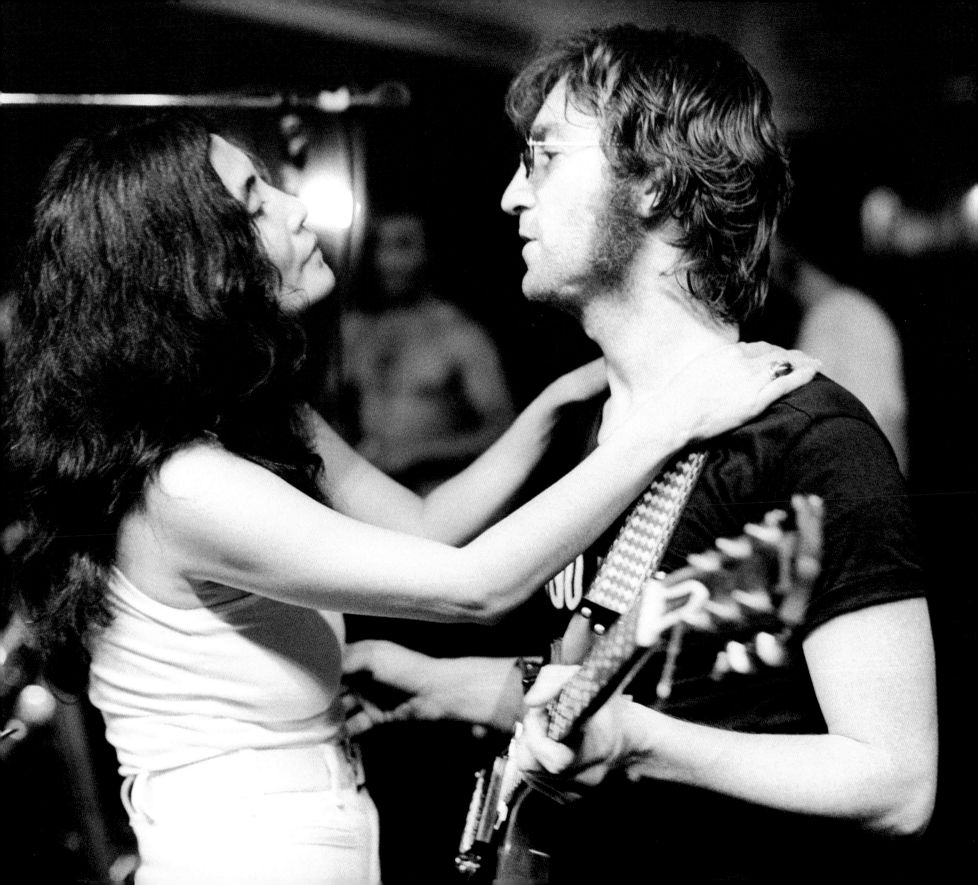

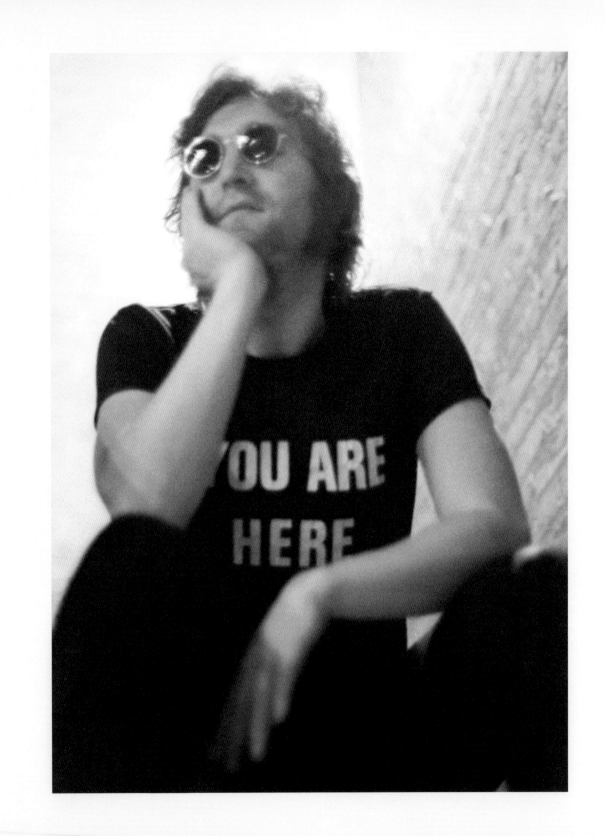

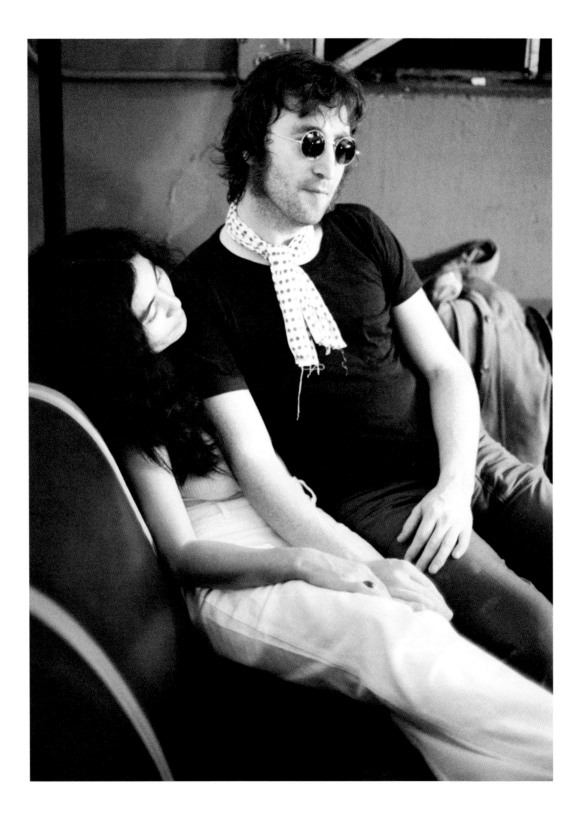

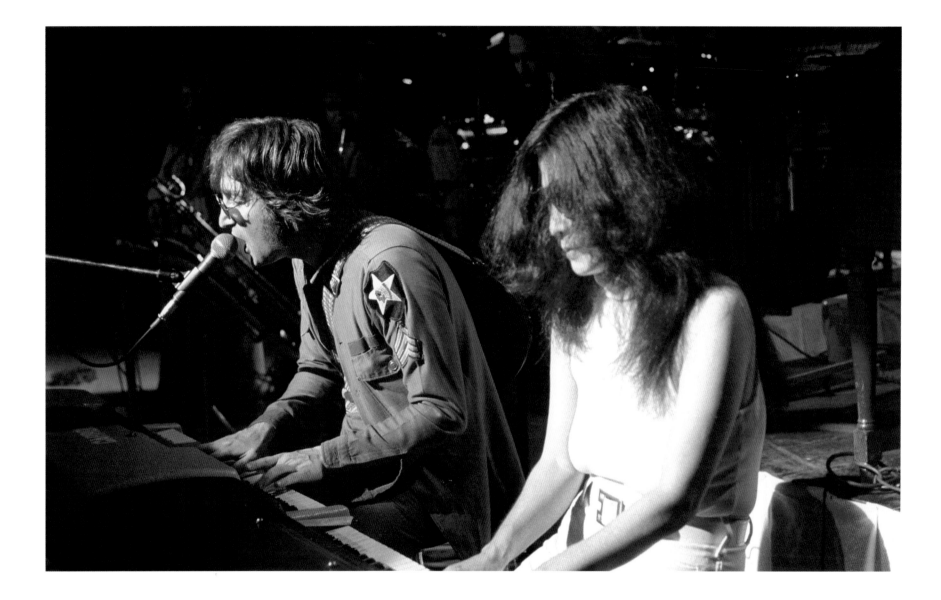

THE MADISON SQUARE

Garden concert, called "One to One," was a benefit for the Willowbrook school for the mentally retarded, a cause championed by newsman Geraldo Rivera. There were hopes that if the show went well, it might spark interest in a John and Yoko/Elephant's Memory world tour.

In many respects, the "One to One" show was a success; the crowd had fun, as did the performers. John, Yoko, and Elephant's Memory were headliners for the special event along with Stevie Wonder, Roberta Flack, and Sha Na Na. At one point, John and Yoko wore hard hats from a Japanese peace organization to represent their message visually. John sang "Imagine," and standing so near to him, photographing him as he sang this incredibly beautiful song, is still the highlight of all my years of rock-and-roll photography. The crowd was as silent during his performance as any rock and roll crowd can be, out of reverence. Other times, they cheered ecstatically for John and booed Yoko equally heartily.

Yoko used a voice technique that enabled her to make a modulating sound. You hear this technique in African and Asian music all the time, but not in American music. People didn't understand what she was doing; they thought she was just screaming and making noise. It took me a few years before I understood that she was using her voice the way her friend Ornette Coleman used the saxophone—she was voicing emotions, not words. Many people don't grasp her method, and certainly didn't at the concert.

After Madison Square Garden, the reviews were harsh. Critics blasted John's "sloppy" performance, as well as what they felt was sloganeering in his lyrics. Partly because the performers had been drinking so much, partly because of the politics of the album, partly because John had given Yoko such a big part in it when the fans had expected Beatles music, the concert was a critical disaster, and any ideas about a tour were dropped.

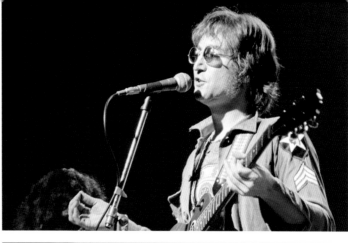

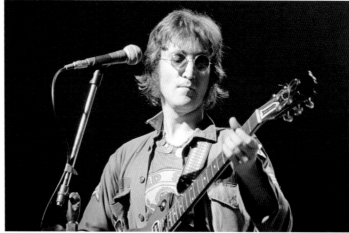

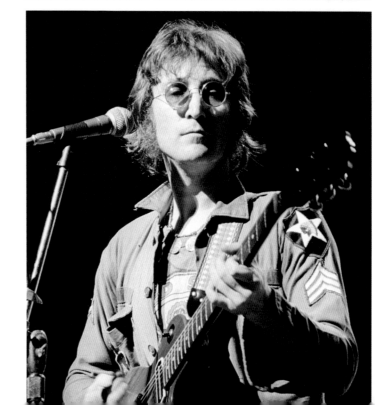

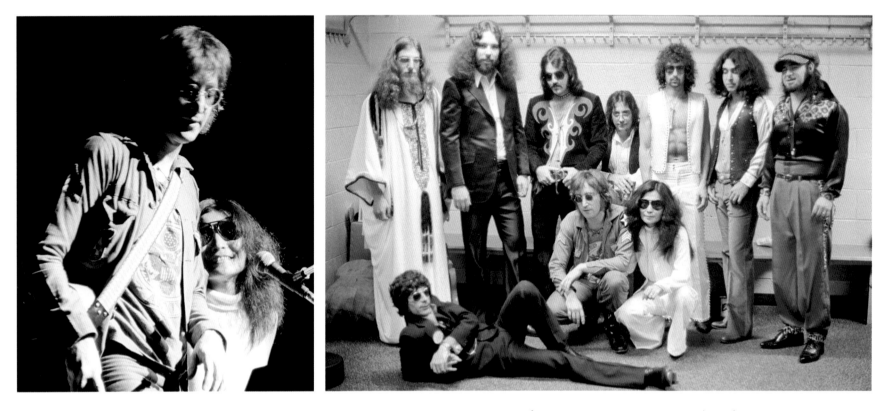

John, Yoko, and the Plastic Ono Elephant's Memory Band with Phil Spector (front) at Madison Square Garden.

John was always much more affected by bad reviews than Yoko, who seemed impervious to them. From her point of view, the concert was a success. Most artists try to please. Yoko wasn't interested in trying to please anyone; she wanted people to react seriously to serious things. She once told me that she came from a school of art where if half the audience didn't walk out, you hadn't done your job properly. When Yoko and John had first become involved, she'd showed him books of her reviews. John's reaction was, "But these are all bad reviews. Why do you keep them, let alone put them in books?" Yoko's response was, "No, they're not all bad. They're all discussing the art."

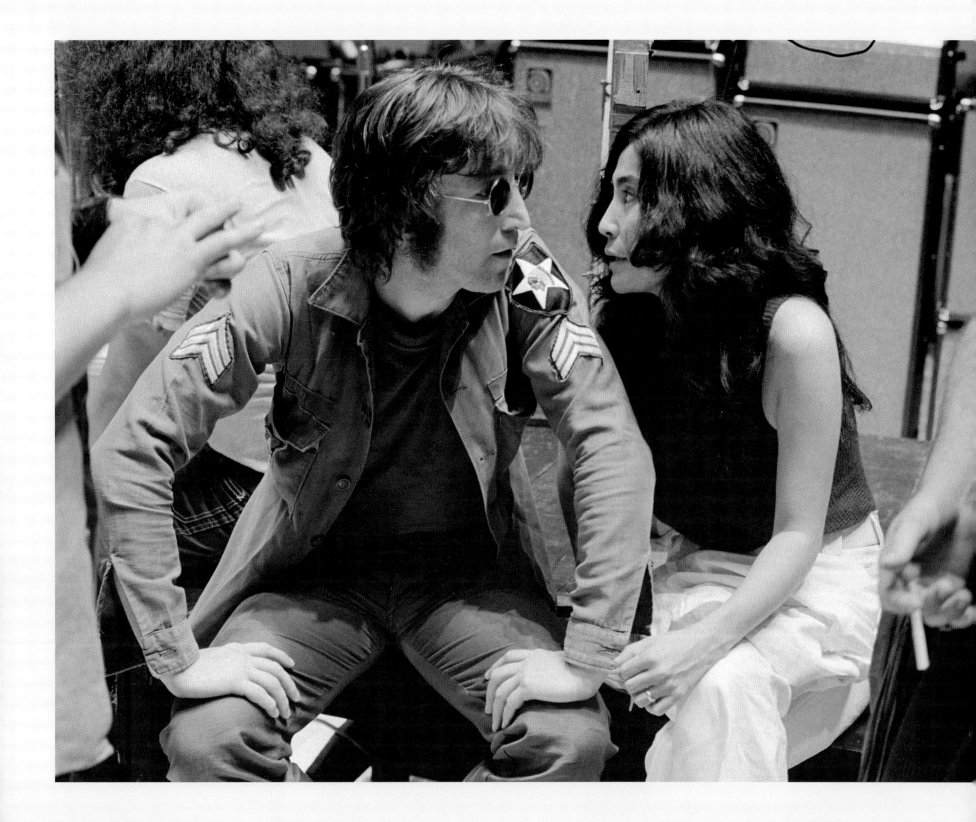

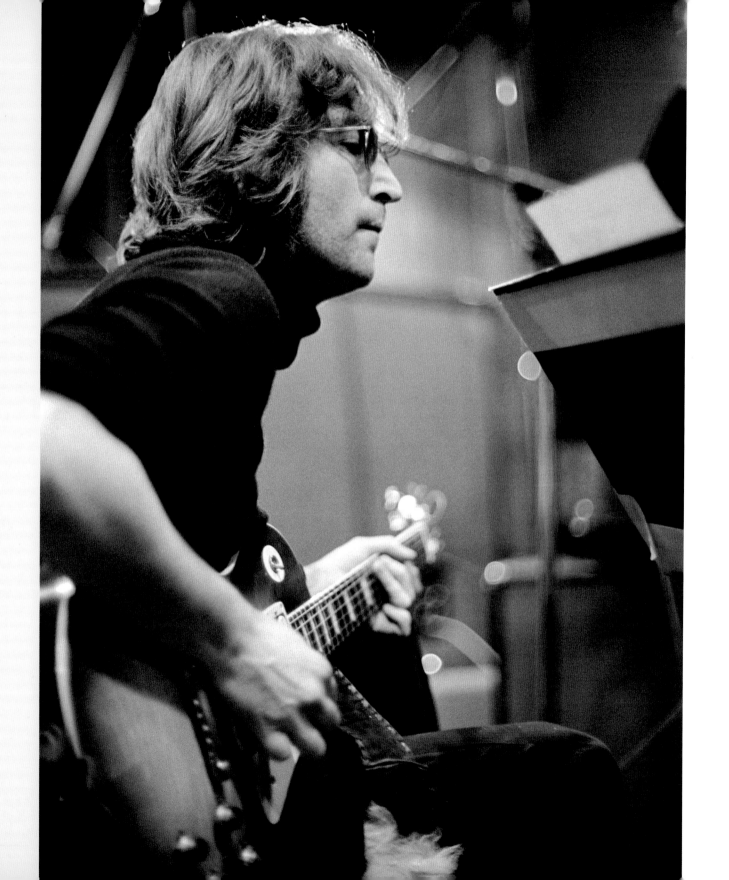

1972–1973

AFTER THE DEMORALIZING reviews from the Mad-

ison Square Garden concert, the Lennons and the Elephants went right back to the

studio. They kept on recording in order to finish the Elephant's Memory album and to

record a new Yoko Ono album. But John was depressed, the critical failure of the con-

cert was an embarrassment, and everyone started drinking even more. When I'd first

started hanging out at the studio, maybe John and a guy or two in the band would bring

a bottle of booze. Later in the night, someone might run to the store if we ran out. But

by the fall of 1972, John was coming in with two bottles, I brought a couple of bottles,

everyone did. We later called these nightly gatherings "The Tequila Sessions," because

there literally would have been a dozen or more bottles of tequila for just ten people.

Yoko wasn't a drinker, but she didn't put limits on John—no one could have con-

trolled his drinking anyhow. As Yoko wrote, "If there was one thing about John, it was

that he was a very strong-willed person and did what he liked most of the time." When

he drank, he'd get really into it and drink a lot. And when he drank a lot, he would drink

more. When this happened, John could get pretty self-centered, not caring about

whom he hurt.

In addition to the bad feelings caused by the reviews, John and Yoko were under

a deportation order, and I think that added to the overall stress level. The U.S. govern-

ment was trying to throw them out of the country, and they suspected they were being

followed. They weren't sure, but they thought they heard clicks on the telephone and

saw people in the neighborhood watching them more closely. As November and Elec-

tion Day drew nearer, it became clear that Nixon was the popular favorite. We all felt

that the administration was dishonest and scary, and it added to the Lennons' fears,

which we later found to be justified.

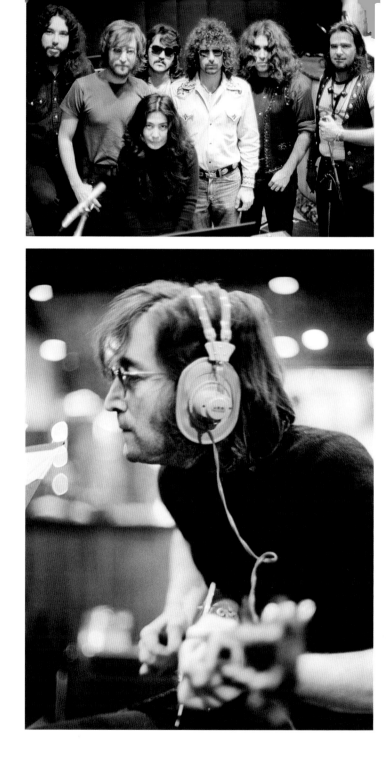

Even I was followed a couple of times. Once, I left the Record Plant studio at about 2:30 in the morning and noticed a car driving a block behind me. The car followed me through complicated turns all the way to Greenwich Village, which was pretty deserted in those days. I parked quickly outside my apartment and jumped out of my car so I could try to get a look at my pursuers. Two men wearing suits and those old-fashioned fedoras G-men wear in the movies glanced at me, then sped away.

My neighbors told me they often spotted guys out on Bank Street, also wearing trench coats and the trademark fedoras. These men would ask passers-by if they'd seen anything suspicious about John and Yoko. The Lennons' street-side apartment left them open to such inquiries and eavesdroppers, and it was becoming too much for them. They were beginning to think about moving to a more secure building, where an extra barrier would be present between their living room door and the street. As it was then, anyone could just walk up the sidewalk and knock on their door. Once, I was sitting in their bedroom, talking, and their assistant came in and said, "There's someone here to see you. He says his name is Jesus. And he's from Toronto. Jesus from Toronto." John laughed and said, "Nope, don't know that one." The randomness of their visitors lost its humor after a while.

To add to the overall anxiety, John's business affairs with his manager, Allen Klein, were increasingly tense. Their clashing would soon lead to John firing Allen; then Allen suing John for un-repaid loans; then John, Ringo, and George Harrison suing Allen for misrepresentation; and then finally Allen countersuing the three former Beatles for lost fees, commissions, and expenses.

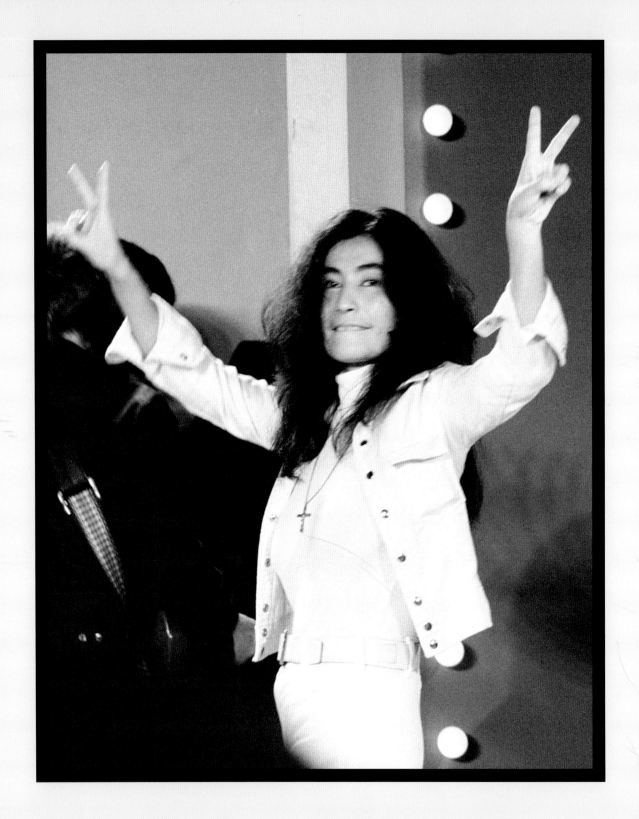

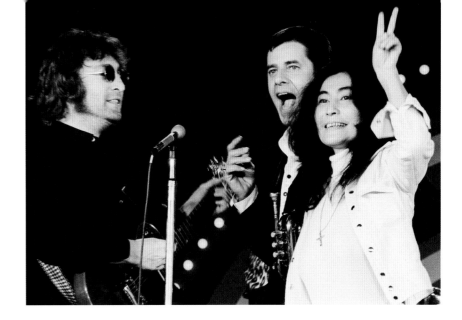

A COUPLE OF DAYS after the Madison Square Garden concert, John, Yoko, and the Elephants played at a Jerry Lewis telethon benefiting muscular dystrophy research. I attended the event, while my wife Nadya recorded it at home with our funky, black-and-white mono video recorder, state of the art at the time. Everyone was excited that Nadya had taped the live show, and right afterwards we had a viewing party in our apartment. The performance was fun to watch and accompanied by a great deal of drinking and craziness. Someone brought over party supplies, and a few of the Hell's Angels, friends of the band, joined us. At one point a couple of the Angels were sharpening their knives on our kitchen counter and making a mess, and Nadya fearlessly went over and told them to be sure to clean up the counter when they were finished. Big Vinnie, another Angel, was standing nearby talking to me, telling me about all the drugs he'd taken in just the past few hours. While he was talking, a roach escaped from his hairy, leather-covered chest and ran across the floor away from him. I thought to myself, "If I were that roach, I would run, too."

There were a few other times John and Yoko came over to our apartment to watch videotapes. Although they had bought a video recorder, they'd donated it to a group fighting for Indian rights in the Midwest. Sometimes that Native American group would send tapes to John and Yoko, to show them the good work they'd been doing. Because John and Yoko hadn't replaced their old recorder yet, they'd come around the corner to our place to watch on our machine.

That neighborly casualness not only defined our friendship, it defined the Greenwich Village music scene, too. My apartment—which was only about 800 square feet if you included the bedroom loft—was the setting for numerous cozy gatherings of rock and rollers, usually for the same purpose: to watch videos I had made, often of them. Labelle or Sha Na Na might turn up at a viewing party, or members of Ike and Tina Turner's band. My building epitomized what the Village was like in the early 1970s. It was—and is—the only government-subsidized general artist's housing in the country, and so in order to live there you have to make a majority of your income from your art. My neighbors were constantly playing music, dancing, painting, and writing. My apartment was on the ground floor then, and because the elevators broke down often, people would frequently hang around in the hallway, witness to whoever wandered in and out of my place, be it Big Vinnie or John Lennon.

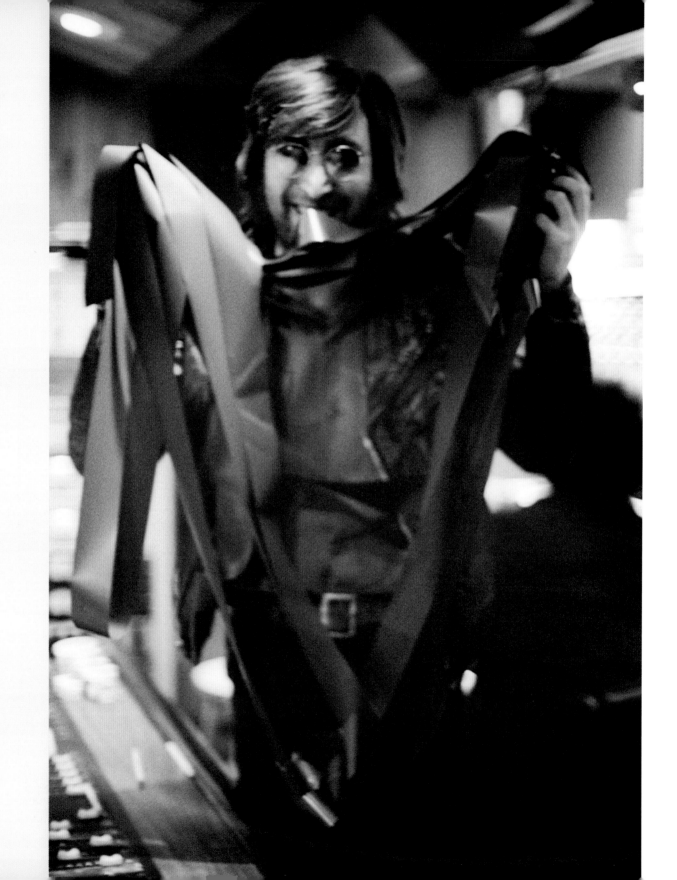

JERRY RUBIN HAD a gathering on the night of the presidential election—but by the time John had finished recording, it was well after midnight and Nixon had already won. John was pretty upset about the election, and his drinking was particularly heavy that night. At one point, he wrapped himself in recording tape, and I took a photo. For a long time I was embarrassed to use this photo, because I didn't want to show how wacky everything had gotten, how drunk we were.

We crowded in to my tiny Volkswagen and set out for Jerry's anyway, though it was 2 A.M. John screamed angrily, cursing wildly at everyone during the car ride—only a Liverpool sailor could have understood some of the language John used that night. The rest of us were upset about the election, too, though aside from John we were pretty quiet on the ride downtown. The vote that November seemed to be a matter of war or peace, and we felt like the war guy had won. There had been dozens of guests at Jerry's, but by the time our entourage arrived, there were only a few stragglers left. John went over to a woman, and then went with her to an adjoining room while the rest of us sat around awkwardly with Yoko, who was obviously really upset and uncomfortable.

We could hear John and the woman moaning through the wall, and so to drown out the noise, I put on a record. I wanted to play something lively, but unfortunately I put on the wrong side of a Bob Dylan album, and the first song that played was "Sad-Eyed Lady of the Lowlands." It's a rather mournful song, and I thought to myself, *OK, Bob, time to go home.*

The day after the election, the recording session was canceled to give everyone a chance to recuperate from the previous night's partying. The day after that, the sessions resumed and the environment was business as usual. John showed up later than the rest of us, unshaven and looking terrible. After recording all night, at dawn we went to a restaurant on Bleecker Street called the Pink Teacup. It had phenomenal soul food, and was open twenty-four hours a day. You could get a good breakfast at five in the morning. There was also a soulful jukebox that pounded out James Brown and other R&B greats. I think that morning at the Pink Teacup, with the emotional mood Yoko must have been in, and all the soul music playing around her, might be when she was inspired to write "Death of Samantha" in which she sadly sings, "But something inside me, something inside me died that day."

After breakfast we walked down Bleecker Street towards home. The sun was just coming up and we walked out on the dock by the Hudson River at the end of Bank Street. It was quiet and calm as John and Yoko walked along together, deep in conversation.

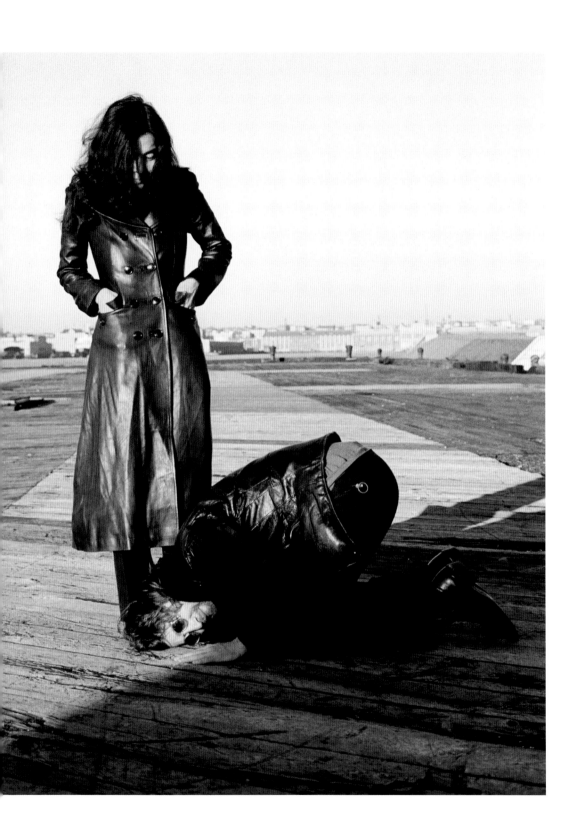

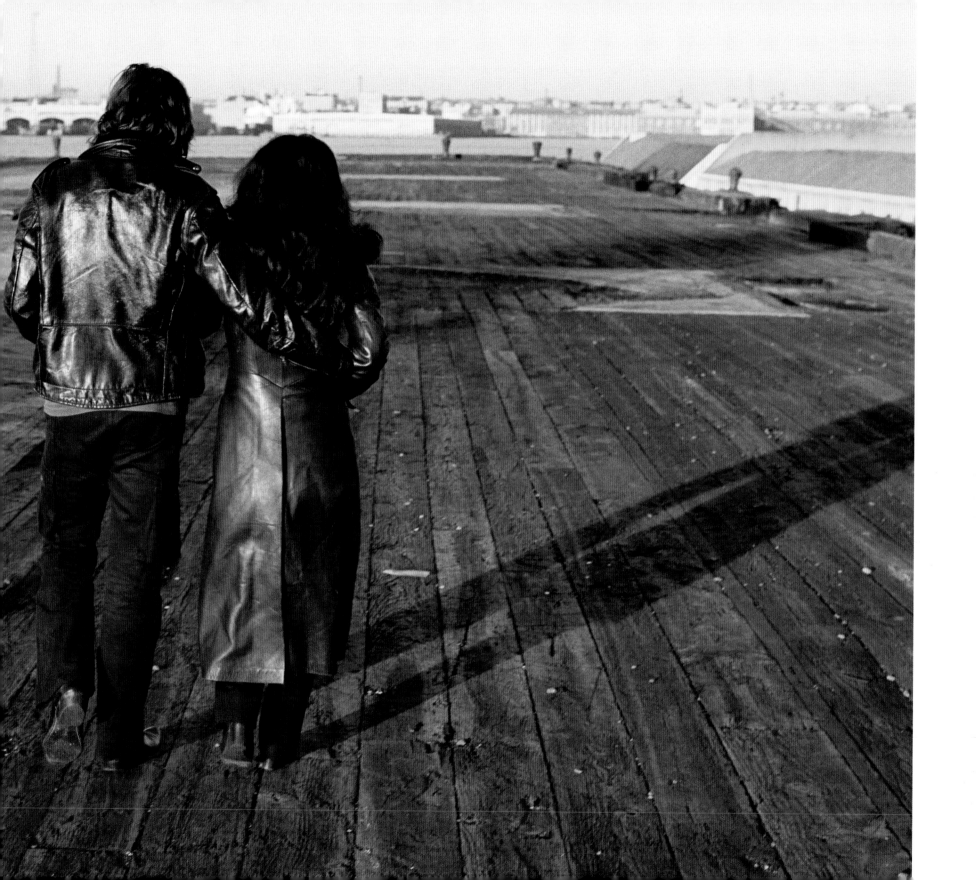

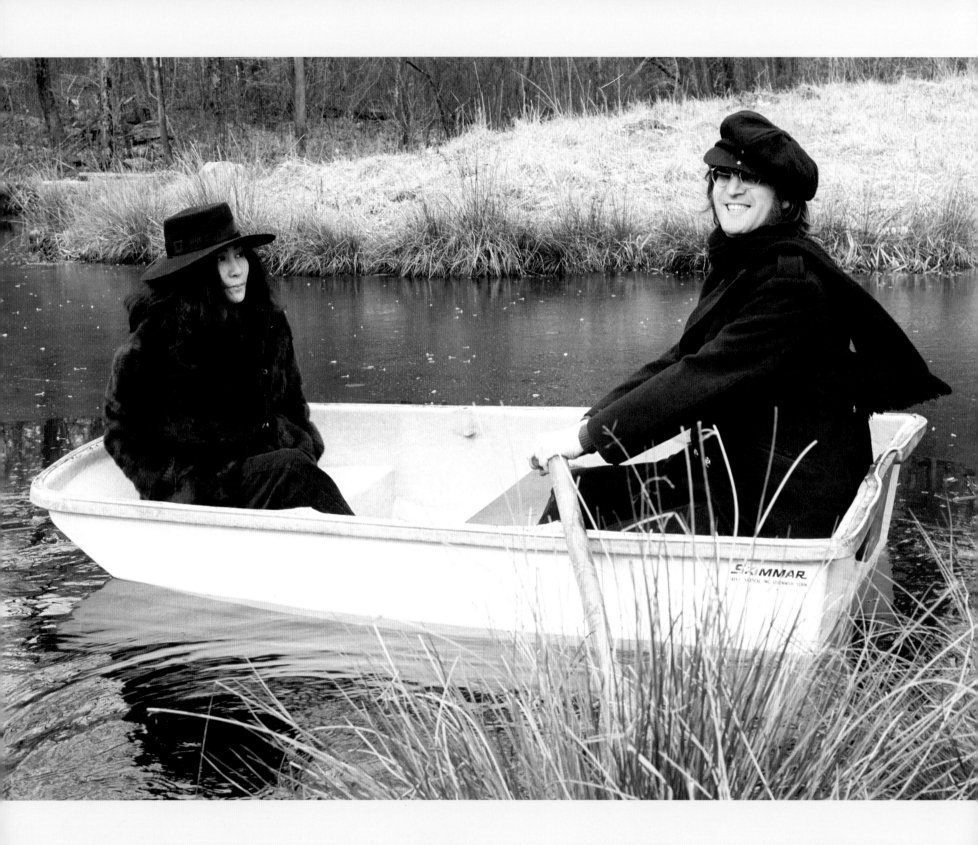

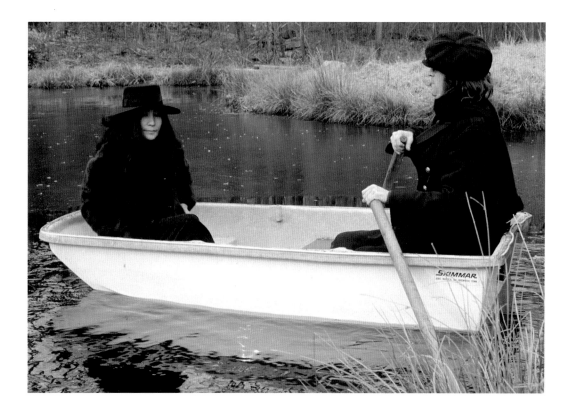

JOHN AND YOKO were looking for a retreat outside of New York, and Nadya—who was working as their personal assistant—suggested they look in Greenwich, Connecticut. Greenwich is a bit like Ascot, outside of London, where John had previously owned a house. Nadya's parents lived in Greenwich, Connecticut, and her mother had researched a few potential homes for John and Yoko with a real estate agent. We decided to spend a day looking at what the agent had found.

I drove everyone up in John and Yoko's big, old station wagon. First we drove to Nadya's mom's house to take a walk around her grounds and get a feel for the countryside. John and Yoko liked the environment very much and relaxed easily. We came across a little rowboat, and John talked Yoko into taking a ride. I love these pictures, because they really show the lightness of the day.

After we walked around Nadya's parents' property and took some pictures, we went to look at the houses for sale. John and Yoko didn't find one that was quite right for them that day, and ended up buying a place on Long Island several years later.

John and Yoko never questioned me taking my camera along—I always had it. I'm not a photographer who works only at assigned moments. Since I was thirteen years old I have always carried a camera, and I've always been ready to take a picture. And the Connecticut trip seemed like it would present more photo opportunities than usual, because we weren't just sitting around the house. I wasn't trying to get shots for a particular reason—it was simply nice out, and we were taking advantage of the situation.

The photos from that day in Greenwich show the lighter side of Yoko, the side those close to her saw all the time. Yoko tends to look serious in photos, especially

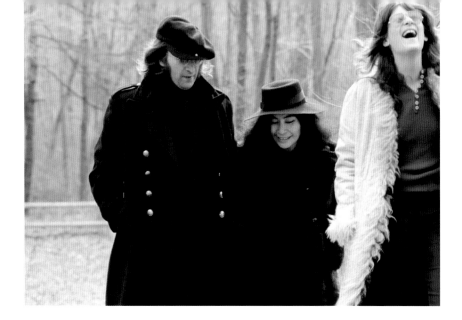

when she wears all black. But I always try to include the lighter ones in the shots I submit for publication. I particularly like the photo where you see her smiling and Nadya laughing. That's the way it was, with everyone laughing; John was such a funny guy, so clever and perceptive. You might be speaking on a deep level about things and he would twist it into a pun or joke and everyone would crack up. Yoko could joke right back to him. That's part of the reason it was so much fun to be with them; they were so funny you would laugh whenever you were around them. Theirs was a very cynical kind of humor. I think that cynicism also helps explain why they got along so well in New York.

Though I loved the photos of Yoko smiling, whenever I brought over a selection of prints for her to choose, she always picked the ones in which she was serious. When I asked why, she explained that it was a Japanese custom to not smile in photos. The American custom of saying "cheese!" and sporting a smile is seen as very strange in Japan, where they feel life is serious, and don't want to be captured on film laughing or looking silly.

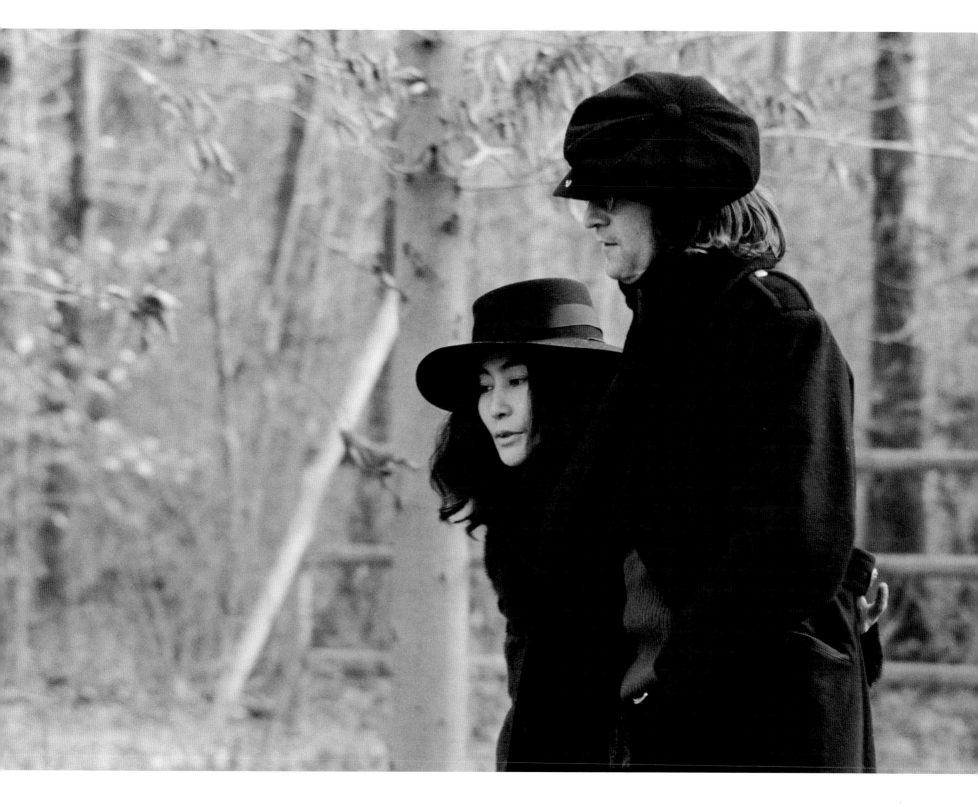

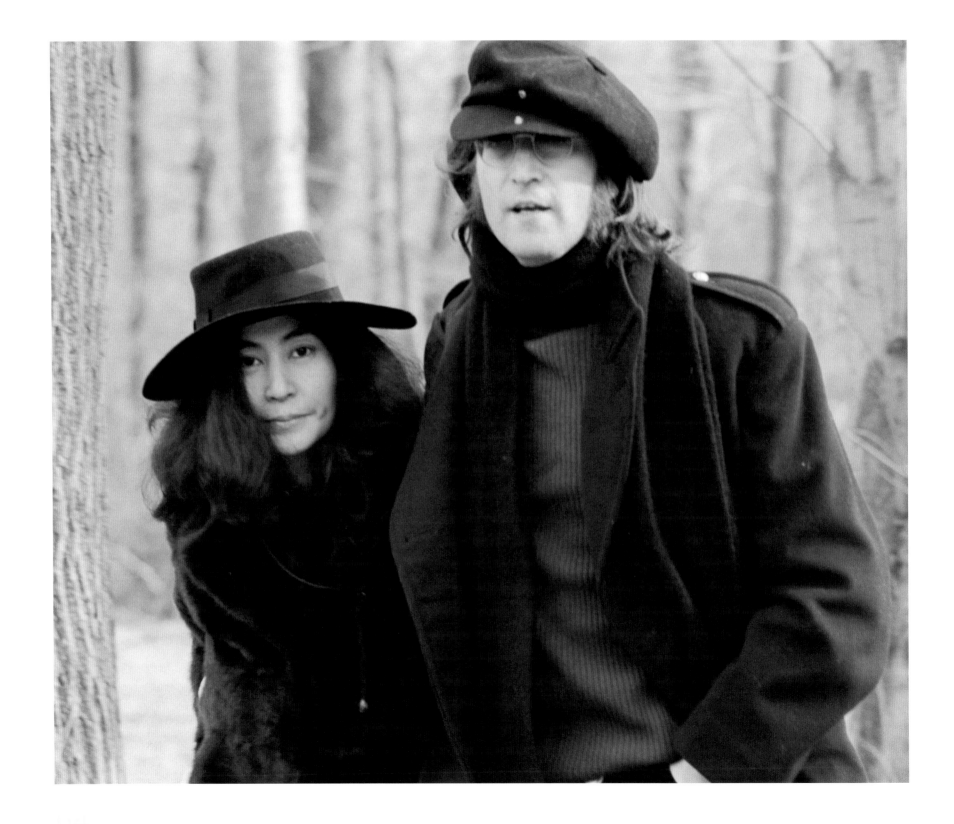

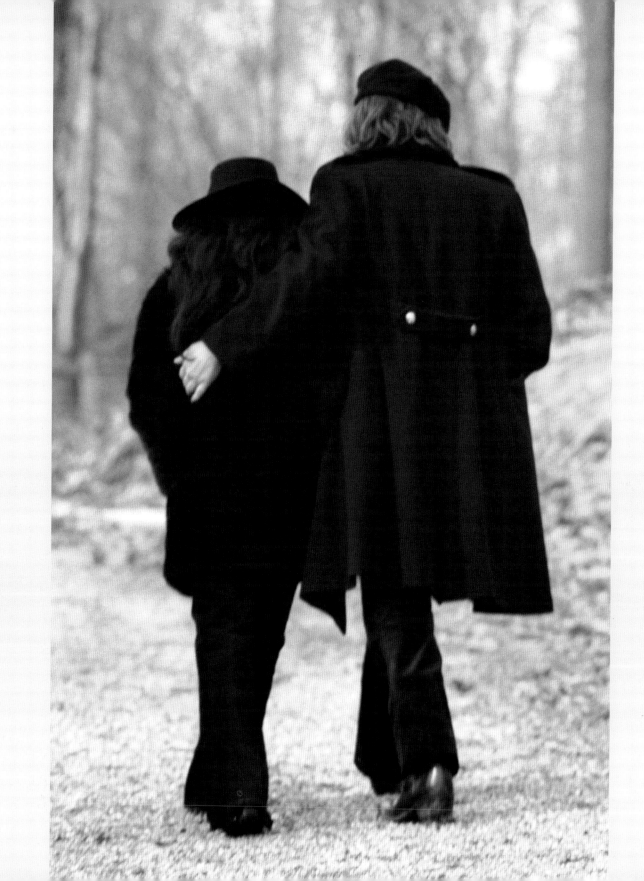

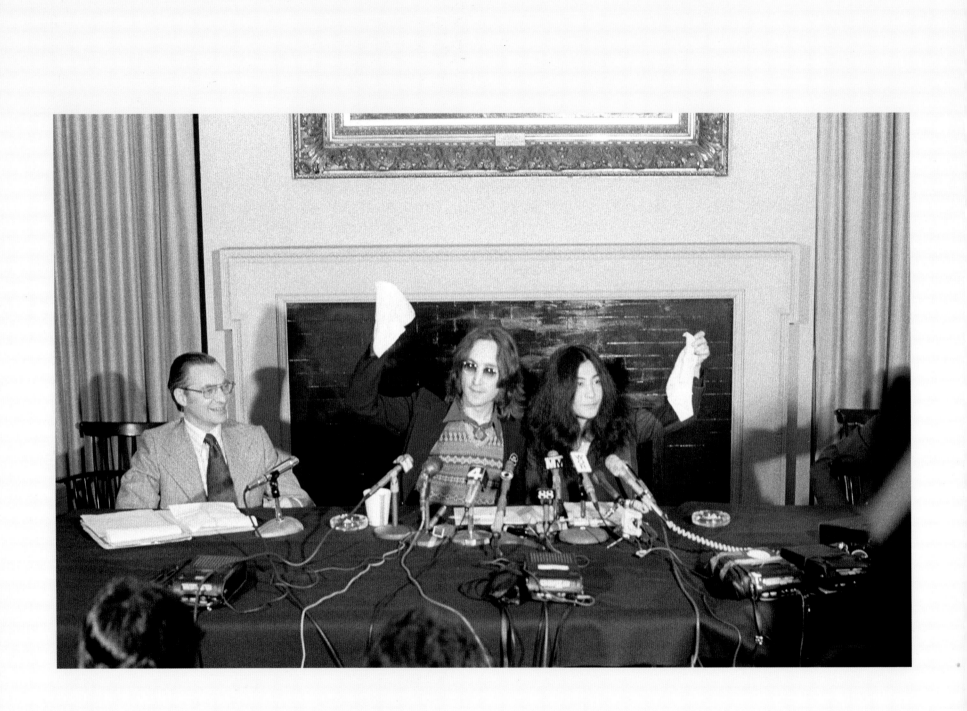

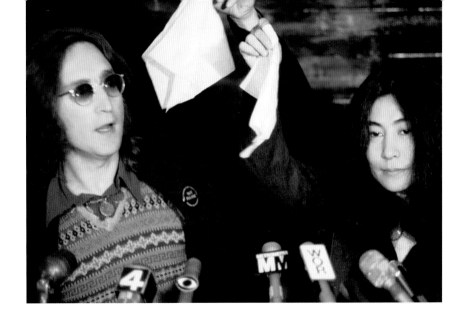

JOHN AND YOKO called a press conference suddenly and mysteriously for April Fool's Day 1973. No one knew the purpose of the press conference in advance, including John and Yoko's attorney Leon Wildes. I went with no idea of what to expect.

In answer to the U.S. government's effort to deport them, John and Yoko declared the conceptual existence of Nutopia, a country with "no land, no boundaries, no passports, only people." As ambassadors of the new country, they asked for diplomatic immunity and waved white handkerchiefs—Nutopia's national flag.

Everyone at the press conference was taken aback. People didn't know whether or not to take them seriously. Though it wasn't the formal discussion about their legal troubles the press expected, they addressed their plight in a far more significant way, as citizens of the world.

John and Yoko were very serious about their declaration, and I personally felt it was a brilliant idea to use conceptual art as part of their defense. Serious as it was, I think they got a great kick out of it, too. They had brass plaques put on different doors in their home to name the rooms, and the plaque on the back door read "Nutopian Embassy."

SOON AFTER, JOHN and Yoko had had enough of living in a street-side home, of having characters like the inimitable "Jesus from Toronto" stopping by. They had arranged to look at an apartment in the Dakota building, which they eventually purchased. I had an assignment to take some pictures of them, so I suggested they stop at Central Park on the way, since the Dakota bordered the park.

The pictures I took that day ended up being some of their favorites. In fact, Yoko recently used the photo of their hands touching on the tree trunk in a CD package. The shoot wasn't very long but it was spontaneous and fun, and we walked around the area now known as Strawberry Fields. It was a breath of fresh air on an early spring day after a winter indoors.

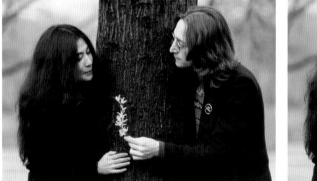
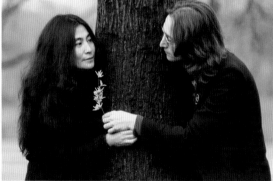

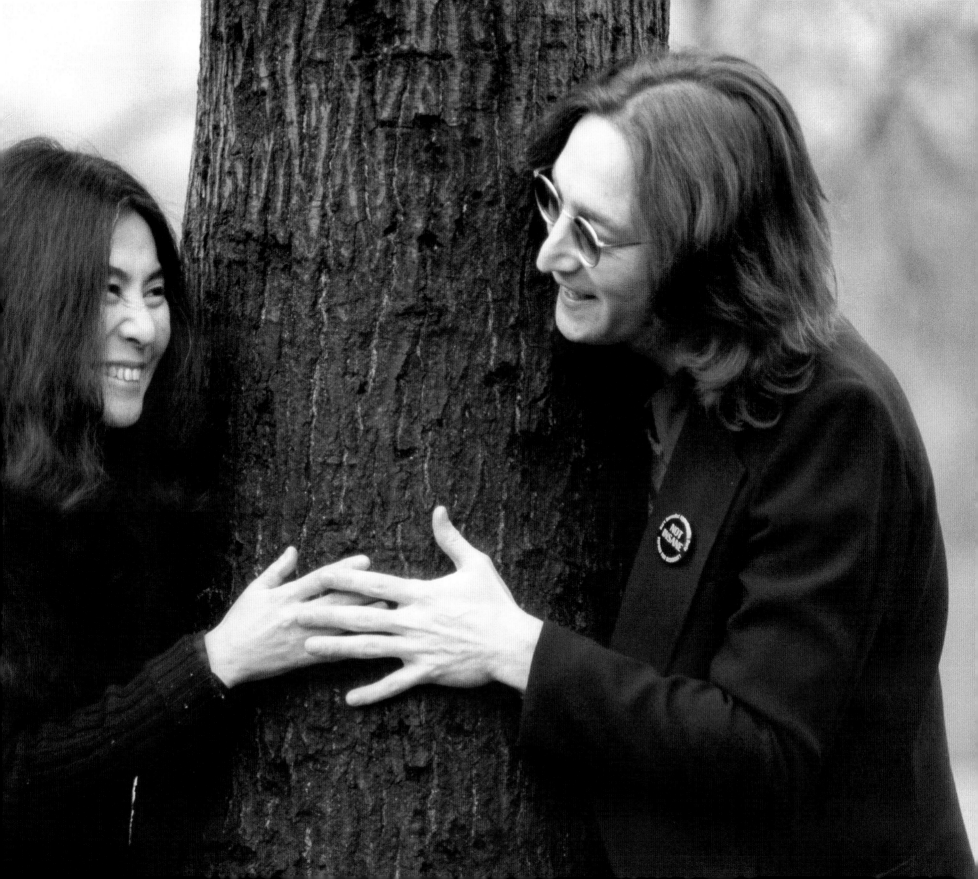

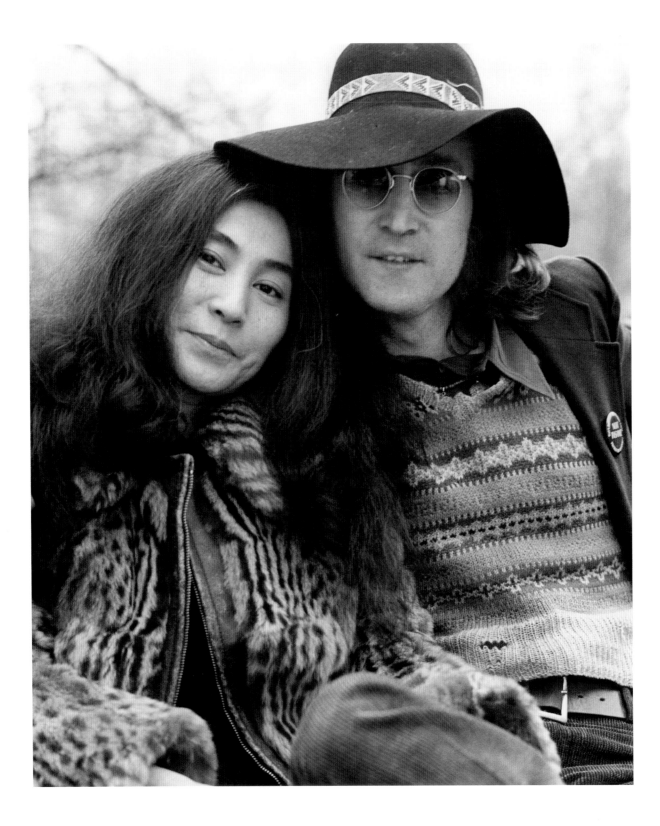

BY THE BEGINNING of the summer of 1973, Yoko was re-cording a new solo album—*Feeling the Space*—with a group of professional studio musicians. She was making this album herself, without John. At the end of that summer, John started recording his *Mind Games* album, also using studio musicians, and working without Yoko.

In September, I was working with the New York Dolls in Los Angeles and saw Yoko perform in San Diego with her new group. When I got back to New York, I visited John several times at the Record Plant and often drove him home after the sessions—John much preferred riding in a friend's car to riding in a limo. On one of those nights, John mentioned that he wasn't staying at the Dakota, but that I should drive him up to 91st Street, to his assistant May Pang's apartment. He admitted that the night before, after I'd dropped him off at the Dakota, he'd just taken a cab uptown to May's. But he didn't feel the need to hide it from me anymore—he and Yoko, he said, were

"kind of separated." I was a bit surprised, but I'm not easily shocked, and I don't like to meddle in people's business. I didn't give him advice, but just said, "Oh, really? That's a surprise."

John was distressed and depressed—about the election, about the criticisms of *Some Time in New York City*, about all his various legal and financial problems—and he was overwhelmed. He was drinking a lot. Yoko, in contrast, was sober and anxious to keep working, to keep going. Shortly after the night I dropped him off at May's, John went to Los Angeles.

I didn't see much of John during this time. He was recording in Los Angeles with Phil Spector and hanging out with Harry Nilsson and Keith Moon. I think it was John's close friend Elliot Mintz who first dubbed that period John's "Lost Weekend," after the Ray Milland movie about a man who descends uncontrollably into drink. John's "Lost Weekend" went on for more than a year and was marked by a lot of wild nights.

FOR THE MOST PART, I stayed close to New York and didn't see John until he came back with Harry in the spring. I just happened to hear on my car radio that he was about to appear in Central Park at a March of Dimes benefit. As luck and timing would have it, I was nearby. I parked quickly and headed to the stage, arriving at the same time as John's limo. In those days, security wasn't what it is today, and I walked right up to his limo as he was just getting out, along with Harry Nilsson. I walked up behind them and onto the stage as if I had come with them. I slipped in like it was natural, as it had been customary for me to attend events as part of John's entourage. John didn't even see me on the stage until later. Then at one point he turned around, holding a child, and said, "Oh. Hi, Bob. How are you?" It was that normal for me to just appear. Before he left the park, he told me he was working at the Record Plant studio, recording with Harry, and I should come down and see them.

I went to the Record Plant soon after and took some pictures of John and Harry relaxing and playing pool. Harry was a lot of fun and had a real camaraderie with John. They were alike in many ways, in that they were both uncannily perceptive, cynical, and funny. Like John, Harry was also a bit of a wild man. It's strange, because when you hear his records, they have a sentimental and sweet quality to them, but when you meet him, he has a whole other side. He was a real fun-loving party guy.

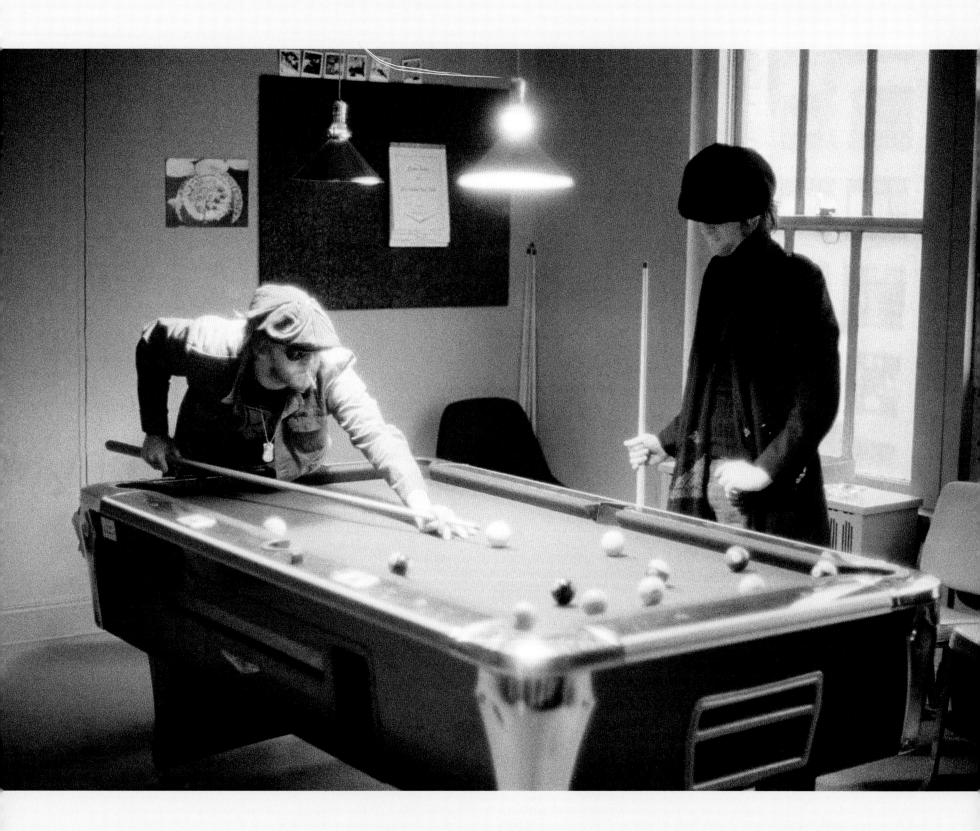

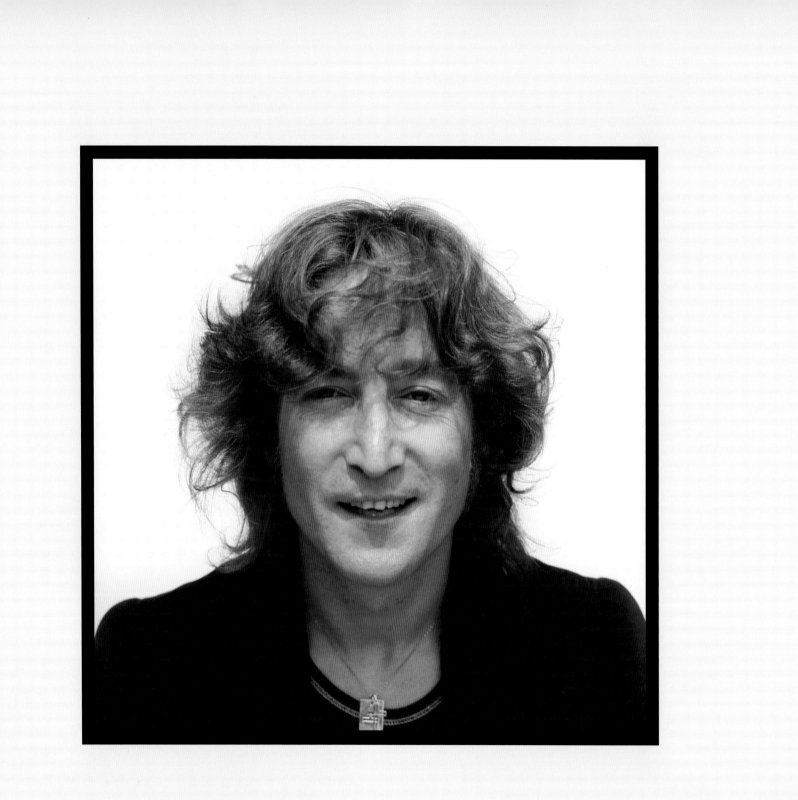

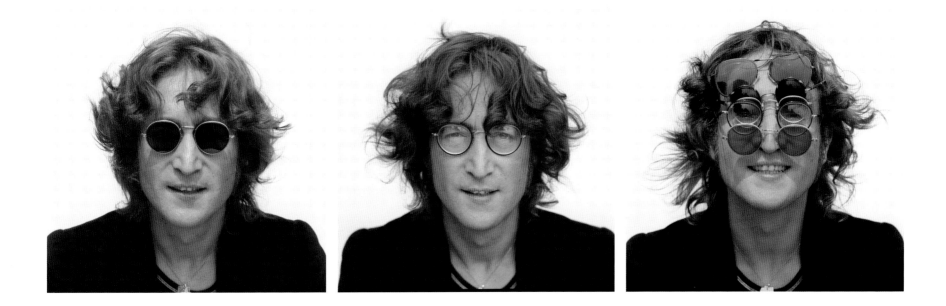

IN LATE AUGUST, just after I had returned from a twelve-day tour of Japan with Yoko, John called and said that he needed pictures taken for his *Walls and Bridges* album. The art director wanted to have a series of pictures, all of his face the same size with different expressions. Then they would cut the pictures into flaps, so you would have one series of his eyes, one of his mouth, another of his nose, and you could rearrange them in different faces and expressions, like a toy. John said they wanted him to go to a studio to get the photos taken, but he didn't want to go through the whole formal process, which would mean makeup and styling and various assistants fussing; it could take a day or two out of his schedule. He asked me to shoot the whole series of pictures just of his face. He was staying in a penthouse apartment on the East Side, and I figured I could just go over there and we could take pictures on his roof patio. It would take an hour and be done, instead of making it a whole big production. And that's pretty much how it turned out—the whole session took only a fraction of the afternoon.

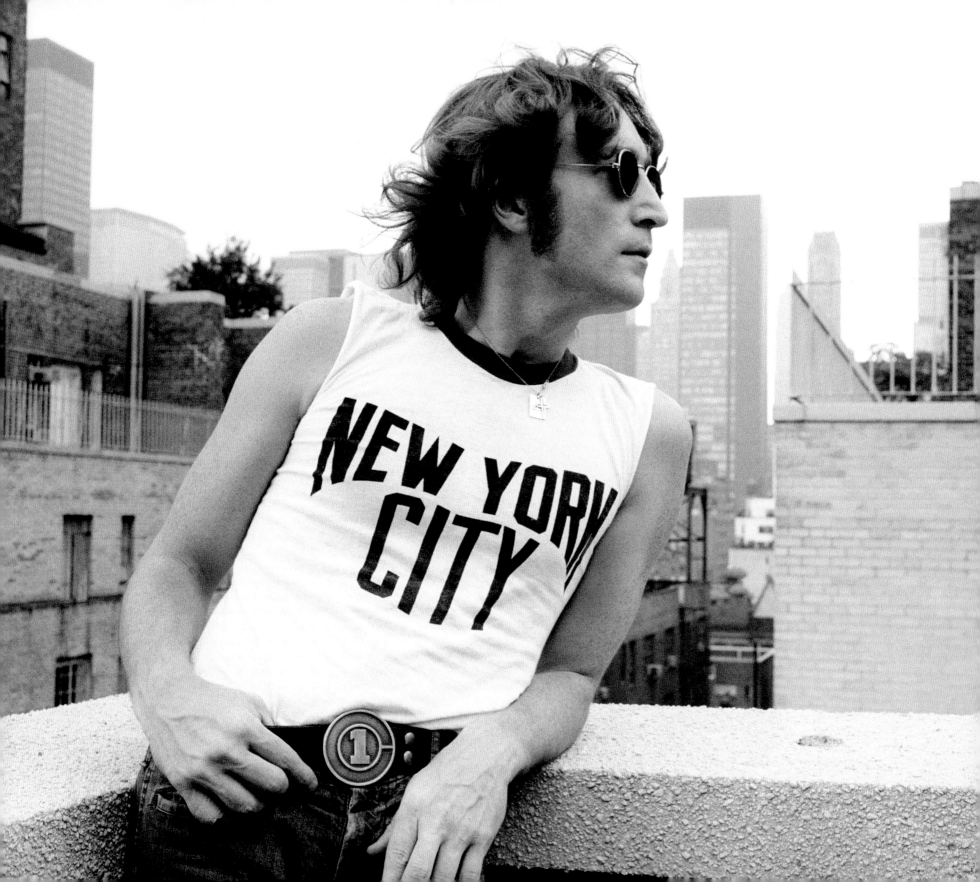

I took dozens of photos of John wearing different eyeglasses, and at one point he ended up putting all the glasses on at once. It's become a really well-known photograph, and I think I know why it resonates with people. When you're looking at that picture, even though John has all these glasses on, you can look through them all straight to his eyes.

When we finished his face shots, John suggested we take more pictures so we'd have the publicity kit ready when the album was released. John posed on the roof in his black jacket. The whole skyline was visible, and I had an idea to play on the New York theme. I had given John a New York City T-shirt a year before. I used to buy them all the time on the street in Times Square and had a half dozen of them myself. One night on the way to see John at the studio I'd bought one for him and cut the sleeves off with my Buck knife, to complete the "New York" look. I asked if he still had the shirt, and he said yes. Fully a year and several moves after I'd given it to him, he still knew exactly where it was. I suggested he put it on, pointing out that it was the perfect time to wear it. He disappeared for a minute and came back up to the roof wearing the shirt.

We had a good time that day, and John enjoyed having his picture taken. He'd been posing for pictures for years, ever since he was first in a band. He knew how to do it and posing came naturally to him. John saw it as part of show business, which it very much is. Like a good model, John would change positions and his expressions while I took photos. I don't give a lot of direction; I'm not one of those photographers who shouts, "Give me more, baby!" I'm actually pretty quiet when I take pictures and let my subjects find their poses naturally. Some photographers love to give direction, but I feel that if I tell people what to do, they're more likely to focus on pleasing me, rather than just being themselves. My style worked well with John. He and I would usually chat and make jokes while we worked. I would keep up a conversation and the pictures would inevitably become part of it.

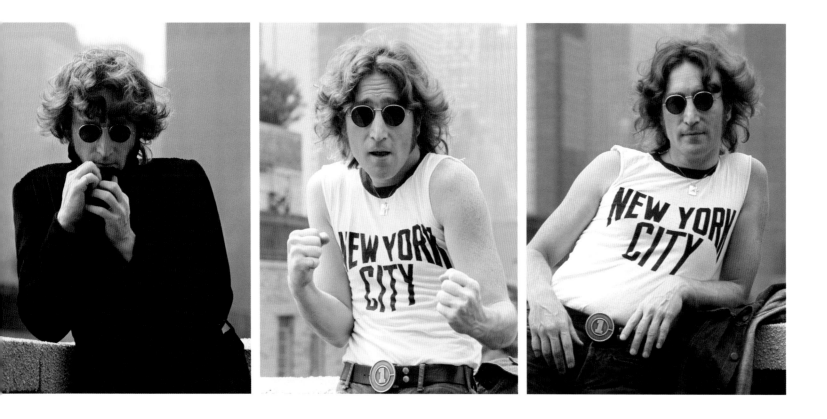

I think people are drawn to the New York City picture because John is so relaxed. I once heard a graduate class in communications critique the photo of John in the New York T-shirt. One student described it as "self-revelatory"—the shirt says New York, the background says New York. The crossed arms and cut-off shirt say New York attitude. New York is represented as a strong, independent idea, and John is as well. The class felt he was also a bit aloof; he's got a rock star's distance, in that he's got sunglasses on, even though it feels like he's looking you right in the eye.

One of the reasons I like this picture so much is that John wasn't posing as a New Yorker—he *was* a New Yorker. And he was proud of it.

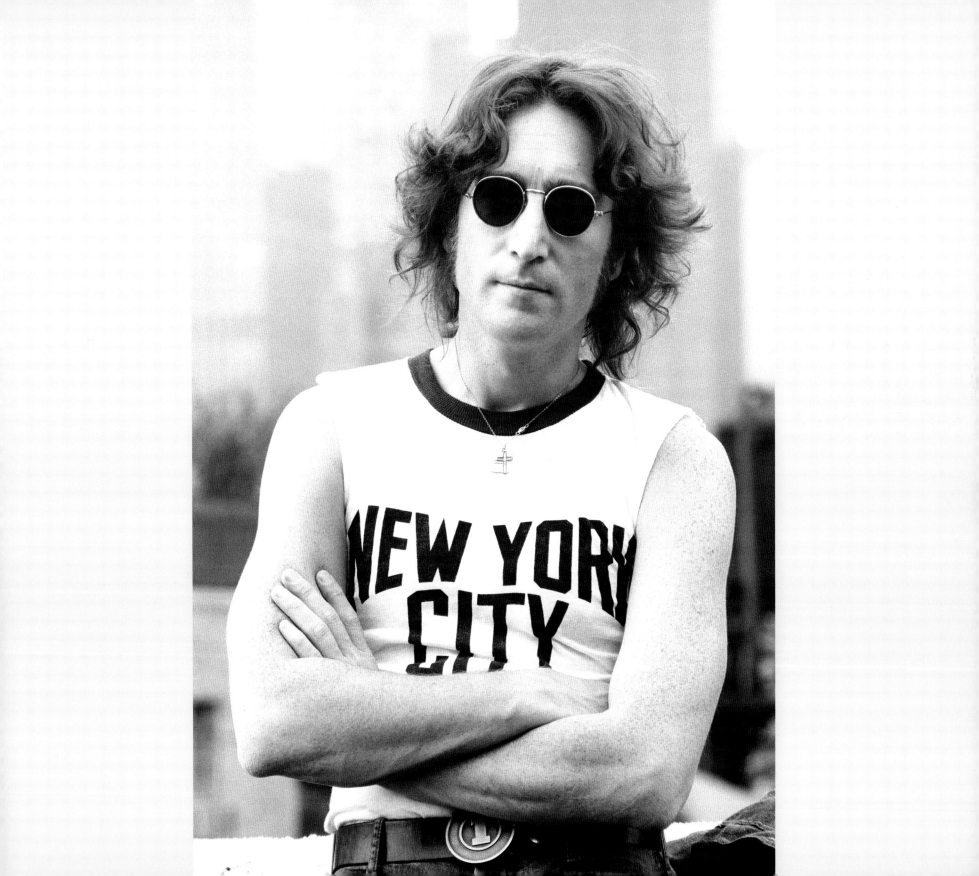

ONE NIGHT, A WEEK before the *Walls and Bridges* shoot, John called me and said he had seen a flying saucer from the roof of his apartment (the same flying saucer he refers to on the inside of his *Walls and Bridges* album when he writes, "On 23rd August 1974 at 9 o'clock I saw a UFO"). May Pang had taken some photos of it, and John wanted me to develop the film right away. I brought the film back to my darkroom, and developed it along with a few rolls of my own film. My film was fine, but May's flying saucer film was entirely blank; there were no pictures on the entire roll. She had used a good, ultra-high-speed film that should have worked well in low light. We never figured out why the film was blank.

When I brought the film back to John the next day, I asked him if he'd reported his sighting to anyone. He pointed out that he couldn't just call the police and say, "Hi, I'm John Lennon, and I've seen a flying saucer," so I offered to make the call for him. I called the *New York Times*, who hung up on me; I called the police, who said they hadn't heard anything; and I called the *New York Daily News*, who said they'd had several calls about it, and that encouraged us. It meant there must have been something strange in the sky that night.

When I was taking the *Walls and Bridges* pictures, John asked for a shot of him pointing to where he had seen the flying saucer. I believed him. I remember John saying once in an interview that he was willing to believe anything until it was disproved; that open-mindedness about the spiritual and mystical carried over to many areas in his life. He was never one to say, "Oh, it can't be."

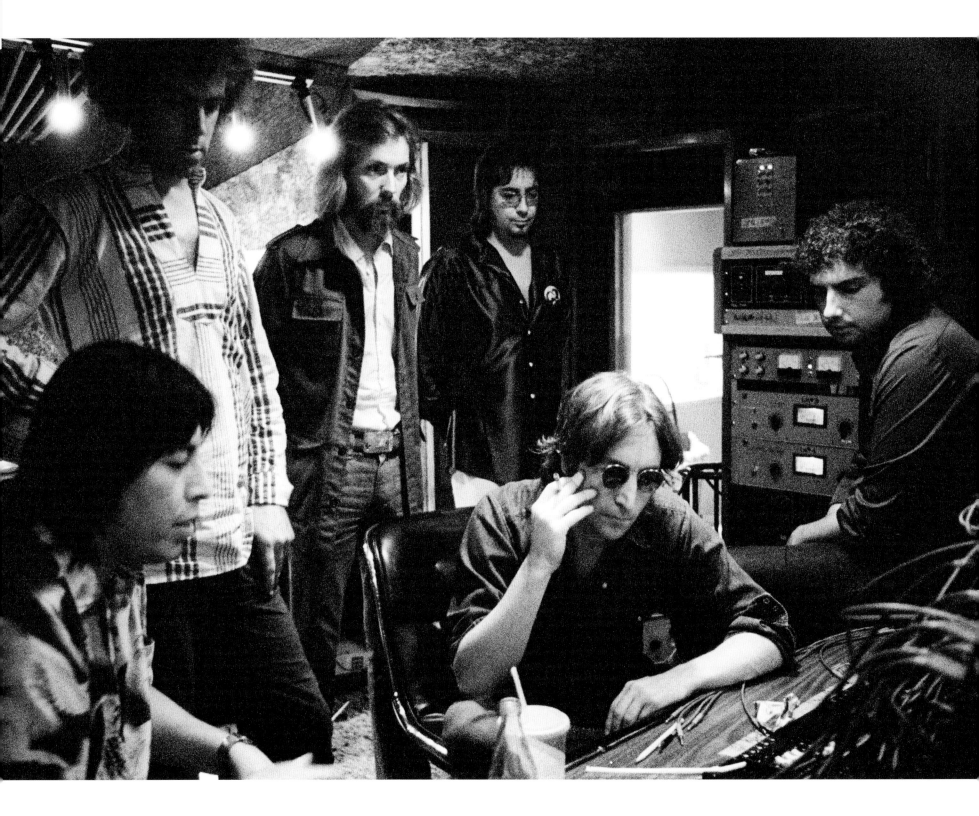

ONE NIGHT IN October, after drinking our way through dinner, John wanted to go downtown to party. I drove John and guitarist Jesse Ed Davis in my Volkswagen to Club 82 on East 4th Street. It was a dive run by very tough, mannish-looking lesbians and was known for its fabulous transvestite shows. Lately rock bands had been playing there, too. As we went down the entrance stairway, John lost his footing and slid the rest of the way, landing flat on his back right in front of the manager, Tommy. Taking it in stride, I said "Hi!" to her and, waving my arm toward the floor, added, "And this is my friend, John Lennon."

Though there continued to be the occasional wild night that fall, John wasn't really drinking and partying as much as he had been. He was taking things seriously, wanting to move forward.

The fall of 1974 was a contemplative time for John, as he was slowly emerging from his "Lost Weekend." He and Yoko were still separated, though they lived in the same city. John's apartment was small, but it had a large outdoor patio off of the living room.

I saw him less than usual when he lived there, as my son Kris had been born that September, and I was busy with him. When I did go over to John's, I'd often bring Kris, whom I carried in a pouch that tied around my neck. Nadya and I took turns taking care of him and pursuing our work in our "off" hours. Our equal parenting arrangement was unusual for the time. John saw how we were sharing the child raising and took an interest in it, complimenting me on my willingness to take part. By the next year, John would be doing the same thing with his son Sean, only he would take the parenting role even further, caring for Sean full-time.

John had been in constant touch with Yoko, always asking when he could come home. One time when I visited his apartment he was on the phone with Yoko, and when he finished he told me that he always waited until he was alone to call, so he could have a private talk with her.

Jesse Ed Davis, Eddie Mottau, Klaus Voormann, Jim Keltner, John, and Shelly Yakus at the Record Plant, Fall 1974.

THE NIXON ADMINISTRATION continued its efforts to deport John, fearing he would stir up political opposition to their policies. I've always been drawn to symbolism in photography—where with just a look at an image, you can get the meaning—and it dawned on me that taking a picture of John at the Statue of Liberty would help dramatize his case. After all, America stood as the world's most welcoming nation, and yet we were throwing out one of the world's greatest artists.

John loved the idea. "Get up early," he said as I dropped him off the night before our Statue of Liberty trip. "And bring your eyes." His parting comment was a jab at my reputation for blurry pictures. I was always much more concerned with capturing the right moment than emphasizing the sharpness or technical quality of the photos. A lot of photographers will fiddle with their lens and miss the moment. I usually got the moment, but it might come out a little blurry. John used to kid me about it a lot. In fact, John did a mock interview with himself once, and when he mentioned his friends, he called me "Bob 'Is it in focus?' Gruen." I knew he was joking, but it still prompted me to look back over a lot of my pictures. In many of the pictures I select, though the image may not be sharply focused, the feelings are clear.

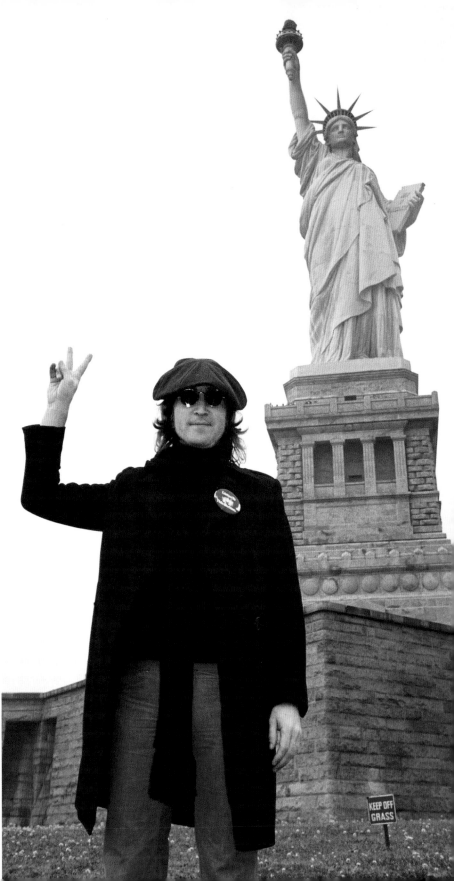

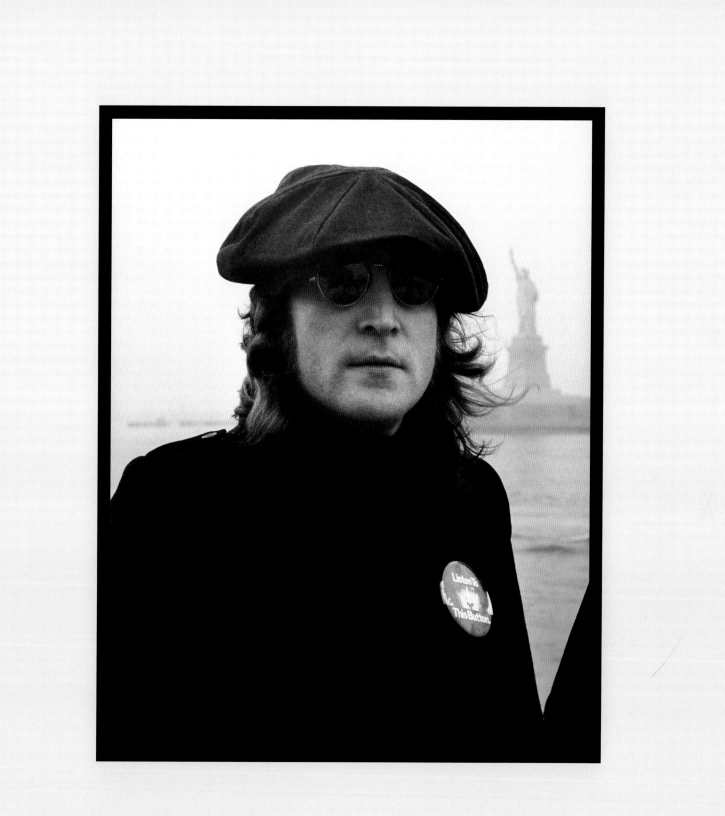

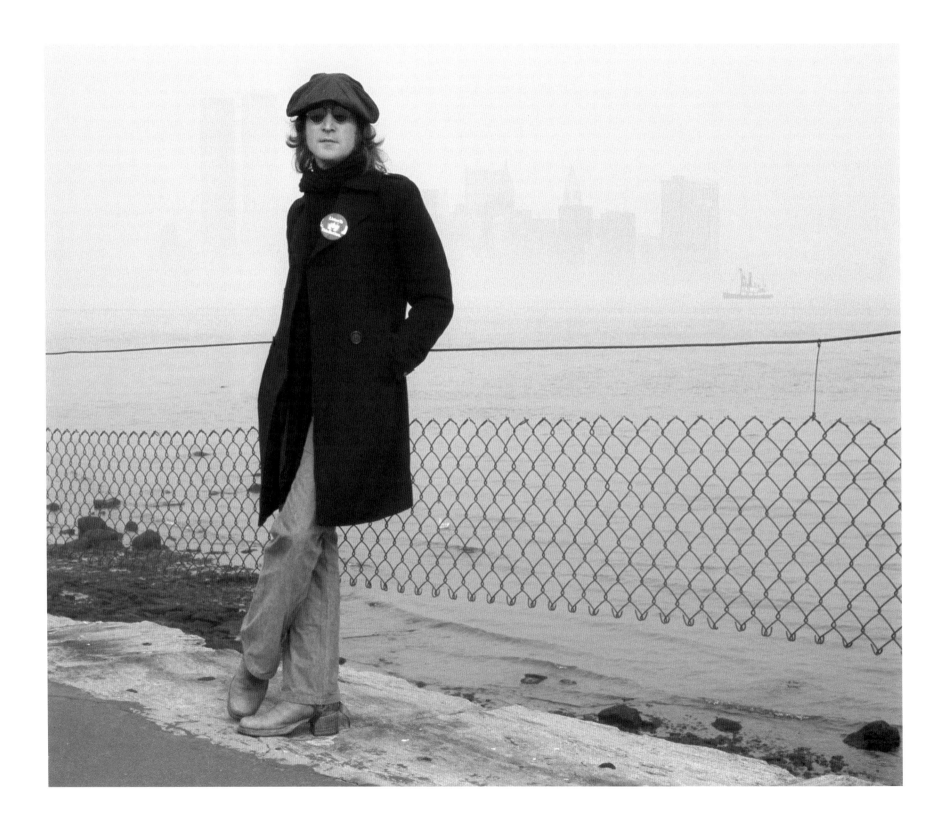

The next day, we went down to Battery Park to catch the ferry to Liberty Island. As we walked around, waiting for the ferry, John looked up at the buildings around us and said, "I bet I'm paying rent on every one of these buildings. There's a lawyer working on *something* for me in every one of them. You know, there's a funny thing about lawyers that work for me. The first time I go to visit them, they have a nice, respectable practice. By the time I go back for a second visit," John laughed, "they've moved to a bigger office, and it always has my picture on the wall."

We went to the statue, walked around to the front, and took pictures for a little while. We didn't know exactly what impact these photos would have, but we both had a feeling they would present an attractive image the media would pounce on. Surprisingly, the photos didn't really get picked up by the press the way we thought they would. There wasn't a lot of ongoing publicity about John's case. It was later—after John won his case, ironically—that the Statue of Liberty picture really became an iconic image representing peace and liberty.

MY MOM TAUGHT ME that it was lazy not to ask for things you wanted. "Let *them* say no," she would say, "If you don't ask, it's like *you* saying no."

This was illustrated for me when John was approached for a special favor in 1973. My friend Steve Paul, who managed the blues musician Johnny Winter, had asked Johnny whose song he'd pick to record if he had the choice. Johnny had given him three names: Bob Dylan, Mick Jagger, and John Lennon.

Steve Paul asked all three. Bob Dylan didn't respond, and when I brought the request to John he said, "I wish I had a song for myself!" Mick Jagger, however, did have an extra song, and Johnny recorded it.

A year later, Johnny happened to be recording in the same building as John. John hadn't forgotten the request and went down to visit him, giving him the music to "Move Over Miss L." So in the end, two out of the three were able to help out—an encouraging affirmation, I thought, of my mom's advice!

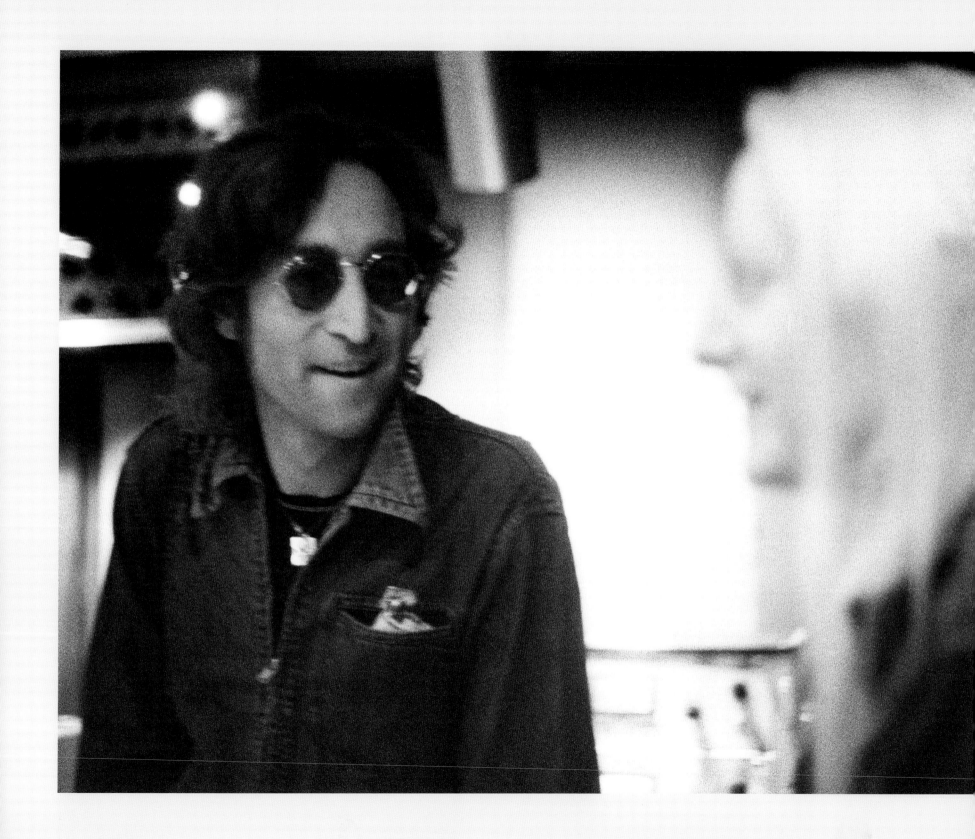

Pete Bennett, Ronnie Spector, John, Bianca Jagger, and May Pang.

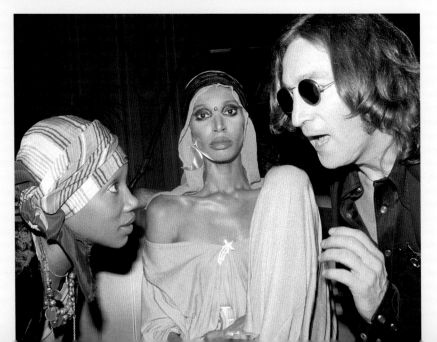

Donyale Luna (center) and John, with friend.

A GROUP OF VISIONARIES adapted the Beatles' album *Sergeant Pepper's Lonely Hearts Club Band* into a big budget musical, with a large cast and high hopes for success. It ended up flopping, but everyone was excited for the opening night. I attended in order to take pictures of the play, and John was there to watch the performance. Afterwards, John asked if he could ride with me to an after-party with the cast and other invited guests—he didn't want to go out to his limo through all the paparazzi and fans. We went out back where my Volkswagen was parked and saw that someone had punched in a window while I was in the show. Some of my camera equipment had been stowed underneath the front seat, but thankfully the thieves hadn't seen it. They had, however, taken a cheap, little transistor radio I'd hung from my mirror after the car's radio died. It was so cheap John once said, "This isn't music; this is static with a beat."

The thieves had also neglected to take a half bottle of cognac that was in the glove compartment. I said, "Now, why would some junkie take a one-dollar transistor radio and leave a beautiful, fifteen-dollar bottle of cognac?"

"Because it's not plastic," John said. They didn't relate to the booze because they couldn't sell it, he said. I shrugged, and we shared a drink of the precious cognac.

We drove across town to the party, where I took some photos of the cast and of Pete Bennett, who had been the promotional manager for the Beatles in America.

John and I talked with the international model Donyale Luna and a friend of hers who was also a model. We decided to go back to Donyale's apartment, but John didn't want the press to see him leaving with her. He got into his limo, and then around the corner he jumped out of the limo and into my car. The British press, known for their persistent and sneaky methods, weren't fooled. When we arrived at Donyale's building, two journalists were in the lobby. "Hello, Mr. Lennon," they said cheerfully. "Did you have a nice evening?" I was surprised they'd tracked us down, but John didn't seem to be. He just nodded to them and continued on his way.

We'd been drinking cognac all night, and when we got inside the apartment John was growing agitated. He was trying to find a song on the radio by Billy Swan called "I Can Help," which is about a man who wants to be with his girlfriend and wants her to have his child. I hadn't heard it yet, and John was determined to find it for me. I always felt it was really telling that John was obsessing about a sentimental song like "I Can Help," while visiting world-class models.

John kept fiddling with the radio knobs in frustration, trying to find the song on Donyale's beat box, which was a piece of cutting edge technology for the mid-1970s. As John grew drunker and drunker, his anger at not being able to find the song rose. Eventually he threw the beat box across the room, and it broke.

"Well," said Donyale, "who should I send the bill to?"

"Not me," I responded. "You're the one who invited him here." We left shortly thereafter, and I dropped John off at the other model's house.

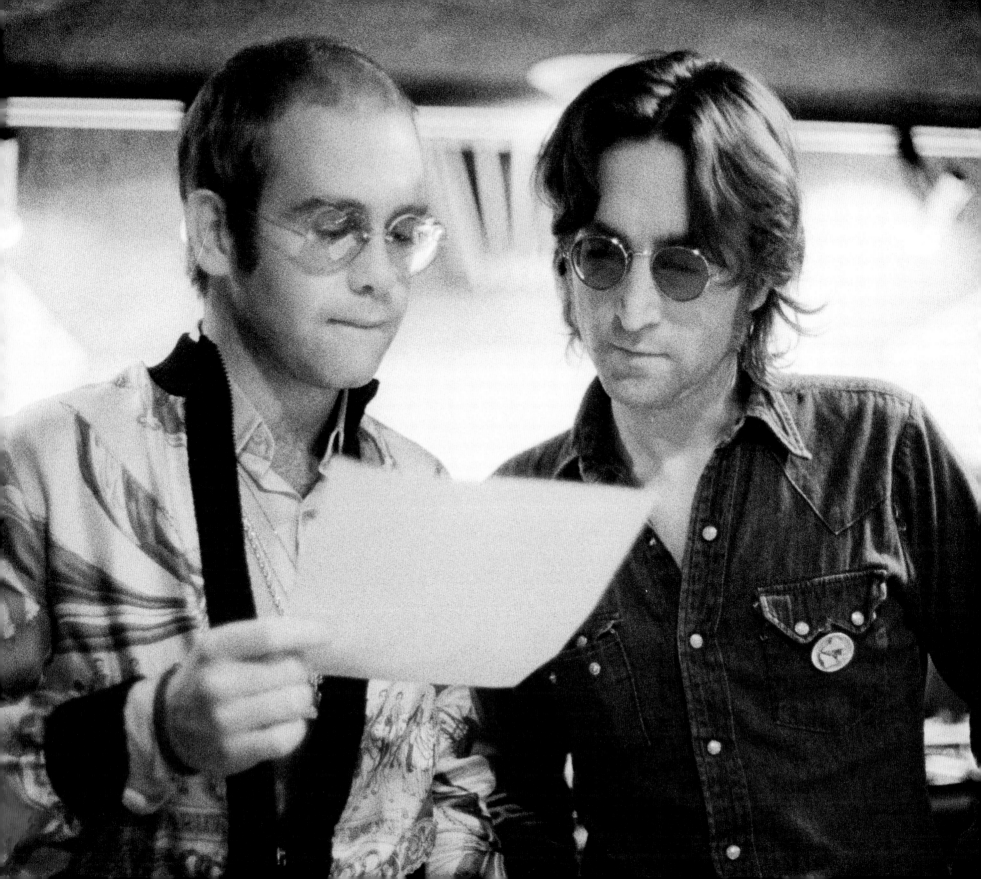

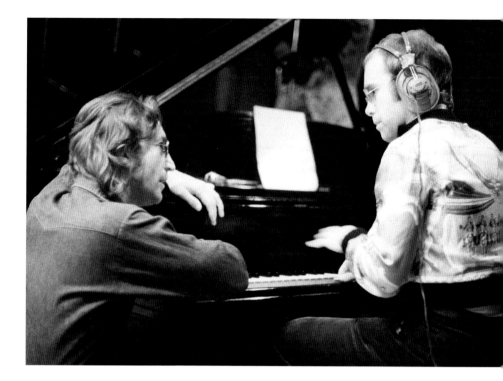

IN SPITE OF a few isolated incidents, John was continuing to try to clean
up his act. He was making a point of approaching work in a much more serious way.
He had also come back from those chaotic sessions in Los Angeles with a core group
of real professionals to work with.

I stopped by the studio to hang out one evening. It had been a couple of days
since I'd been by—when you're not involved in the actual recording, there's only so
much time you can spend in a recording studio without getting bored. As soon as he
saw me walk in, John said, "Where have you been? We've been recording with Elton
John for hours, and you should be taking pictures!"

I took lots of shots as they recorded "Whatever Gets You Through The Night." It was
an incredibly familial atmosphere. John and Elton were good, old friends from London;
in fact, Elton would become godfather to John's son, Sean, the following year.

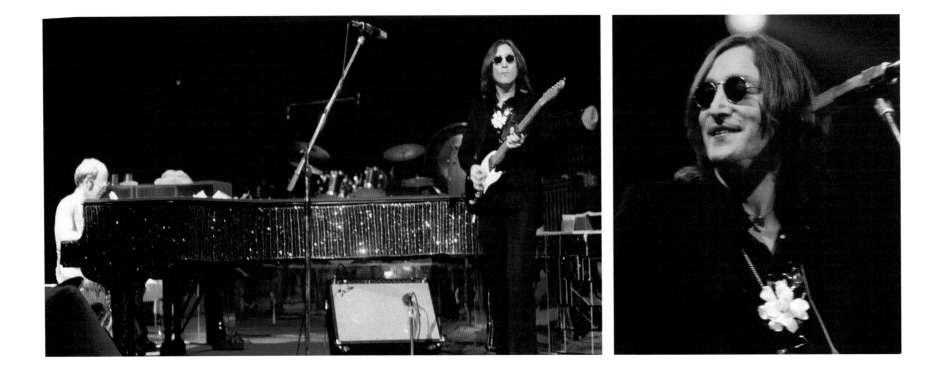

Listening to the playback later that night, Elton asked John if he would sing with him at Elton's upcoming Madison Square Garden show. John replied jokingly, "If the song gets to be Number One, I'll sing it with you." Getting the top slot is not an easy accomplishment, and John figured it wasn't likely. But soon after John made his joke, "Whatever Gets You Through The Night" was at the top of the charts, and John joined Elton onstage at the Garden.

Yoko attended the performance and went backstage after the show to say hello and saw John in the dressing room. It was the first time they'd been face to face since he'd left home. Soon after that, John went to visit her and moved back home.

Later, he talked to me and other friends and journalists very openly about his separation from Yoko. "A lot of people break up when their marriage doesn't work," he said. "We got to a point where the marriage wasn't really working, and we separated, but the separation didn't really work, either. And so we got back together and made the marriage work."

John and Yoko had an open, honest relationship, more so than most people. They seemed able to be completely truthful and say, "This is who I am, and this is what I do." That was the outcome of their split and reuniting—they ended up with a relationship in which they were their individual selves, and could still be partners creating together.

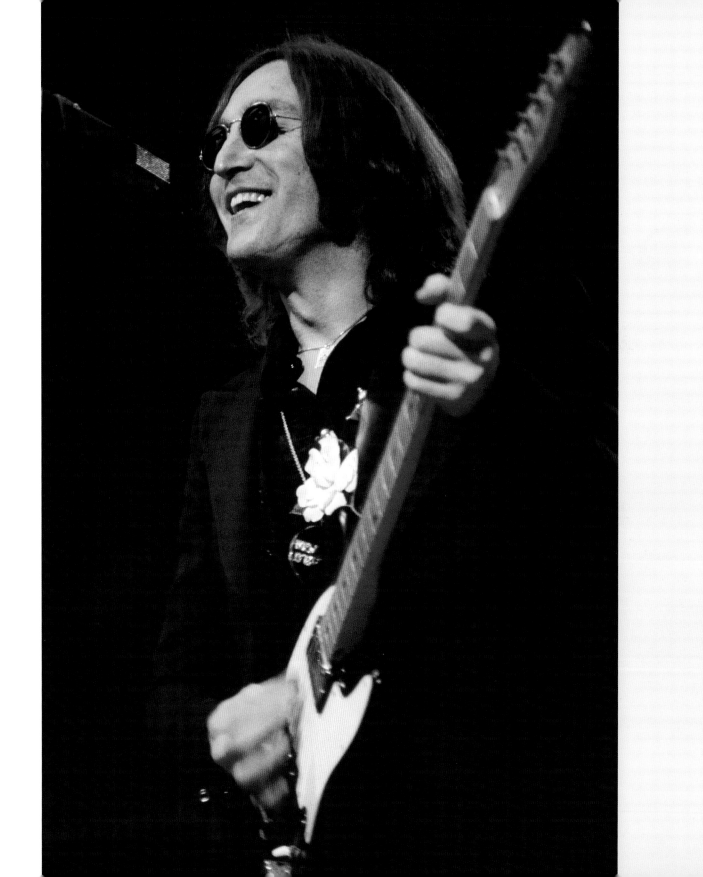

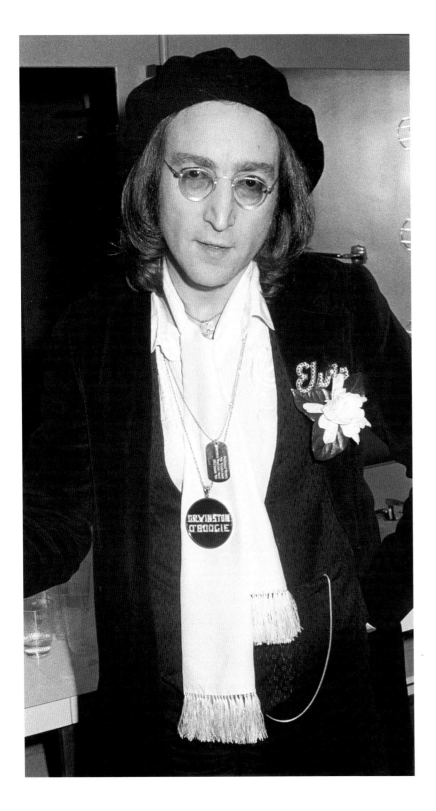

JOHN AND YOKO'S first public appearance after reuniting was at the 1975 Grammy Awards, when John presented an award with Paul Simon. I met John and Yoko backstage. A stylist told John it was time to do his makeup. John said, "No, I don't want any makeup." The woman pushed, "But it's for television! You'll look really pale." And John countered, "That's great. For a rock-and-roller, the paler the better."

David Bowie, Paul Simon, and Art Garfunkel posed for pictures with John and Yoko backstage, along with Roberta Flack. At a party at the club Les Jardins after the show, David Bowie and John became engaged in a deep conversation, then disappeared. Tony King, a hilarious, flamboyant man who worked for many big stars at one point or another, and who was an old friend of John and Yoko's, said to me, "Yoko's looking for John. Do you know where he is?" I didn't, but later I happened to be standing in the hallway when someone opened the door to the women's bathroom. I noticed three pairs of cowboy boots–suspiciously under one stall. The boots were David Bowie's, John's, and a limo driver's.

I saw Tony again and said, "I think John's in the ladies' room." Unfazed, Tony said, "Oh, the ladies', is it? Thank you very much. Very well then."

Around this time, John and David Bowie collaborated to write the song "Fame," and I can't help but think about that night when I hear it. One line says, "Fame: what you need you have to borrow./What you want is in the limo."

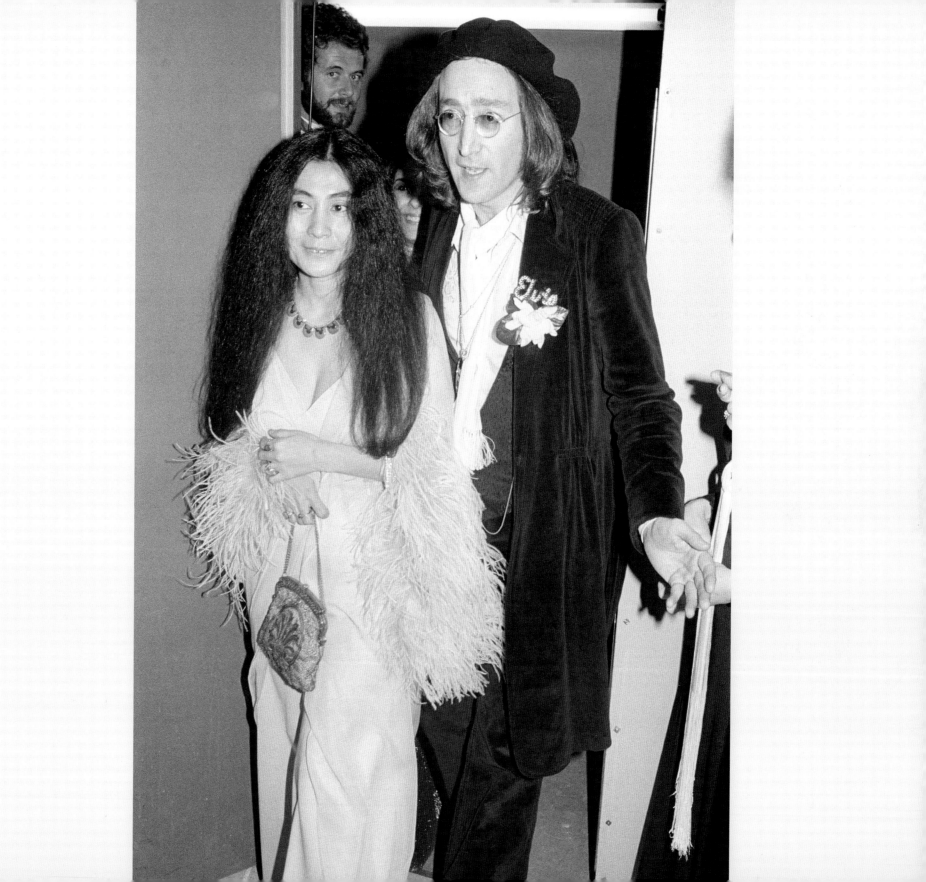

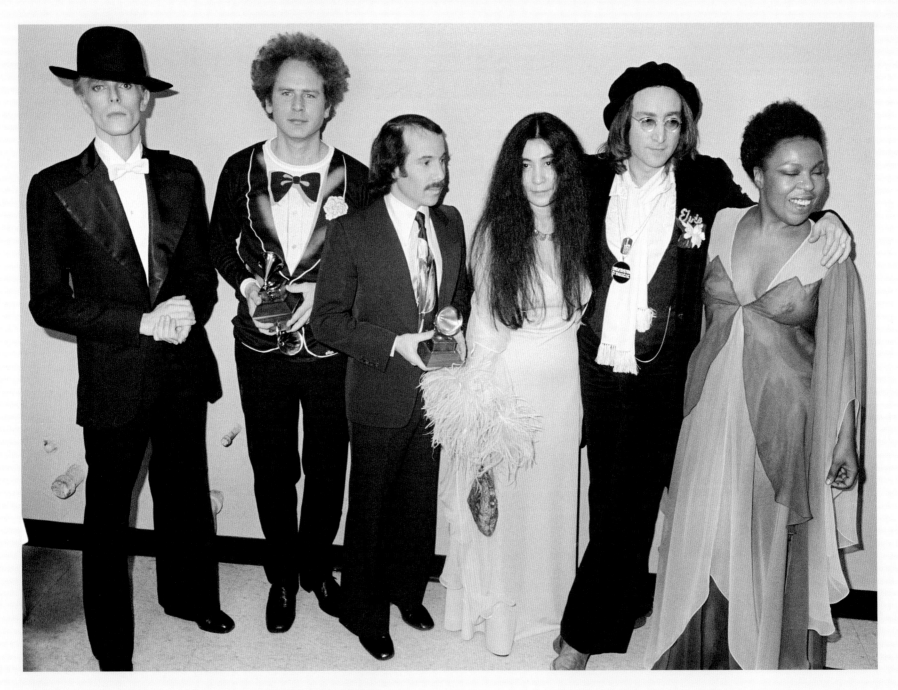

David Bowie, Art Garfunkel, Paul Simon, Yoko, John, and Roberta Flack.

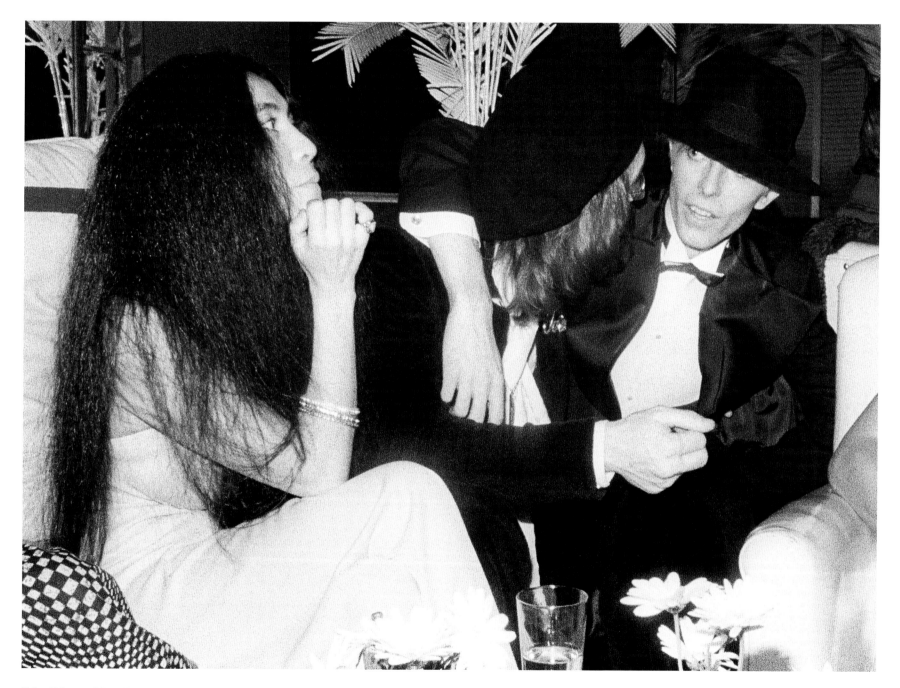

Yoko, John, and David Bowie at Les Jardins.

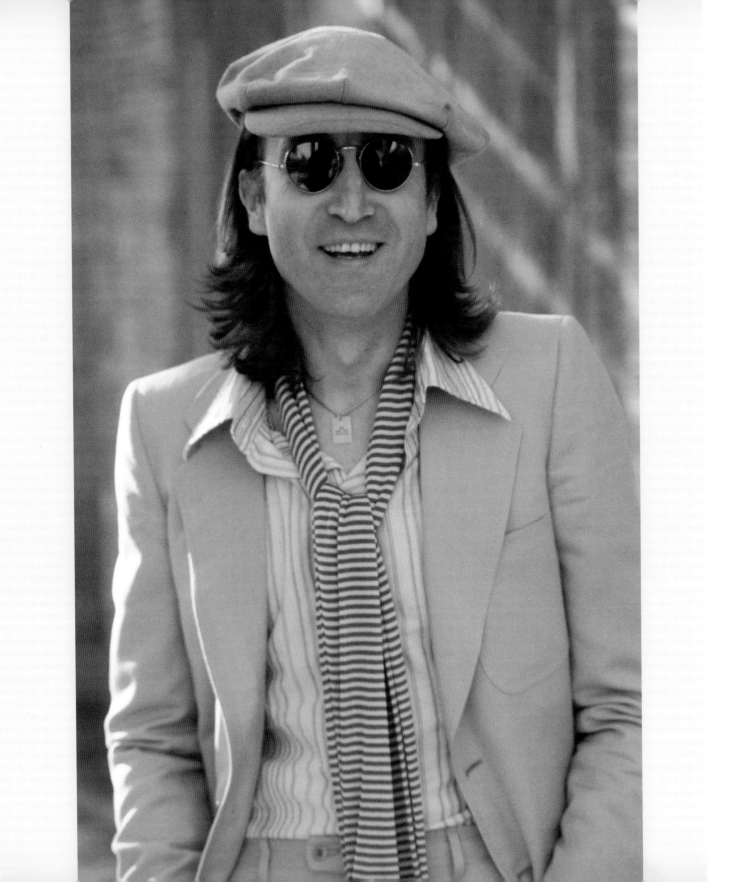

NOT LONG AFTER John and Yoko reunited, Yoko became pregnant. John was ecstatic to be a father and to be back with Yoko. One of the last interviews he gave before becoming a "househusband" was with a reporter from the German magazine *Bravo*. In it he talked about how he was now in a different, better place.

I suggested that rather than take photos inside an apartment or hotel room, we go out to Untermeyer Park, which is just past the city limits in Yonkers. Within Untermeyer, there are lots of types of grounds, with English gardens, a cupola with a mosaic of Medusa, big grassy fields, woods, and a man-made stone mountain with a cave. I knew the park would offer a lot of interesting photo opportunities.

During the drive and on our walk, I listened to John's interview answers. He seemed a lot clearer about his goals. He talked about how good it was to be back with Yoko, about how he wasn't drinking anymore, that he was learning how to be sober and to relate to his wife. And you can see in the tone of the photos that his whole demeanor was changing—he was looking better, he smiled a lot, and he looked confident and a lot happier.

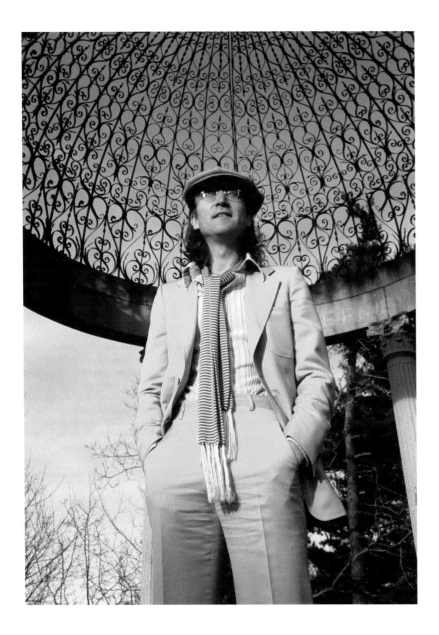

It was a chilly day, so on the way back we stopped at a diner for tea and a roll. I've always loved the picture of John with his tea and the dollar bill lying on the check. He's got a nice jacket on, but he's also got an army coat over it. The image shows a "working class hero," which is indeed what John was to so many people.

This was one of my favorite afternoons with John. He was very open, free, candid, clever, and funny. Those were the moments I treasured, the times without a large group of people around, just being able to talk to John about his life and opinions in a more intimate setting. He was always throwing in jokes, making everyone laugh. He would use wide-ranging references and twist them into puns making really deep, sensitive points. His humor is made evident in his books. For example, in *Skywriting by Word of Mouth* he wrote, "He who laughs last is usually the dumbest kid on the block."

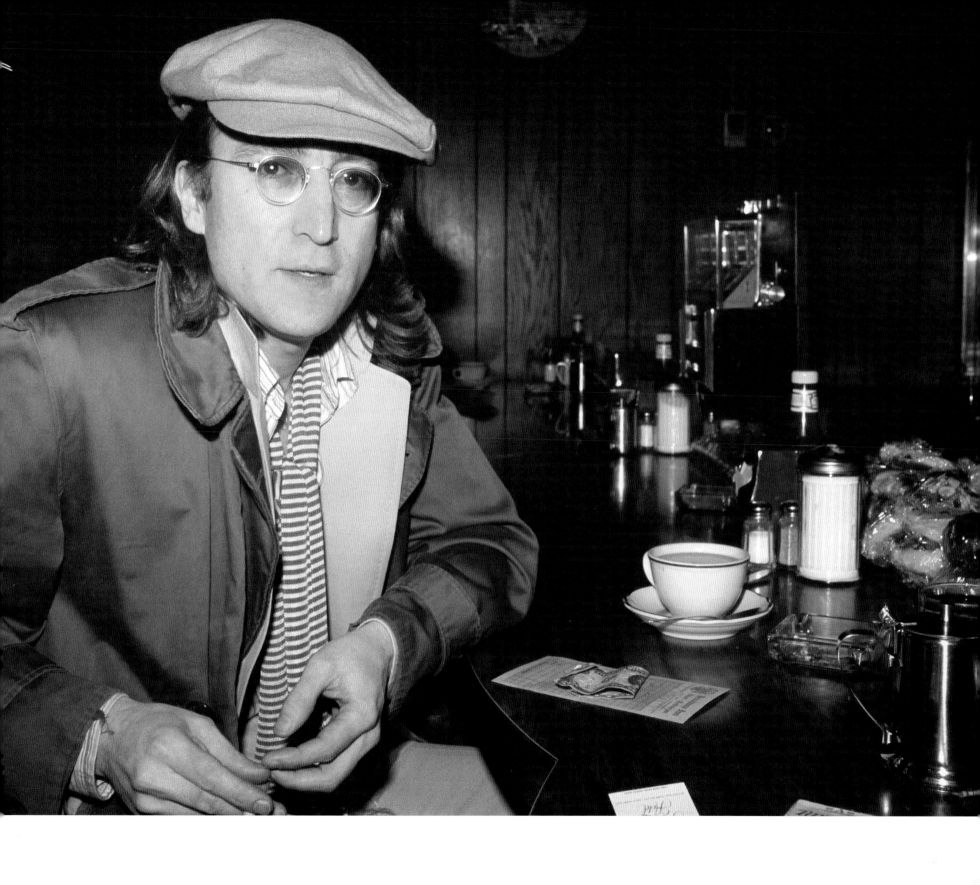

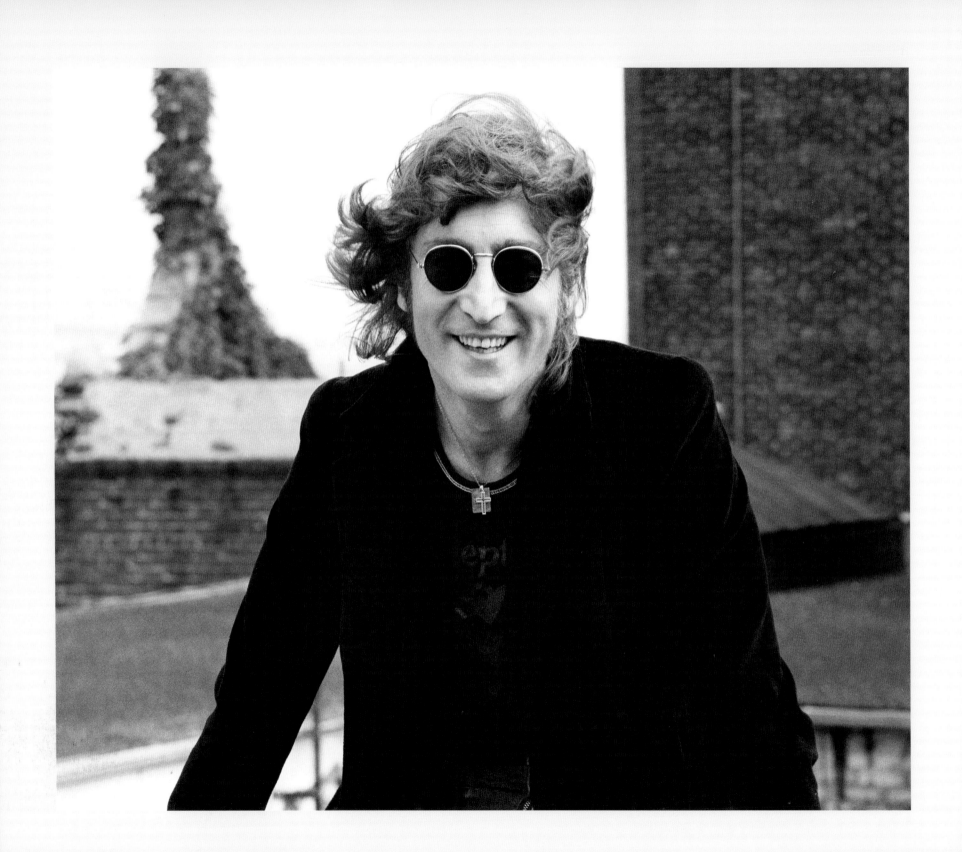

JOHN WAS LIVING at home with Yoko. His friend Harry Nilsson came to town one Friday night in July, and John went out with him to party. John called me to come along, in part because I knew a lot of the club owners and bouncers, and could make it easier for John and Harry to slip through the crowd. John didn't want to go up to the doormen and say, "Hi, I'm John Lennon. Remember the Beatles?"

When John—or "Dr. Winston," his code name—called, I told him I had some work to finish, and I'd meet them at Ashley's restaurant in Greenwich Village. It was nearby, on 13th Street and 5th Avenue, and John knew Ashley Pandel, who had been in charge of promotion and publicity for Alice Cooper and was friends with virtually everyone.

By the time I got there, John and Harry had left for a club called Trax. By the time I got to Trax, I'd just missed them by a few minutes. When John went to a bar—with Harry, especially—they'd get mobbed by people wanting to talk to them and he'd have to leave. After Trax they went over to JP's on the East Side, and again I followed and just missed them. "Forget it," I thought. "I'm not going to chase them the whole night."

On Sunday afternoon John finally called and asked if he could come over—he still hadn't been home since his night out with Harry, and he needed to calm down.

"Come on over," I said, "but I just moved to a new apartment, and it's a little difficult to find. So when you get here just buzz me, and I'll come down and get you." A half hour passed, and I thought it was strange he hadn't shown up yet. I decided to call down to my doorman and see if he'd arrived. As I was walking towards the buzzer, John came breezing in, smiling and clearly in a great mood. "Boy, what a weird building you're in," he said.

"Why didn't you buzz me?" I asked.

John said he thought he could find me on his own, but soon got lost in the maze of illogical hallways. He ended up knocking on random doors, asking people where he could find Bob Gruen. Since my building is made up entirely of artists, naturally John Lennon knocking on doors created a stir. Come to think of it, probably anyone who answered their door to find John Lennon would be excited, artist or not. But being artists, my neighbors took it one step further. Each of them invited John inside to take a look at a painting, or to listen to a new piece, or to watch their most recent choreography. "No," he told each of them, "I'm just looking for Bob Gruen." After that day, I enjoyed a newfound popularity in my building.

JOHN AND YOKO'S SON, Sean, was born on John's birthday, October 9th, in 1975. It was a very difficult, caesarean delivery, and in its aftermath, John established himself as one of the hospital's most attentive dads. Some dads would come once or twice a day to participate in the feedings, but John was there for every feeding—every four hours, precisely on time. Right from the beginning, John wanted to be the only one to hold Sean, and he made sure he knew everything that was going on medically with both Yoko and Sean.

John called me when Sean was a month old and asked me to take some photos for his family. I took a lot of shots of him, Sean, and Yoko. John seemed happier than I had ever seen him and was looking forward to spending all his time raising his new son.

John was much more enthusiastic about the photo shoot than Yoko. Since the birth, John had fed and changed Sean, while Yoko recuperated from the delivery. She was still pretty weak, whereas John was busily content in his role as a father.

I understood John's need to be home with Sean, because we had talked before about the opportunities John felt he had lost with Julian, his son with his first wife, Cynthia. John felt he had missed out on really getting to know his older son, and so had resolved to spend as much time with Sean as he could, to raise him himself and really get to know him. John also wanted to become closer to Julian, and over the next few years made considerable efforts to bring Julian more and more into his life.

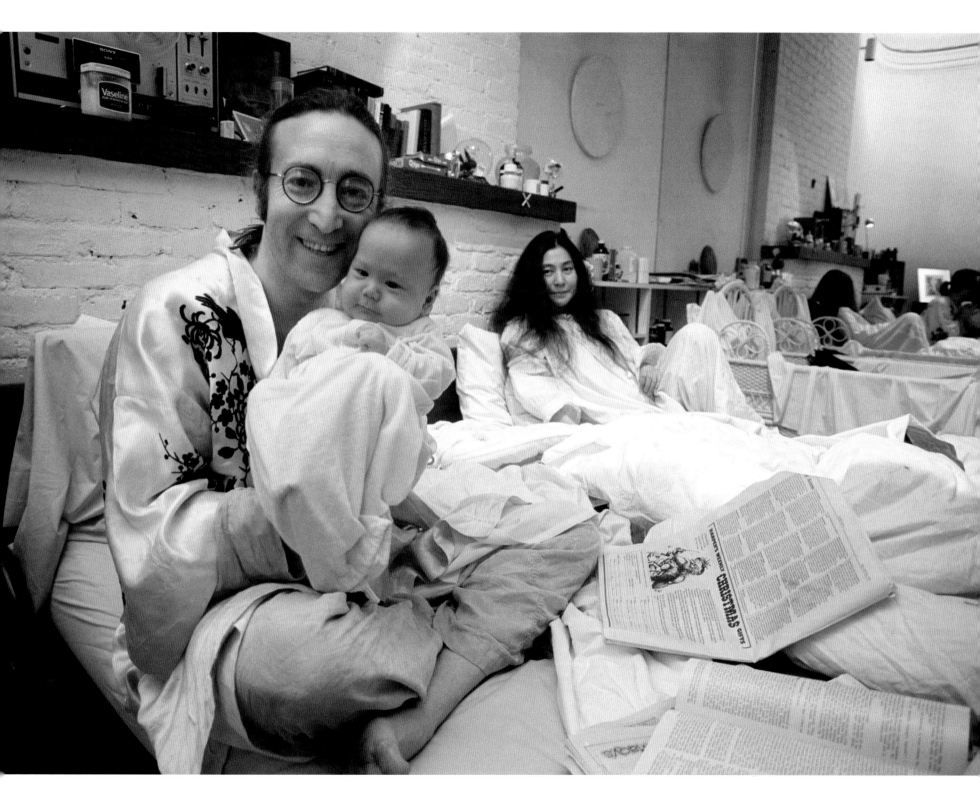

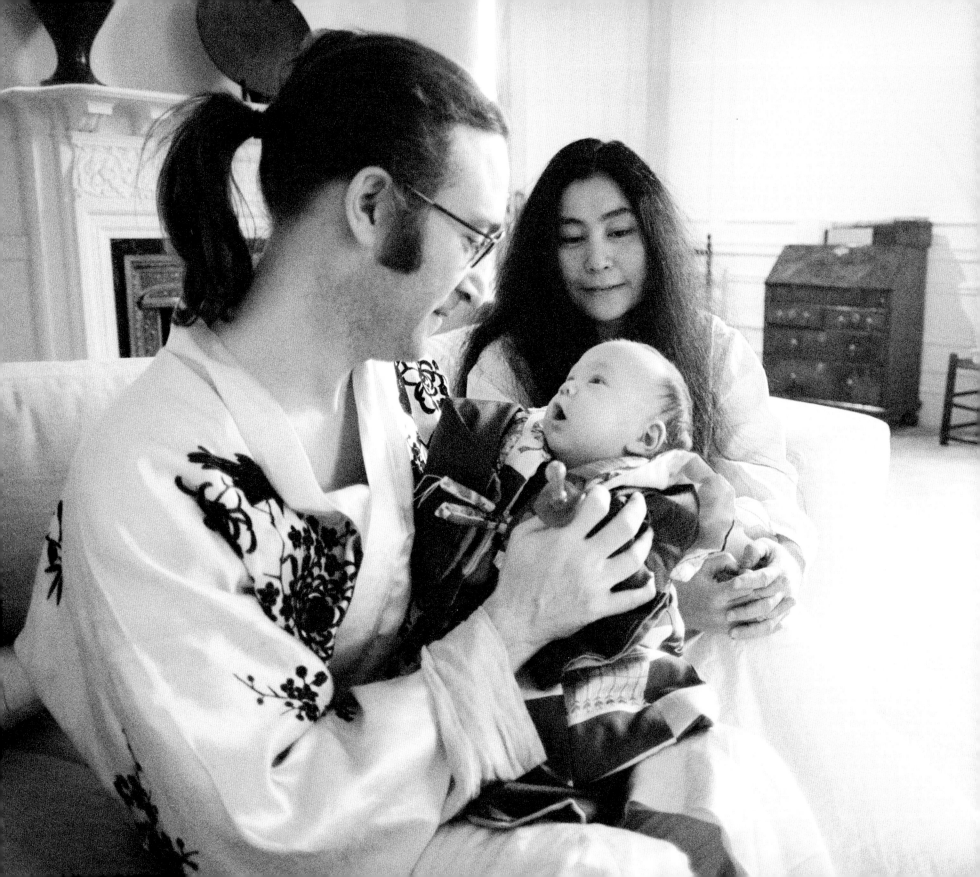

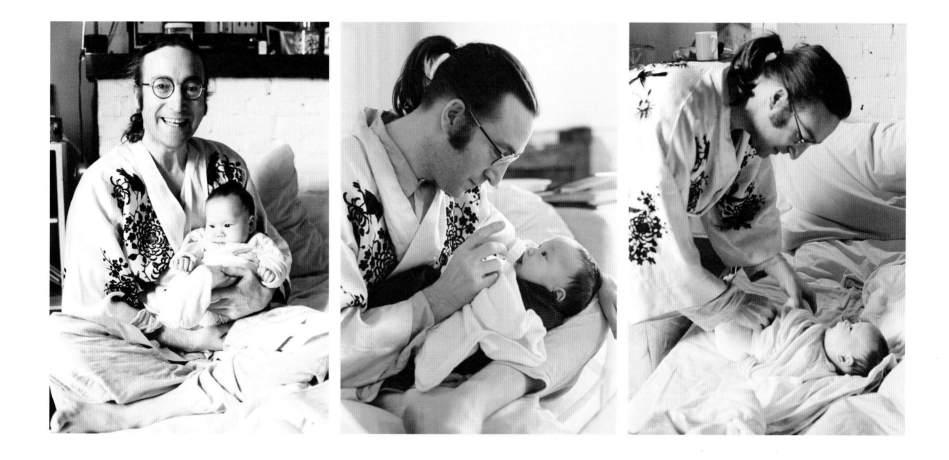

I WAS AT THE DAKOTA one night in December when Linda and Paul McCartney came to visit. We were just sitting around, watching TV and smoking when the apartment doorbell rang. In the Dakota, such an everyday occurrence as an unexpected visitor simply doesn't happen. One of the reasons the Lennons had chosen to live in the famous building was because it had tight security, including guards at the sidewalk and in the reception area. You had to be announced at the front desk and wait behind two sets of locked doors while the apartment you were visiting was called for permission to let you in.

Understandably, John was a bit paranoid when he heard his doorbell. Only John, Yoko, Sean, and myself were in the apartment, so John asked if I would answer the door and try to keep the visitor from coming inside.

The Lennons' apartment had a small foyer between two doors. When I opened the inner door, I heard what sounded like Christmas carols. "Don't worry," I yelled back to John and Yoko. "It's just some kids caroling." When I opened the outer door, I saw it was actually Paul and Linda. They'd been singing "We Wish You A Merry Christmas." I was really surprised and said, "I think you're looking for the guys in the bedroom."

As they came in, everyone was really happy to see each other. John and Yoko jumped up when Paul and Linda walked into the bedroom. They were obviously excited to see each other again. There was a lot of hugging and catching up, and we had a round of tea. I stuck around, but didn't take any pictures. Of course, I do wish I had taken a few shots, it was such a unique evening. But it just didn't seem the right thing to do, as I felt that would be too intrusive. I was there as a guest, a friend, not a photographer on assignment.

I never talked to John at length about the Beatles, but I knew he was very proud of having been in the group. He simply felt it was time to move on. John was once in Central Park when someone yelled, "Hey, John Lennon! When are you getting the Beatles back together?" John yelled back, "Hey, when are you going back to high school?"

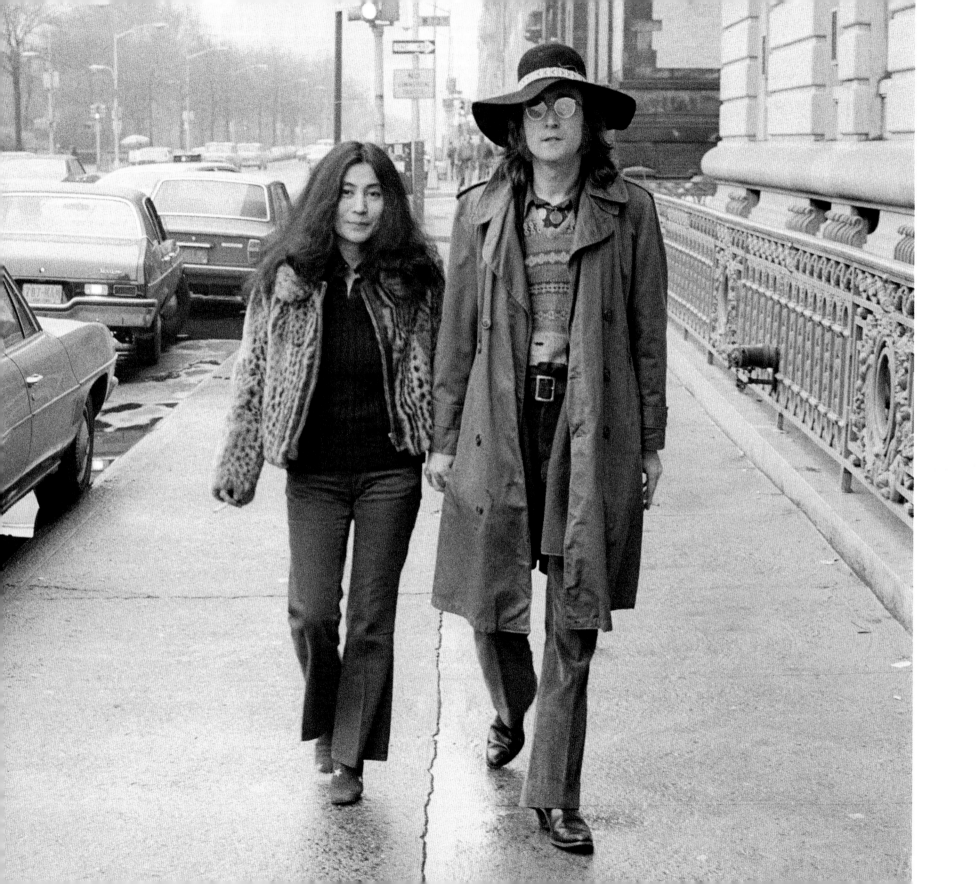

IN JANUARY 1975, a lawsuit involving John and Morris Levy went to court. When John came back to New York from his adventures in Los Angeles, he was mixing his *Rock 'N' Roll* album and gave Morris a rough tape of it. Not long after John had given him the tape, Morris called me and said he needed some pictures to put on the cover of a John Lennon album. I told him I could only use pictures that John had approved.

"It's no problem," Morris told me, "don't worry. I'll put the artwork together, and I'll make sure John sees it."

I didn't give Morris any photos, but I did call John. "Don't show him anything, and don't let him see anything," John said. They ended up in court because Morris did release the album, titled *Roots*, without John's approval.

The transcript of that case makes for great reading, as John describes to U.S. Federal Court Judge Thomas Griesa the difference between a rough mix and a final mix. In order to be clear, John explained the entire recording process: how to lay down tracks, how to mix tracks, what defines a rough mix, and how you create a final mix. John explained what made Morris's tape a rough mix and argued that he would never have given a rough mix to someone to release as a record. The judge ruled in John's favor.

I went to watch a few of those trial days and saw John testify. It was against the rules to take photos in the courtroom, but I couldn't resist and took a couple of John on the stand. In the end, Judge Griesa got a copy of one of my pictures and hung it on his wall.

THE MORRIS LEVY TRIAL had been stressful, and not long afterwards John and Yoko came down with the stomach flu. They were nauseous and didn't eat for two or three days. When they recovered, instead of going back to eating the way they had been, they decided to begin a fast.

John and Yoko were good friends with comedian, activist, and nutritionist Dick Gregory at the time, who was an advocate of a fruit-only diet. For forty days, John and Yoko consumed only fruit and vegetables that had been run through a juicer. I visited them a couple of times during that period and noticed their behavior really had changed. You could tell they were calmer. They started seeing things a lot more clearly, and there was less stress in the air.

John devised a clever way of coping during the fast. Once he started his fast, all he could think about was food. He was aching to devour a huge, beautiful meal, but instead he started reading cookbooks. He would read recipes with elaborate ingredients and intensive preparations, and have prolonged food fantasies. Instead of imagining wolfing down a six-foot sandwich, he would have a fantasy that lasted much longer than that, a fantasy that involved prepping and cooking a fantastic meal. Ultimately, John started reading books about nutrition and diet, and he learned a lot about healthful eating.

John broke the fast when an assistant came over and baked some bread, and the smell was too powerful to resist. Still, the fast had changed him. He went back to the macrobiotic diet that Yoko had introduced to him when they first met, a diet which focuses on eating only whole, natural foods. Aside from the fast, another influence on John's attitude about food was a chance meeting with film star and antisugar crusader Gloria Swanson in a grocery store, which led to their subsequent friendship. Gloria's husband, William Dufty, had translated George Ohsawa's *You Are All Sanpaku*, a book that outlined how the macrobiotic diet helps you. John loved the book, and when John was enthusiastic about something, he couldn't help but share it with everyone. Such was the case with the macrobiotic diet. He gave me and a lot of his friends our own copies of *You Are All Sanpaku*, as well as Dufty's other book, *Sugar Blues*.

John's interest in food and his health continued the rest of his life. The macrobiotic diet relied on the basic principle that you are what you eat; John became much more aware of what he, Sean, and Yoko ate and of how their food was prepared. He became a lot healthier and leaner, which can be seen clearly in the pictures from the later years of his life.

John had grown from an amateur in the kitchen to an expert at making a deliciously balanced meal, perfectly spiced. On one occasion when I visited around dinnertime, John went over to the stove and cooked a pot of brown rice, baked fish, and some steamed vegetables. It was absolutely delicious, and I was very impressed that he'd cooked such a simple, nourishing, elegant meal. The first few times I'd seen him "cook," right after we met, he could only make a pot of tea (he was English, after all), toast with jam, or a bowl of cereal. When traveling, he'd never even had to call room service himself. He'd changed from a drunken rock star to a concerned parent who knew how to eat well and how to serve his child well.

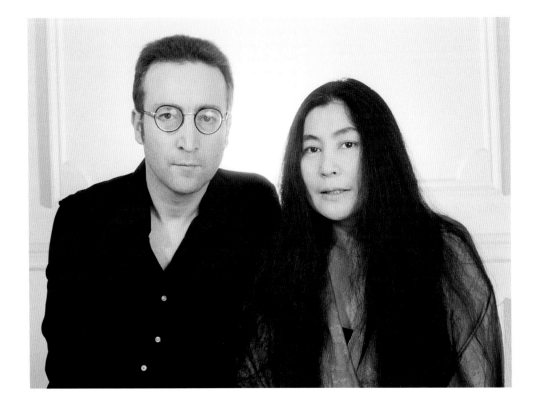

ON THE VERY DAY John turned thirty-five and Sean was born, the Lennons learned they'd won their immigration case and would be permitted to stay in New York. That winter, John asked me to snap a simple identification picture. I came over and took a picture of him sitting on the couch in his living room. It was later used on his permanent resident card, something I was always proud of.

Five years later, on John's fortieth birthday, I realized enough time had passed that John would be eligible for U.S. citizenship. I asked him if he was going to become an American. He looked at me with shock that I would even ask such a question. "I'm British," he said. "It's an Englishman's right to live wherever he pleases."

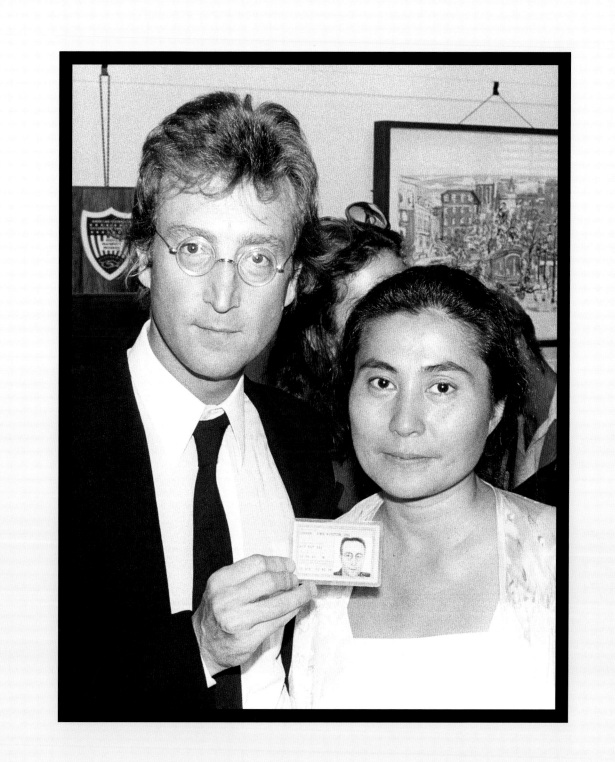

BETWEEN THEIR BATTLES with Morris Levy, Allen Klein, and Immigration, John and Yoko's legal troubles had followed them everywhere. Often, they'd be out on the town and a strange hand would reach out to serve them a subpoena. Once, when my wife Nadya was working with Yoko, Yoko was taking part in a panel discussion. A man popped out of an elevator at the event and thrust a piece of paper at Yoko. When Nadya grabbed it and demanded, "What's this?" The guy replied, "It's a subpoena for John Lennon." Nadya stuffed it back into the guy's jacket and said, "Well, she's not John Lennon. Keep your subpoena." That was typical of the sort of unpleasantness that constantly surrounded the Lennons during their lengthy legal problems.

In January 1977, John called me one morning at three. "Are you busy?" he asked. "Yeah," I said, "What do you think? It's three in the morning." John asked me to come quickly to meet him at the Plaza Hotel. When I arrived, there was an entire floor of rooms filled with lawyers and secretaries. The Beatles were in their final negotiations to end the management contract with Allen Klein. Paul, George, and Ringo had sent lawyers in their stead, but since the negotiations were taking place in New York, the Lennons wanted to be there.

Though everyone had some private space for retreat (one guy even took a bath in the midst of all the commotion!), they all gathered around a huge table when they needed to have a discussion. John and Yoko were completely surrounded by lawyers. Every time either side changed a word in the contract, a flurry of activity ensued as pages were retyped, copied, and distributed. An entire room of women sat at their typewriters, ready for the next draft to be sent their way, and a whole cadre of assistants brought the lawyers papers, tea, and cigarettes.

On one level, John was amused by the intensity of the negotiations. He told me that the original agreement between Klein and the Beatles had been two or three paragraphs on a single piece of paper. Now it was going to take an eighty-seven-page document to dissolve. By the time I arrived, the environment was bordering on joyful.

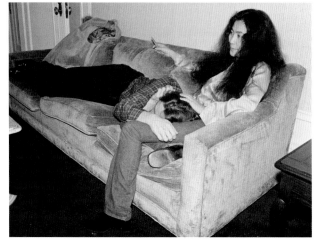

John and Neil Aspinall. Allen Klein and the lawyers with John and Yoko.

Everyone's interests had been agreed upon, and the legal documents only needed to be fine-tuned. John would soon have access to his money again; for so long, it had been tied up in escrow, and no one had been allowed to touch it. John had always retained a sense of humor about the situation, though. Once, I was walking with him and someone said, "Did anyone tell you you look just like John Lennon?" He'd said, "Yeah, I wish I had his money."

As the final paper-signing approached, John and Yoko were exhausted, but elated. The all-night session at the Plaza was the last in a series of many such exchanges, and marked the end of a long, grueling period of charges and countercharges. My favorite picture from that night is of John lying on his stomach, looking right at the camera with a knowing look on his face.

I saw Allen Klein throughout the night, but didn't talk to him. For several years, I'd viewed him as a powerful businessman who was hurting John and Yoko. He had a reputation for being the meanest and toughest manager around. In his office there was a picture of him holding a shotgun hanging next to a plaque that read, "Yea, though I walk through the valley of the shadow of death, I will fear no evil . . . Because I'm the meanest S.O.B. in the valley." Even so, on that last night of negotiations, John and Yoko were very friendly with him. As the time for signing drew nearer, Allen showed himself to be a nice guy. I remember he went out to Zabar's at some point and got hundreds of dollars' worth of breakfast for everyone: large tins of caviar, lox, the works. It was a deluxe breakfast, all his treat. I liked Allen's sense of humor, and in the years after that night we developed a friendship.

All involved parties signed the papers at dawn. Allen pulled out a large loaf of bread and placed the contract on top of it. It made a perfect formal photo of him "splitting the bread" with John and Yoko, and was later used in the press release announcing their settlement.

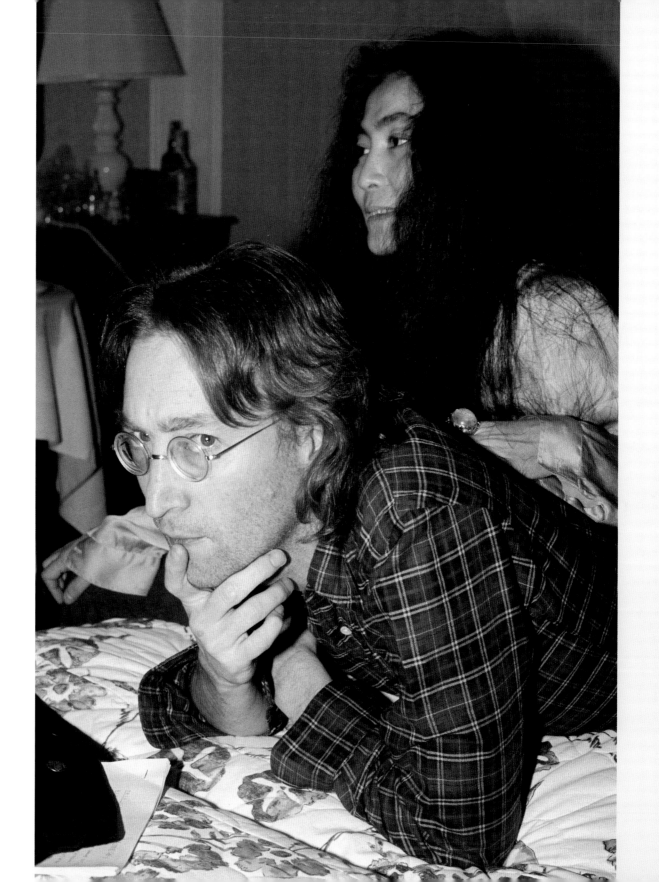

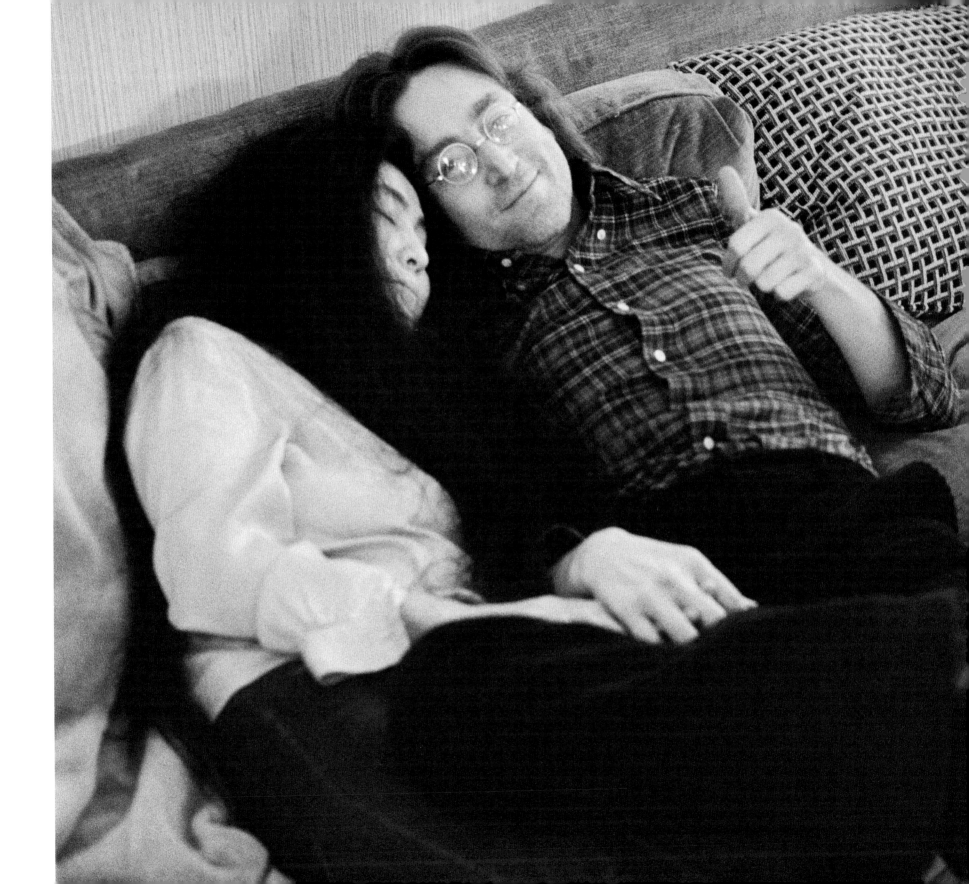

The deal officially done, everyone headed home, and I offered John and Yoko a ride. I'd recently bought a 1954 Buick Special, which is a real rock-and-roll car. We walked towards it at 9:30 in the morning, and I said, "You're going to love my car."

It was a huge automobile, and the backseat felt completely removed from the driver's seat. "Should we all jump in the front, like in a teenage movie?" John asked. What always meant so much to me about our relationship was that no matter where we were or what we were doing professionally, we'd always walk out as friends.

On the way home, I talked to John about the Bay City Rollers, a young band I'd started working with, whom I knew wanted to meet John. I asked him if he'd meet with them. "Tell them," he said, "that if they're still around in five years, I'll meet them."

I asked him if he had any advice he could share with the Rollers. "Tell them," he said, "to get as much money as they can in their own name *now*."

YOKO CALLED ME one afternoon and asked, "Bob, do you have a suit?" Though I'd never needed to wear a suit around John and Yoko, I did indeed own some! She invited me to go with them to a dance performance by the great choreographer Merce Cunningham.

Cunningham was an avant-garde artist, and yet the performance was staged on Broadway, signifying his mainstream acceptance. It was an interesting, abstract performance, and we all enjoyed it. Afterwards, a dinner was held in the lobby of the theater for all the show's attendees. John and Yoko were able to spend some time with many of Yoko's downtown artist friends along with James Taylor and Carly Simon. The event symbolized a change for the artist, a move uptown and John recognized that. He also loved meeting Yoko's friends, and being a part of a group of artists who continually sought new ways of expression.

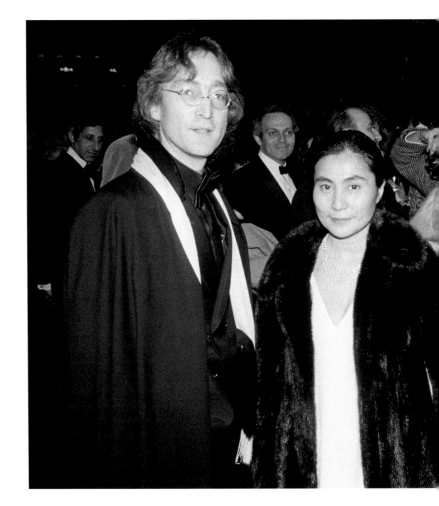

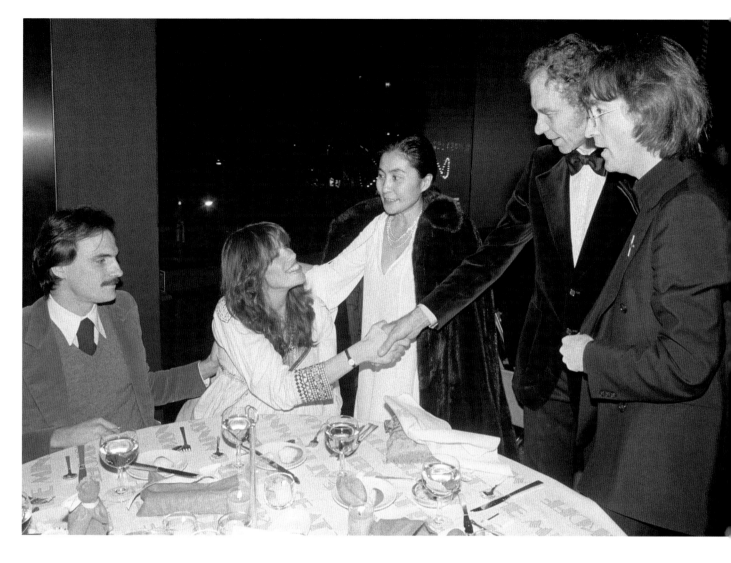

Yoko introduces James Taylor and Carly Simon to Merce Cunningham.

JOHN STAYED HOME and out of view with Sean for a few years in the late 70s. He'd also removed himself totally from the world of music. He had canceled his subscription to *Billboard*, and if the radio was turned on at all, the station was classical music. I'd call John from time to time when there was a big show coming up, but he'd never come out. Once I said, "Do you want me to keep telling you about these shows?"

"Yeah, keep telling me," he said. "I like knowing what's going on."

Once, I called and he answered quickly, "Hold on." I could hear an acoustic guitar playing softly, and John singing a sweet song. When he got back on the line he said, "What's up? I was just putting the baby to sleep."

"There's this rock show going on," I said, "but you sound like you're having a good time, so don't worry about it." I actually didn't think he should come out and drink and party, when he was in such a nice place, emotionally and physically; I knew the struggles he'd gone through to get there.

Even though I fully supported John in his new role, sometimes the change in him was hard to get used to. In the 60s and 70s, Central Park hosted great outdoor concerts during the summer. For a rock-and-roll fan, the venue was heaven—for around $5 a ticket, you could see acts like Otis Redding, The Who, Bruce Springsteen, or Blondie. In 1980, because of all the noise complaints from the people who lived near Central Park, the concert series was to be canceled for the following summer. When I told John that the series was ending, he said, "Oh, thank God. Good riddance."

"What are you talking about?" I said. "This is the greatest venue in the world—sitting in the summer night, in a world-class town, listening to music for a few bucks a ticket. How can you, of all people, be against it?"

He answered, "It keeps Sean up." John's family life was now far more important to him than music, or anything else. And no matter what it was John decided to do, he did it fully. And John had decided to commit himself to his son.

John, Yoko, and Sean spent a lot of time in Japan during this "househusband period," and their absence from the music scene had a lot of people asking why. Fortunately, they didn't let the pressure from fans and peers keep them from enjoying their new, quiet life. John would send me postcards sometimes, and it was his trademark to cut bits and pieces from magazines to personalize the card. One of the postcards I received symbolized John's new life: On top of a photo of a field of wheat, John had cut and pasted images of two dead bodies and then the word "Newsmakers" on top. The flip side of the card displayed a drawing of a happy, bright sun, and above it John had drawn what had become his regular signature—a drawing of his face, Yoko's, and Sean's. (After all, if he'd signed anything "John Lennon," it might never have gotten through the mail.) That was the whole message, and it made complete sense to me—why be a destroyed 'newsmaker' when you could be an anonymous but happy sun? During those years when people would say to me, "Why is John Lennon just staying home with his wife and baby?" I would remember that happy sun and think, he simply doesn't want to be anywhere else.

旧碓氷峠見晴台からの展望
旧碓氷峠の南にあり、妙義山、さらに南アルプス、北
アルプスの山なみを一望におさめることができる。

POST CARD

TOKYO
31.8.78
NIPPON

080

80

hi

Bob Green
463. West St.
New York
New York
10014
U.S.A

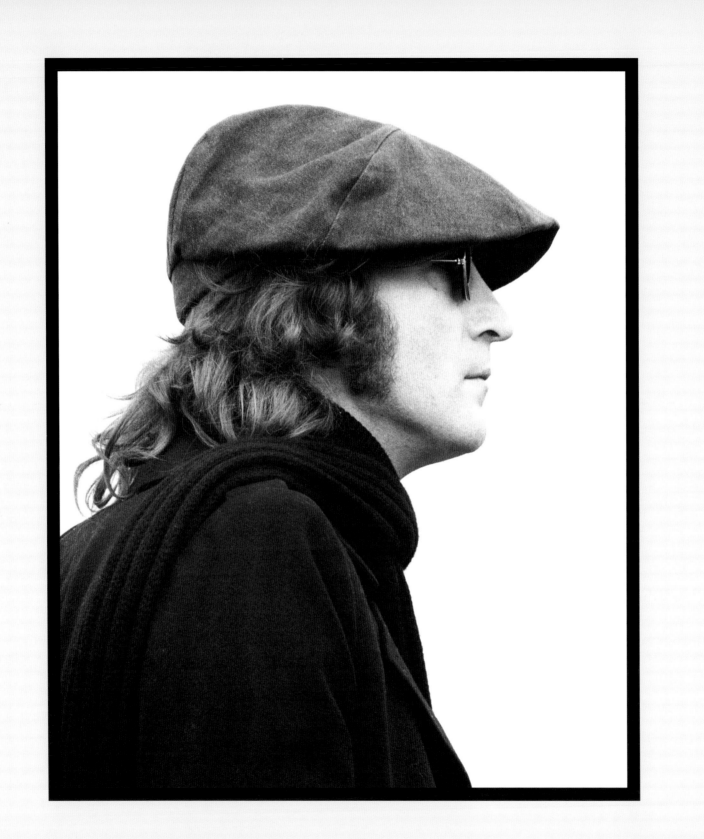

JOHN ALSO USED his time out of the limelight to take care of himself. Yoko had an idea that if you took a trip and traveled in a certain direction, a range of possibilities would open up for you. John told me he packed only an overnight bag and went on his own to the airport, then traveled around the world to Hong Kong, to South Africa, then back to the U.S. An odd report appeared in the newspaper from a cab driver in South Africa who said he picked John up at the airport. John just wanted to go out and see South Africa between flights. The driver took him to a park, and John sat there for an hour or two before returning to the airport.

It was one of the first times John had traveled by himself. Since he'd been a kid in high school, he'd gone everywhere with an entourage. From his popular days in high school and certainly when he was a Beatle, people always surrounded him and helped him take care of all his travel arrangements.

Though John was nearing forty, he told me it had been very frightening to him to make even the simplest of arrangements. First he had to learn how to go out of the house, get cigarettes, and do chores on his own in his neighborhood. Then he

learned how to travel around the world alone. When he went to Hong Kong, he booked himself into a hotel. It was the first time he'd ever gone up to a desk and told the clerk he had a reservation. When he called room service for a cup of tea, it was the first time he'd ordered room service on his own. He told me that he was so nervous that after they brought the tea, he stood at the window and noticed the cup was shaking in his hand.

John reveled in the anonymity and independence Hong Kong offered, and the experience made a lasting impression on him. From his Hong Kong hotel, John saw a mass of people boarding a ferry to go to work, and he went outside to join them. People didn't recognize him; he was able to feel normal, anonymous. As he walked through the crowd and got on the ferry, he felt truly relaxed in public for the first time in his life. No one pointed out John Lennon, no one screamed and asked for his autograph. John was an ordinary person walking through the crowds. The trip represented tremendous growth for him. He started to learn to live the way everybody else does and to be responsible for his own daily needs.

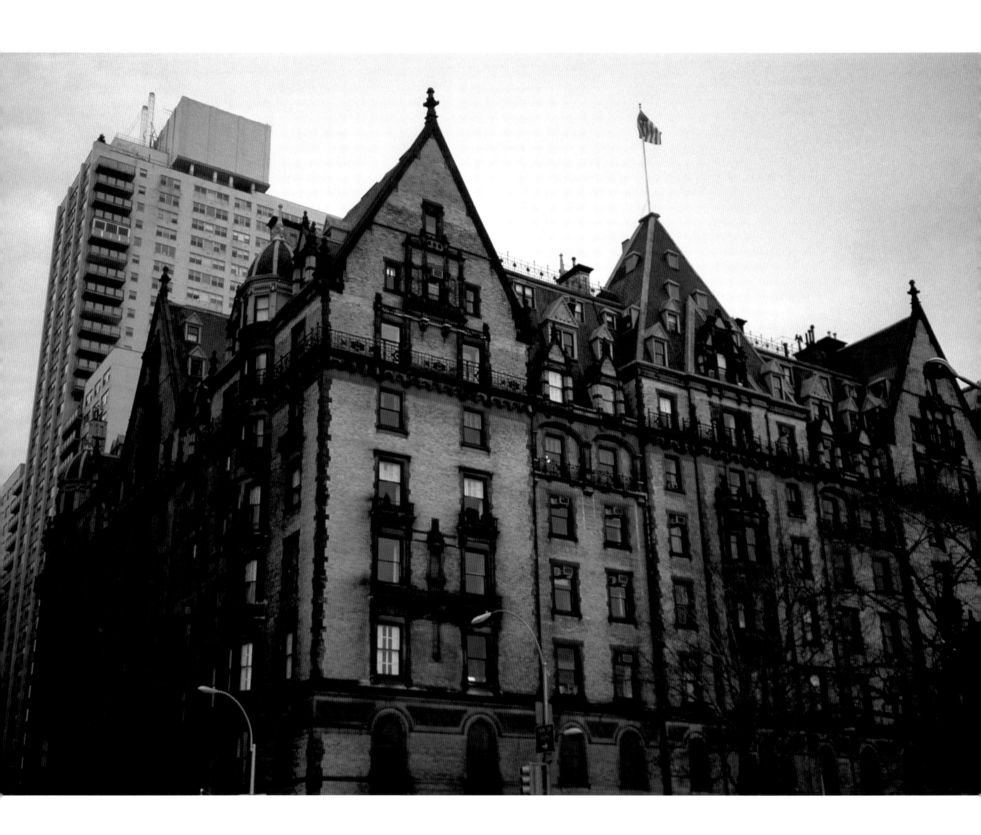

I LIVED IN JAPAN for most of a year and came back to New York in the summer of 1980. By that time, John and Yoko were back in the studio working on a new album, and I'd pop in on them frequently. We soon talked about doing a photo session.

I showed up at the Dakota for the shoot, which had already been postponed for weeks, and quickly realized it was going to be put off again. On this particular day, John was full of energy, and Yoko was all business. She wanted John out of her hair for a while so she could finish up her work and move on to the studio. Yoko said, "Why don't you boys go to the corner coffee shop and come back here later?"

Café La Fortuna was a quick walk away and had a quiet garden in the back. The owners always played opera music, and John had become a regular. He could walk there, have a coffee, and read the paper or a book without people bothering him. A trip to Café La Fortuna was representative of the changes he was making—he'd been acting less like an elusive rock star and more like a normal New Yorker. That day was the first time in a long time that we'd sat down together and really talked.

I told him about my apartment in Tokyo, and John told me about a trip he took to Bermuda, during which he felt his macrobiotic diet had saved his life.

John had rented a sailboat called the Imagine and planned to sail from New York to Bermuda. He took an assistant and some professional crewmen to help him sail the vessel. Along the way, they sailed out in the middle of nowhere, with absolutely nothing on the horizon. "The ocean is one big blue circle," he said, "and the sky is one other blue circle, and you're this little dot in the midst of all this blue, just floating along." He'd loved the feeling of being out smack in the middle of the universe.

While they were out in the ocean, a severe storm hit. The huge waves could have easily capsized the boat. The whole trick to staying upright and alive in that severe a storm is to always keep the boat pointed into the waves. Yet everyone except John was violently seasick from the motion of the boat. Not only did they need to be in bed, they needed to be tied to their beds so the motion of the boat wouldn't throw them around the cabin. John felt the men's poor health was brought on by their diet—everyone but John had been relying on hot dogs, potato chips, and other greasy foods for sustenance. John had brought along his own little sea stove, which hung on hinges and swung with the waves. He prepared his brown rice and all his macrobiotic fare while everyone else ate junk food.

The crew was useless, so John had to step up to the challenge of the storm. He was annoyed because he had paid these professional sailors to get him down to Bermuda, and now he was being called on to save their lives instead. Somebody had to steer the boat into the waves, so he stood at the helm and did it himself. Dressed in a yellow slicker, he literally tied himself to the helm so that when the boat rose and lurched, he wouldn't fall overboard. In spite of the initial adrenaline rush, this type of sailing soon becomes monotonous, but keeping your concentration and keeping the boat pointed into the waves is a matter of life and death. John told me that sailors would sing sea shanties to get into the rhythm and pass the time—but he didn't know any sea shanties. "All I knew were my songs," he said. "So I sang my songs, Beatles' songs."

John said he felt it was Yoko's spirit that guided him and kept him alive that night. He later wrote a song called "Dear Yoko," in which he sings, "Even when I'm miles at sea; And nowhere is the place to be; Your spirit's watching over me dear Yoko."

We talked for a while about the new album, and John already had some thoughts about the kind of photos he wanted to promote it. He sketched a diagram on a napkin of him and Yoko to illustrate his idea. In the drawing, John and Yoko stand in the dawn as people are starting to hurry to work. The sunlight would be coming up, he explained, and the image would convey him and Yoko starting out together, starting a new day. That's how he thought of the new album, as starting over.

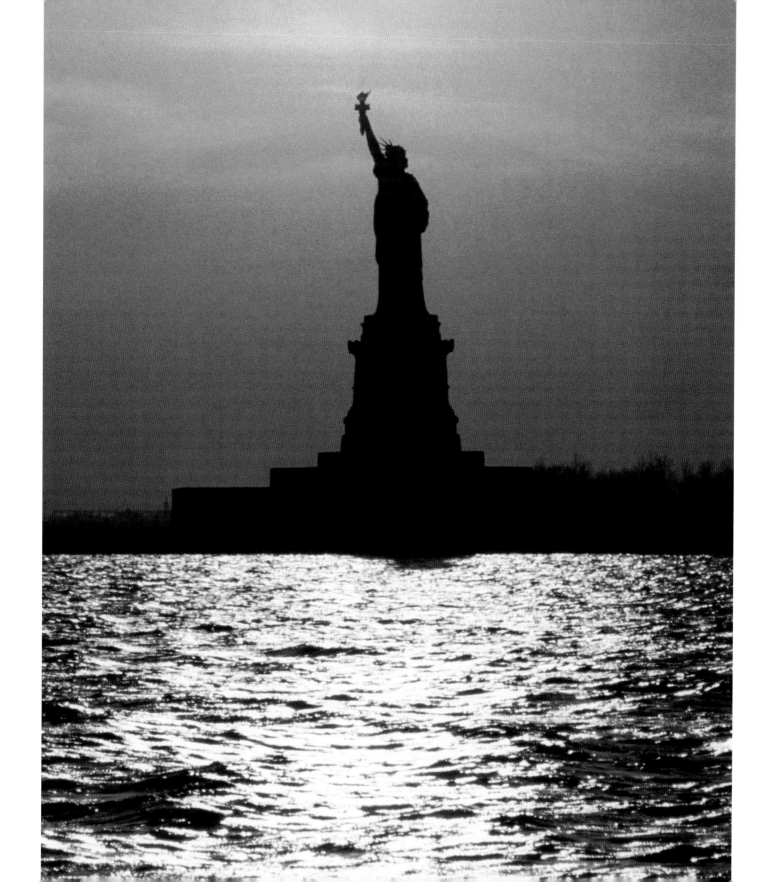

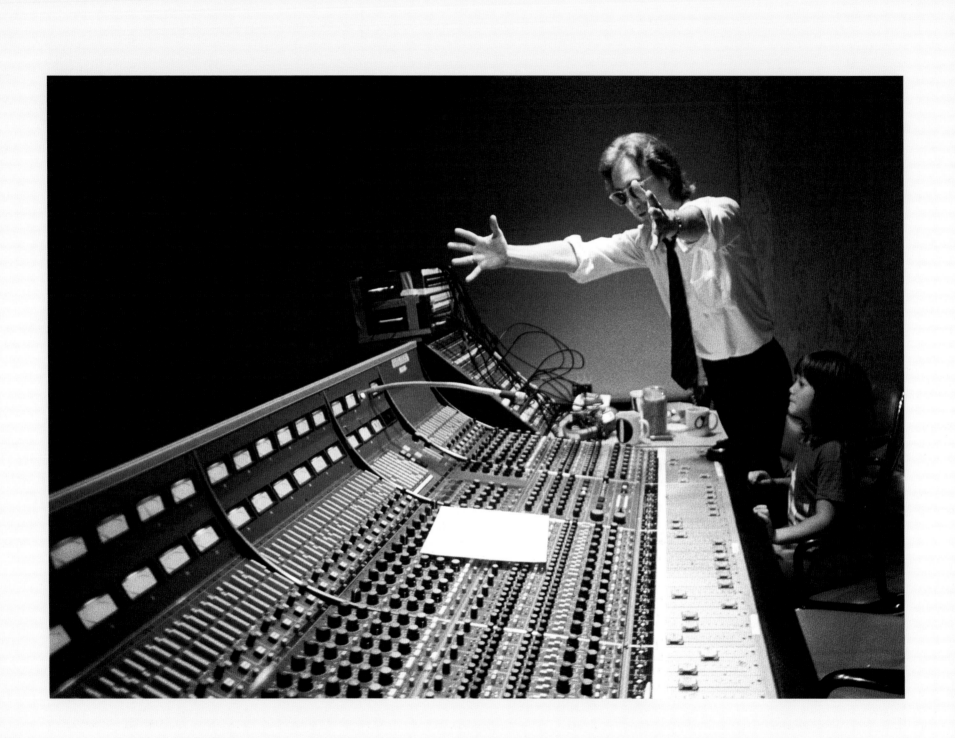

JOHN'S LOVE FOR MUSIC was great, and he shared his passion with both of his sons. He was delighted when Julian showed an interest in music and even had him play drums on one of the tracks that became his *Rock 'N' Roll* album. John also passed his enthusiasm on to Sean.

Before John started recording again, he'd been spending all his time with Sean and was really connected to him. John once said of their bond, "If he doesn't see me in a few days or if I'm really, really busy, if I just get a glimpse of him or if I'm feeling depressed, without him even seeing me, he picks up on it and he starts getting that way." When John returned to work, they obviously couldn't spend as much time together. John had a picture of Sean in front of the TV, and there was no question how much he thought about his son.

John also had a picture of a very obese Orson Welles taped up on the wall, to show him the consequences of excess. He said the picture helped keep him focused, and reminded him of the benefits of being healthy and living a more responsible life. The difference in the studio, brought on by John's change of philosophy, was dramatic. Whereas before Sean was born, the studio cooler was filled with tequila, cognac, six packs, and mixers, now it held sodas and fruit juices and one can of beer. The message was clear: "We understand people drink, and if you have an emergency and need a beer, it's here." But drinking wasn't encouraged in the sense that it had been before.

Sean came to the studio occasionally so he could see what his daddy was doing. I took a picture of John with his arms spread out over the control panel with Sean looking on. People love it because it looks like John's majestically introducing his son to the world of music. That's not untrue, but there was more going on. What John was actually doing was showing me how this board worked automatically. In the photo, you can see that all the controls are set. Each one of the controls monitors the volume of one of twenty-four different tracks. Previously, in order to make a mix, you'd have to manually move the controls up and down and add a little more volume to one track at the same time you let up on another. Then the machines were combined, so there would be forty-eight or even seventy-two tracks. You'd have to have the engineer and the receptionist and everyone who happened to be around come in to help.

Finally, the whole recording process was computerized. The musicians could run through a song once and set the controls the way they wanted, then lock it, so that ultimately all the controllers were run by the computer. I had never seen the device, and since it was new, John was pretty excited. "Watch this," he said. He turned a song on and said "Ta da!" as the whole apparatus started moving by itself. It was a great moment, for me and for Sean, to be audience to John's demonstration and witness to his enthusiasm.

ON OCTOBER 8, 1980, I left a birthday party for singer Nona Hendryx and went to see John and Yoko at the recording studio. It was after midnight by the time I arrived, so technically it was October 9th, John's 40th birthday and Sean's fifth birthday. I'd taken a piece of cake from Nona's party and I gave it to John so he could start his celebration off right.

Yoko gave John his gifts, which he excitedly showed off for the camera. Yoko used to knit a lot and had made a tie for John in the colors of his old school in England. She also gave him a pin of the American flag that was decorated with diamonds, rubies, and sapphires. John wore it proudly; the gift clearly meant a lot to him.

John and Yoko worked all through the night, and I left the recording studio with them at 8 A.M. We were all going home to go to sleep. In those days, instead of going to sleep in my bed, I'd often go out to the Hudson River dock near my house and nap for a while. That way, I'd get a nice tan and not look as pale as someone who went to bed at 8 o' clock every morning. As I was lying there, a plane started skywriting. I realized it was writing "Happy birthday John and Sean. Love Yoko." I knew this could be a powerful photo, so even though I hadn't slept in a few nights, I ran all the way back across the dock and into the house to grab my camera, then back out to where I'd been lying so I could get an unobstructed view of Yoko's message.

I OFTEN DROPPED BY the Hit Factory while John and Yoko were mixing their *Double Fantasy* album. John was very pleased with the way the work was progressing. One night in a playful mood he picked up my camera and started running around taking pictures of everyone in the studio. When he turned the camera on me, I handed my other camera to someone nearby who took a shot of John taking a picture of me.

Earlier, I'd given John the psychedelic shirt he wore that particular night. I'd started spending time with a group called the Rockercisers, who wanted to teach people how to exercise in place—they pitched it as "aerobic dance for future astronauts." As soon as I gave John the bright, loud shirt they'd designed, he took his shirt off and put the new one on. The Rockercisers were pretty happy when they saw the picture of John wearing their shirt.

John was very conscious of his appearance, always looking around to see what was new, what was different. He often bought new clothes. Once I visited John wearing my bright blue, shiny, vinyl winter parka. Vinyl clothing wasn't that popular yet, and I was proud of my unique, spaceman-like, outfit. The very next day, John was wearing a nearly identical jacket, but without a hood and in a darker shade of blue. I felt a twinge of competition between us that day, but I felt good that we had a similar taste in clothes.

John was complicated when it came to material possessions. He wrote the famous lyrics, "Imagine no possessions," but his various toys, like his psychedelic Rolls Royce, were also well known. Still, I will never forget him singing "Imagine" live at Madison Square Garden, changing the lyrics from "I wonder if you can" to "I wonder if we can." John recognized that it was human to crave material possessions, and that it was a universal struggle—no matter who you were—to resist those urges.

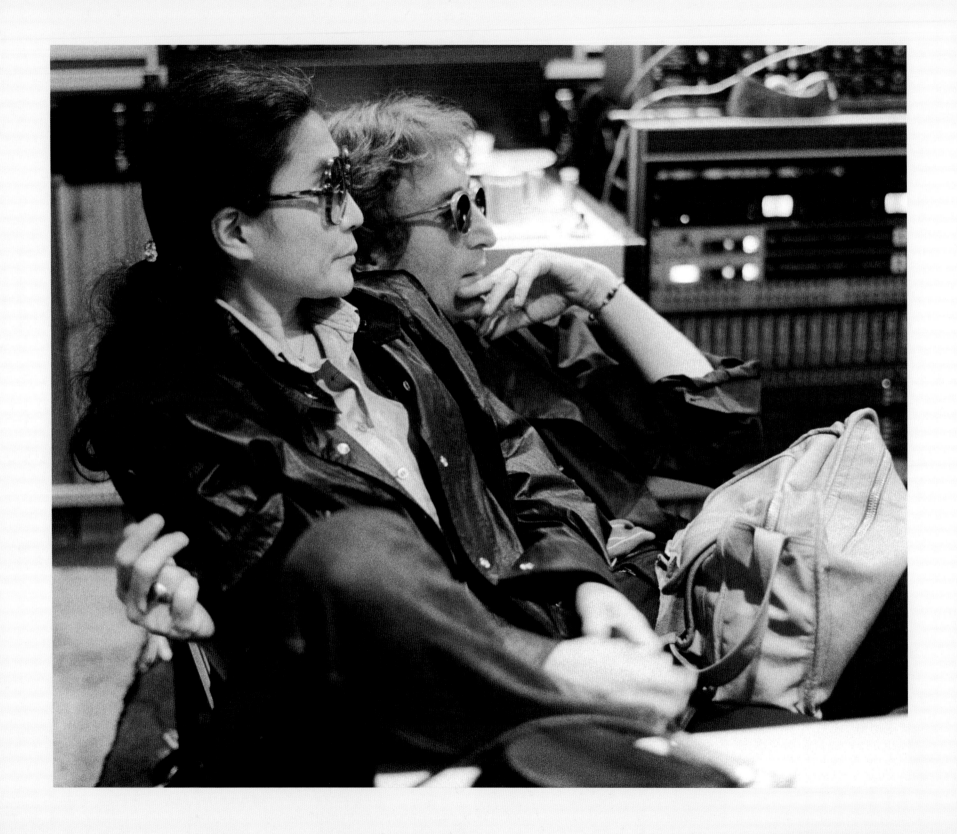

JOHN TALKED OPENLY and frequently about his relationship with Yoko in the many interviews he gave in December 1980. It was clearly uppermost in his mind, and the album *Double Fantasy* was very much a symbol of what John had been working to achieve for so long—a successful, meaningful relationship. *Double Fantasy* was a John *and Yoko* album. The title *Double Fantasy* was John's idea. A double fantasy is a type of freesia John saw on his Bermuda vacation. Freesias are small bellflowers with a sweet smell, and a double fantasy freesia has two colors on the same plant. John loved the symbolism of the different colors. To him, a double fantasy represented two people living together, having the same dream of a relationship, in the same way that the two freesia colors shared the same plant. That concept essentially encapsulates *Double Fantasy*. The album uses a simple question-and-answer format, as John and Yoko alternately express universal issues that people deal with in every relationship.

Originally, John and Yoko wanted to make two albums and release them together as a double album. They were pretty secretive about their plans at first. Yoko called and asked me to come to the Dakota one night. She said they were working on a project, but wouldn't reveal any more details. She said she and John didn't need me yet, but they would soon, and she wanted to know my schedule. Not long after that night, I read in the paper that they were recording, so I called Yoko and asked it if

was time for me to come over yet. "Not yet," was all she said.

Two weeks later, Yoko called me again and invited me over to the studio. Until then, only John, Yoko, and the musicians had been allowed to pass the studio's receptionist and enter the recording rooms. In fact, not even the record company representatives who were negotiating a deal to distribute *Double Fantasy* were allowed in.

My first visit fell on the last night they were recording the basic tracks for the *Double Fantasy* album, and John wore a jacket and tie to mark the special occasion. I sensed he was pretty tired that night, but elated about a job well done. He'd been in the studio for a couple of weeks, working hard to perfect all the tracks. We went up to Mr. Chow's Chinese restaurant later that night to celebrate. Everyone was proud of the album and glad the work was done.

Most of the pictures of John and Yoko making the album show them very in touch with each other, physically. Even if they sat on separate chairs, they'd make it look like a couch. They could act as a tag team, as well, where they could take charge of one another's work, and instruct the backup musicians or engineers as to what was needed, even if it wasn't technically their song. If one of them had listened to a track so often as to lose objectivity, the other would take over and keep the work moving. They were very much a team, with a shared vision.

RECORDING ARTISTS often rent out space surrounding their studios and fill it with their own furniture and comfort items; the homey touches close by made the long hours in the studio more manageable. John and Yoko rented the room next to their studio and brought in an upright piano. This shot of them at the piano became the first publicity image released for *Double Fantasy*.

Besides taking you away from home, making an album could also be exhausting. There are often hours and hours of sitting and listening to the minor details that created the overall sound. Once when John and a sound engineer were doing just that, I fell asleep on a couch right in front of the control panel. John and the engineer kept hearing a sound on the recording that wasn't supposed to be there, and they listened to the recording again and again in an effort to isolate and eliminate the noise.

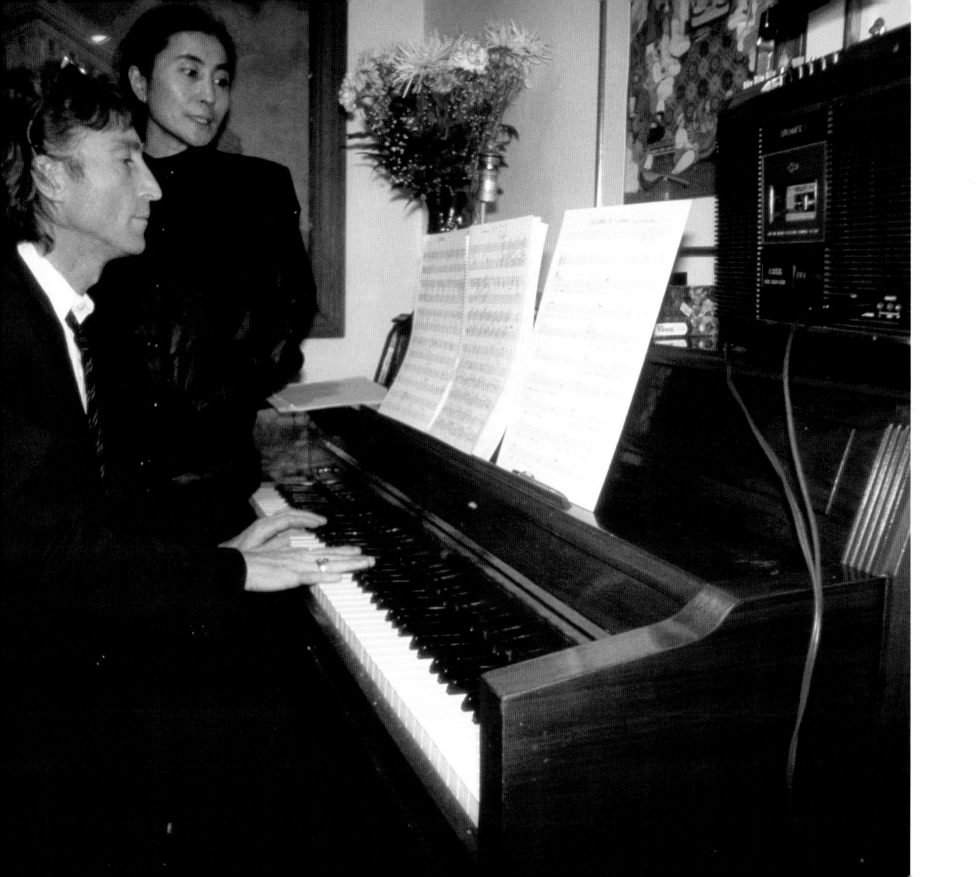

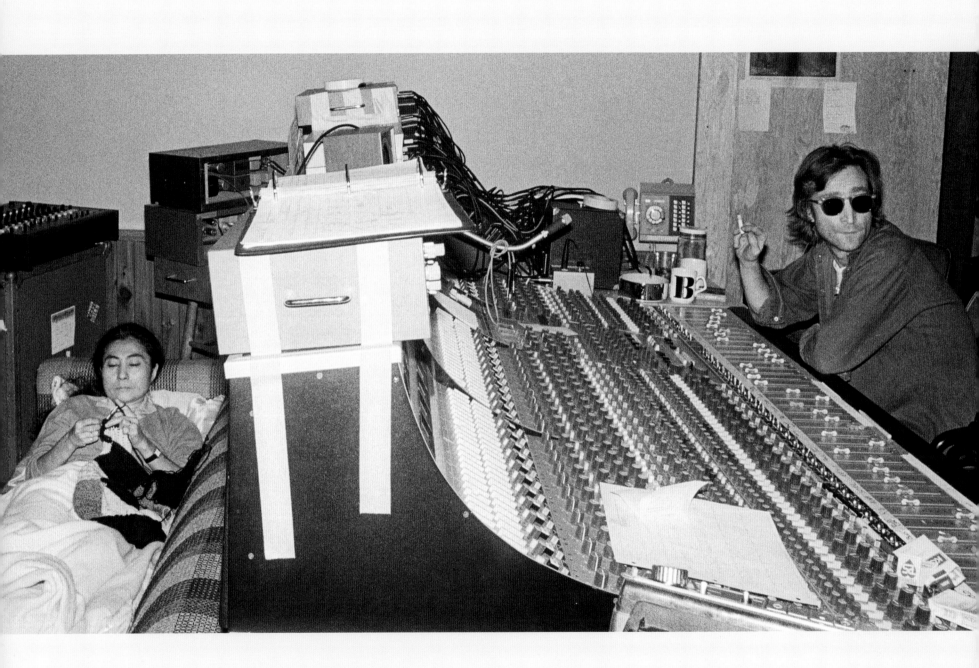

Then they heard the sound as they were rewinding the recording and realized it was coming from somewhere in the room. They quickly determined that I was the source, snoring away obliviously on the couch.

John, always curious, decided to see what would happen if I woke up to the sound of my own snoring. He and the engineer planned to rig up a microphone to capture my snore fully, and then play it back to me full blast. Unfortunately for their experiment, I woke up as they were manipulating the microphone.

I wasn't the only one who sought out moments of relaxation during these long sessions. I took this photo of Yoko taking a knitting break, with John at the helm, on one of the later nights—which extended to seven or eight in the morning—as they mixed the final parts of the album.

People don't usually see this warmer side of Yoko, but it's there. Yoko is quite a knitter, and a fabulous mother, too. She used to knit scarves and gloves for Sean and John in her downtime at the studio. She was also a wonderful and wise cook, always concerned about nourishment. John had even taken to calling her "Mother" himself.

Of course, you never knew when you might be needed in the studio, which might be why everyone spent so much time there. One night my friend Jonathan Takami and I were sitting around in the studio lounge when John came out and asked, "Who's got boots on?" Because Jonathan and I were both wearing cowboy boots, we were recruited to help with sound for the album. There is a part in *Double Fantasy* where it sounds like people are walking down the street past a beggar. To create this effect, John sat down on the floor with a bowl with a couple of coins in it, shook it, and chanted "alms for the poor." While John chanted, my friend and I walked in circles around him. I've always wished I had a picture of the moment, but I don't think it would have been appreciated if I'd started adding camera clicks to my boot-stomping sounds.

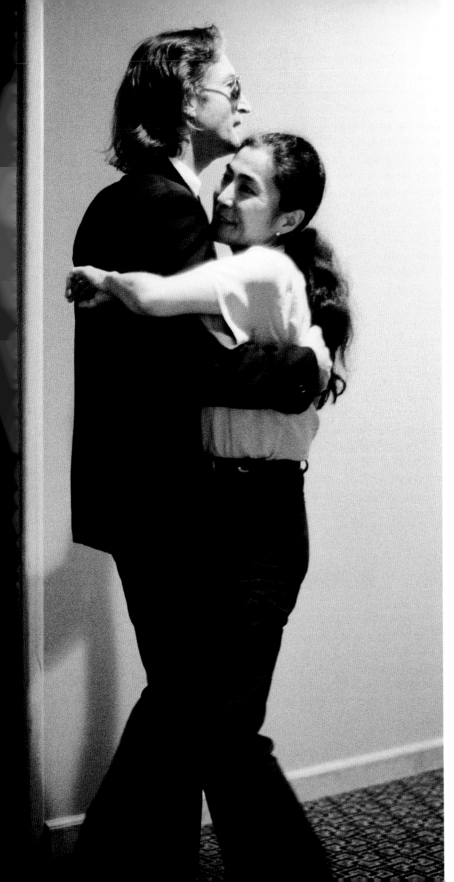

JOHN AND YOKO realized they would only have half of the album done in time to release it for the holiday rush in November, so they made the release into one album instead of a double and planned to finish mixing and recording the second half that winter. The first single became "Starting Over." That's the way John viewed *Double Fantasy*—as a means of starting over, but from a wiser perspective. John and Yoko planned to tour with the album, just like John had done as a young Beatle.

One morning, after John, Yoko, and the rest of the musicians had been in the studio all night, someone tuned a little beat box radio to Scott Muni because he was going to play the world premiere of John's song "Starting Over." The song sounded great on the radio, and everyone was excited. When the track finished, Scott announced how much he liked it. "This song is so great," he said, "we're just going to play it again." When he played it again, John and Yoko were so happy they started dancing around the studio.

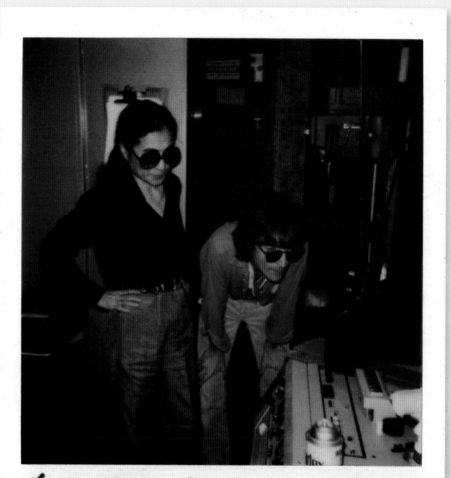

Yoko + John LENNON at HitFACTORY LISTENING TO 1st CUE ON AIR Broadcast of "STARTING OVER" SINGLE Photo by Bob GRUEN

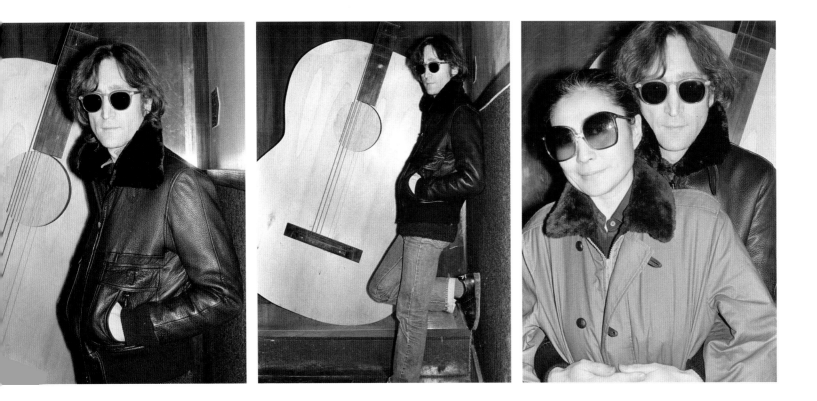

IN THE BEGINNING of December 1980, I got an assignment to submit several shots of John and Yoko for a *Village Voice* article. I told Yoko that I could probably use some of the pictures I'd already taken over the last couple of months. I went down to the studio to let her choose her favorites, as I always did, and she suggested I take some new ones instead. They were promoting *Double Fantasy* heavily, and as a result many of my photos had already been published.

I took a few pictures in the studio and a few of John and Yoko posing in the hallway of the Record Plant. A huge guitar was displayed behind a glass case at the Record Plant. Although most people thought the guitar was just a random decoration, John had actually had it made in 1971 as part of their *This Is Not Here* exhibit at the Emerson Museum in Syracuse. The piece was way too big to get in the door of an apartment, so he'd lent it to the Record Plant to store and display. Since I knew the guitar actually belonged to John and Yoko, I posed them in front of it. At first they stood in a normal, "couple" kind of way, facing the camera in a very straightforward manner. Then John pushed Yoko against the wall and said, "Take this picture—this is what everyone wants to see." Sure enough, that's become one of my most popular photos of John and Yoko.

Before we left, John announced that he'd just gotten a new jacket. He said it was a fancy, Yamamoto designer jacket and it was embroidered in gold with spiritual sayings. But it was at home on his bed. "I really want you to take a picture of me wearing it," he said. "Can you come back tomorrow?"

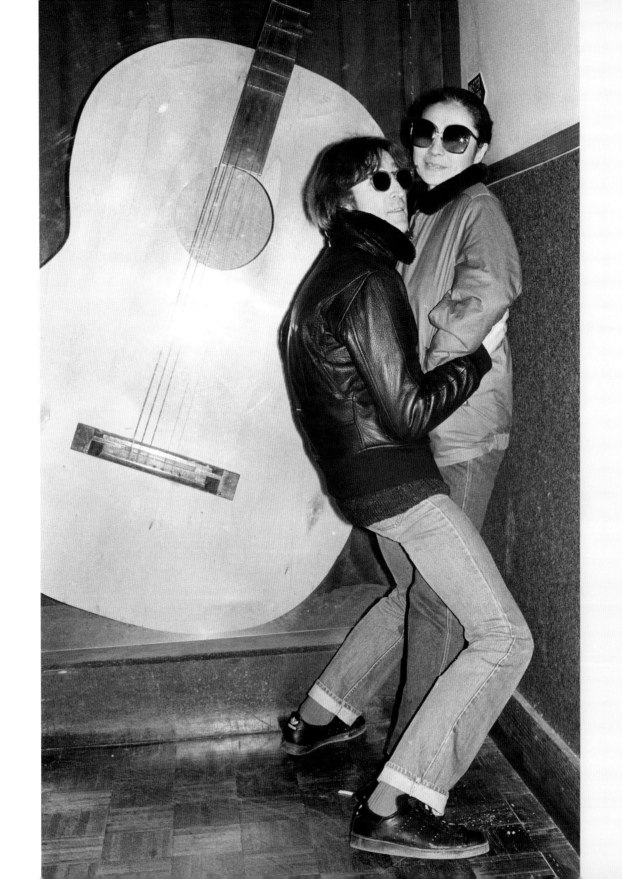

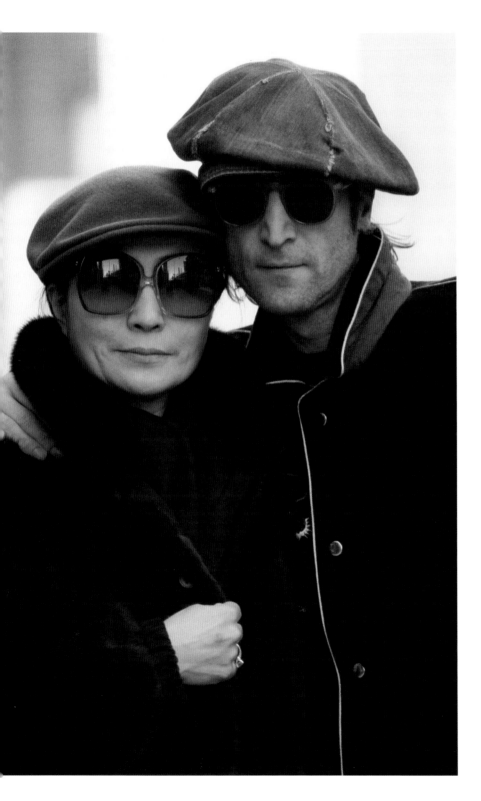

I came back the next night, and they were still working on Yoko's new song, "Walking On Thin Ice." Due to a technical delay, I ended up sitting on the studio steps with John most of that night, talking about his plans for the future.

Double Fantasy was selling well—it was in the Top Ten, and he was hoping it would reach Number One. He was looking forward to a world tour that was set to launch in the spring. John was especially pleased that Yoko's music was getting good reviews as well. "They're writing Yoko up as having the more interesting kind of music, and calling mine more M.O.R. [middle of the road]," he said. He said this didn't bother him, adding, "I'm going right down the middle of the road to the bank." He was really proud of Yoko, too. "I worked with two of the world's greatest artists," he said. "Yoko Ono and Paul McCartney—and that's not a bad record."

John talked about his plans, and we discussed our mutual love of Japan and how we were excited to go there on tour. We talked about which were our favorite restaurants in Tokyo, where we'd shop in Paris, what we'd do. The whole mood of the conversation was focused around how great life was, how everything was really coming together.

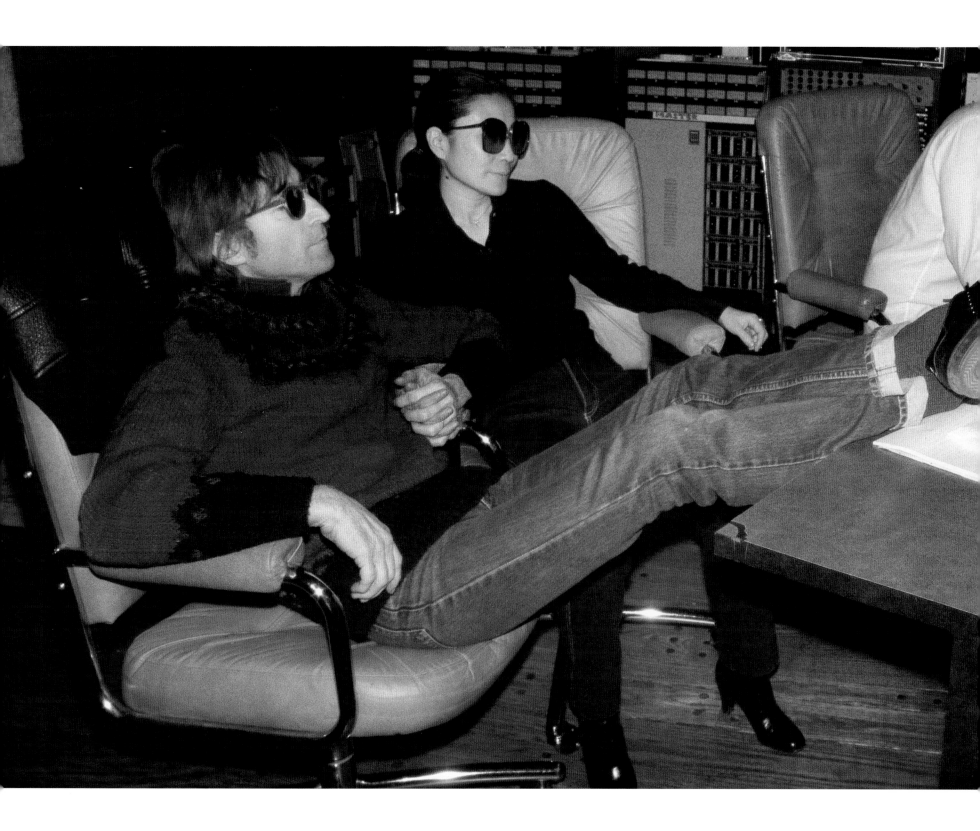

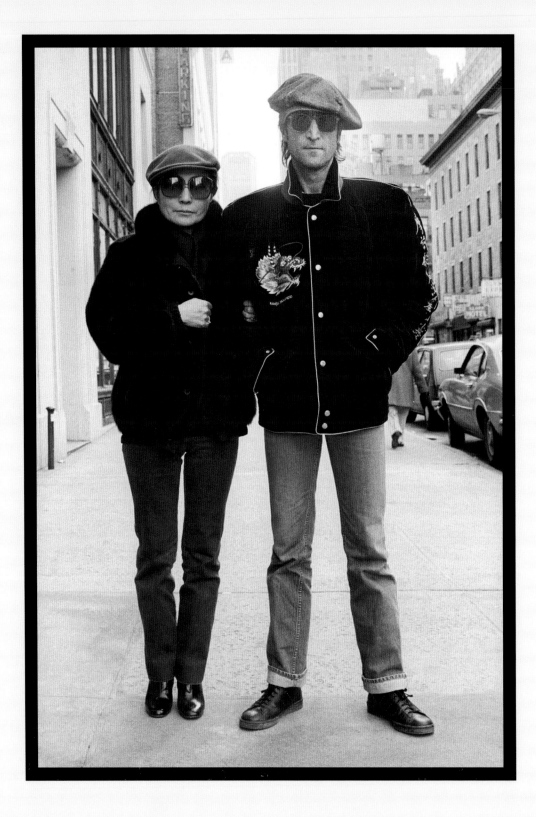

John sounded very grounded that night—clear and confident. He enjoyed talking about what he'd learned from raising his son and the kind of happiness that brought him. At the age of forty, he'd learned about the happiness that comes from delayed gratification—that if you don't get high every night, you get an even higher feeling when you see your child learn something. He talked about his ideas of living a responsible life, eating a healthy diet, thinking through your actions. Whereas in years past, he would have chosen to momentarily numb all unpleasant feelings, he told me he'd learned about the gratification that comes from working through those feelings, and coming out of a slump through natural—rather than chemical—means.

Yoko wasn't finished working on her track until six or seven in the morning, so the sun was rising when we emerged from the studio. Yoko was tired and ready to go home. "Forget the pictures," Yoko said, "we'll do them tomorrow or next week." John said, "But Bob stayed up all night waiting, and I brought my coat." So on the way out, we stopped on 44th Street—the same place where I'd photographed him with the Elephant's Memory back in 1972.

I took half a roll of black and white and half a roll of color. In the morning light, the pictures looked just like the sketch John had drawn on the napkin at Café La Fortuna several months earlier. People were hurrying to work around them, and John and Yoko were standing confident and ready to face the world, to start another day.

I took a shot of John getting in the limo. He turned and said, "I hope you got a good one, because you've got an exclusive on this jacket."

I said, "I think so."

"Okay," John said as he closed the door, "we'll see you later."

december 8th,

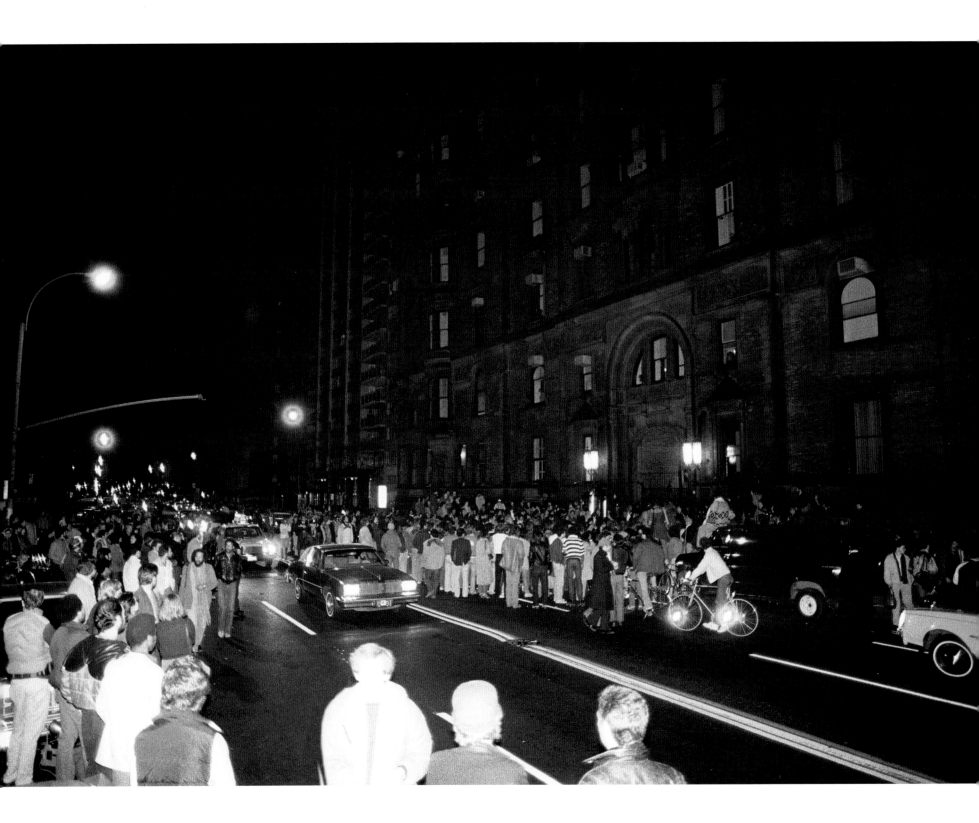

THE DAY AFTER I'd taken the photos of John and Yoko on 44th Street, they were scheduled to have an interview with John Peel for BBC Radio. Although I was supposed to come take pictures, I was exhausted. I slept late and didn't wake up in time to go to the interview.

I talked to John the next day and told him I was going to come by the studio that night. Because John had been talking for a while about wanting to catch up with what other musicians were doing in their live performances, I'd lent him a videotape from my friend Don Letts with footage of the Sex Pistols, the Clash, the Boomtown Rats, and Elvis Costello performing. He said that he'd watched the tape and liked it. He told me he was going to leave it at the front desk of the Dakota for me to pick up.

On Monday night, December 8th, I was developing the pictures of John and Yoko I'd taken Friday and Saturday morning—the ones in front of the giant guitar and the shots out front on 44th Street. The *Village Voice* had given me a 2 A.M. deadline. To make it, I would have to finish developing the prints, drive up to the studio to show John and Yoko, and then drive down to the *Village Voice* office. At around 11 P.M., as I was rushing to finish, my building's doorman rang my bell and asked if I had a TV or radio on. "No," I said, "why?"

He told me he'd just heard John Lennon had been shot.

My first thought was that maybe John had gotten mugged after going out to get something to eat. I knew John rarely carried a lot of cash, so I thought maybe somebody had asked him for money and got mad when he didn't have any. Being shot doesn't mean dying, I thought. My phone started ringing. Toby Mamis, the original Elephant's Memory publicist, called me from California to ask me what was going on.

"I have no idea," I said. "What did you hear?"

"I've got the TV on, and they're saying John Lennon is dead."

I slid down to the floor. It was the worst thing I'd ever heard. Death is not negotiable, changeable, reversible. I started thinking, "How can I control this? How can I change this? How can I make it better?" But when someone's dead, you can't make anything better, and my mind was reeling with the permanence of the news and with how unbelievably wrong John's death seemed—this news out of nowhere, when so much positive energy was building around him.

My phone kept ringing, with calls from friends from all over the country. I suddenly realized that the whole world was watching, that people everywhere were going to be following the story. Everyone was going to be talking about it, everyone was going to want pictures. And that was my job—to help John look good. I knew I had to get my pictures sent out. Almost as if I was sleepwalking, I started going through my files and pulling out pictures of John Lennon.

I called the *New York Post*, the *Daily News*, and the *New York Times* and told them I had pictures. After an hour or so, I went up to the Dakota. It was a scene, people crying and crowding around John's home. People were in shock and wanted to gather together for solace. There was a lot of hugging and hand-holding, and tape recorders playing John's music. I wanted to leave a message for Yoko that I was there, if there was anything I could do, but I figured I'd have a difficult time getting through the guards. Then I remembered that John had planned to leave Don's videotape at the reception desk. I pushed my way through the huge crowd to the cops who were guarding the door. I said I needed to pick something up from the desk, and they let me through.

The Dakota has an outer gate by the street, then a driveway, and then stairs leading up to the reception desk. In the winter, they put glass walls up around the stairs, so that it makes an old-fashioned temporary wooden vestibule and serves as a heat barrier. As I walked up, I saw the bullet hole in the glass doorway, which made me feel ill. The deskman looked as stunned as I felt. I asked if a package had been left for me. There the tape was, right on the shelf like John had said it would be, and he had included a copy of the *Double Fantasy* album. I asked the deskman to call into the office John and Yoko kept on the ground floor, and left my message for Yoko. By the time I got home later that morning, I had calls from every major art director from every major media outlet in the world, all of whom wanted pictures. I knew I had to start working, getting pictures sent out. I felt it was my job to share my pictures of John.

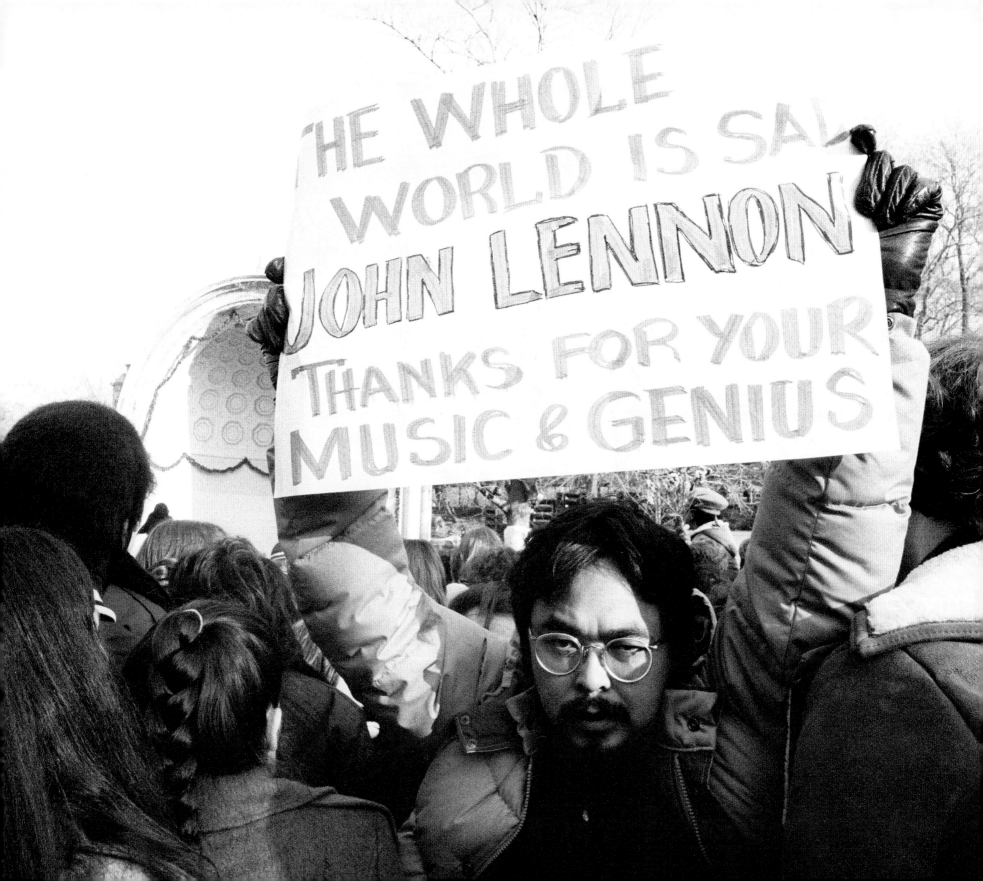

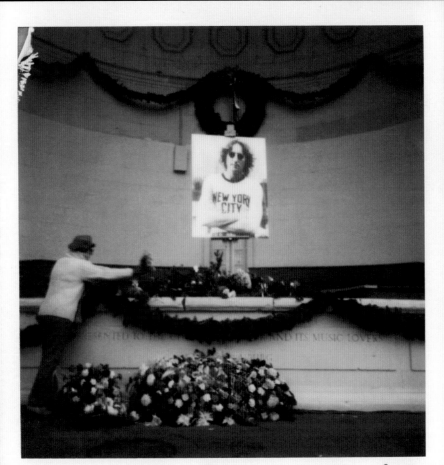

CENTRAL PARK NEW YORK
MEMORIAL FOR JOHN LENNON
DEC. 14, 1980

A DAY OR TWO LATER, Ron Delsener, the country's most established promoter, called to tell me about a memorial event planned for that Sunday. Yoko's wish was for ten minutes of silence in honor of John that everyone could participate in. It didn't matter where you were or who you were—everywhere around the world, at noon New York time, people could gather in their homes with their families and friends and be silent for John. She had no interest in organizing a formal gathering where the VIPs would be the only ones with tickets. John was a man of the people.

The city felt that a lot of people would want to gather at the Dakota, which would become a focal point. Rather than have thousands of people in the street, the city officials thought they should shift the inevitable gathering east to the band shell in Central Park. They asked Ron Delsener to set up something people could focus on. Ron arranged for some speakers to play John's music, and he asked me if I would enlarge a picture for a centerpiece. I asked if he wanted me to bring some to the office so he could pick one out. "No," he said, "you knew him. I know you'll pick a good one. Just pick it *now*."

I gave a lot of thought to which picture I'd choose, because I knew hundreds— maybe thousands—of people would attend. One I considered was what I think of as the "rocker" shot, where John's playing his guitar onstage. So many people thought of him as a musician-hero, as a Beatle. But John was much more than just a rocker—he was an artist, a spokesman. Another shot I thought about was a portrait from the Butterfly Studio. That photograph ran on the cover of the *New York Times* and showed John's intelligent, introspective side. But that photograph didn't seem quite right, either.

Then I saw the piece Yoko wrote in the *New York Times*. Her message was, "Please don't blame New York for John's death—what happened could have happened anywhere." I agreed, and knew John was very proud of being a New Yorker. That's why I chose the picture of him wearing the New York City T-shirt.

I arrived in Central Park on the day of the service just as the silent period began. Thousands of mourners had gathered on the grey, cold day, and though it was quiet, you could hear people crying softly. Aside from the crying, it was so eerily silent I could hear the sound of my own footsteps. A sea of bundled heads looked down, and thousands of people held hands. John's music played before and after the silent period, and everyone listened without saying much or singing along. Every year on John's birthday, fans still gather in Central Park at the Strawberry Fields area near the Dakota.

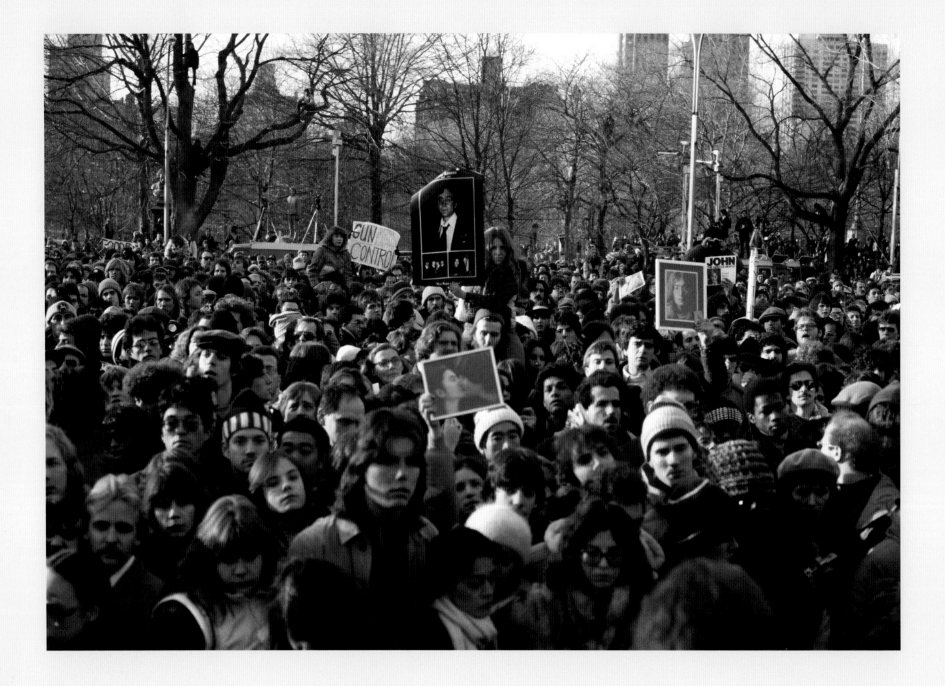

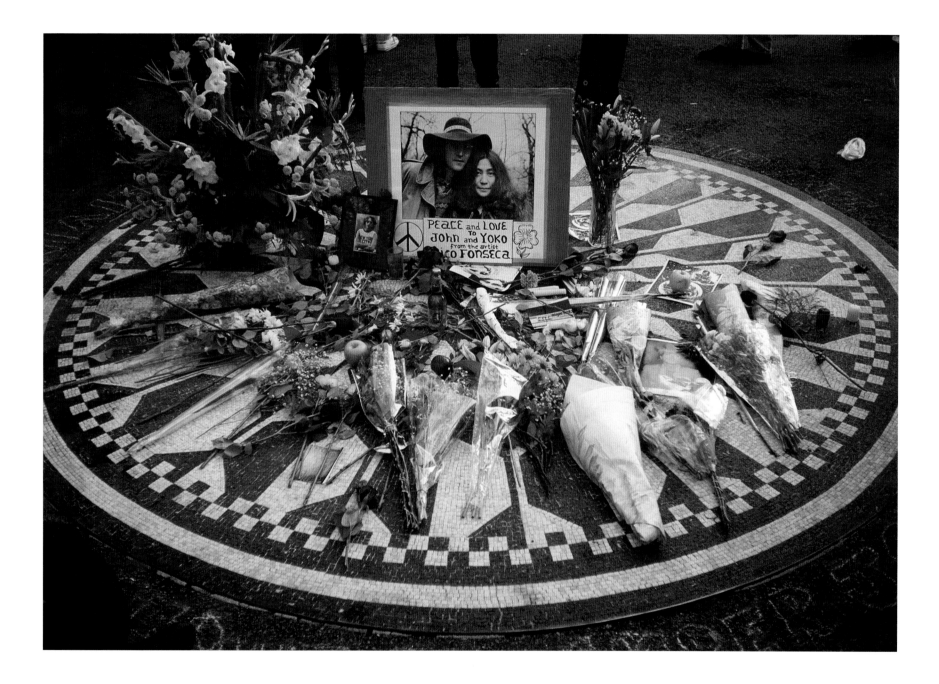

IN THE SPRING of 1981, Yoko asked me if I would help her with an idea she had for the cover of her album *Season of Glass*.

A lot of the new record was an expression of Yoko's emotions, her account of how it felt to be suddenly a widow, to be suddenly without John. For the album's cover, she wanted to use the blood-splattered glasses John wore when he was shot, though the idea terrified her. She knew it was going to be difficult and asked me to come and help set up some lights. We were both crying when she opened a box and took out the glasses. But it was something she felt she needed to do, to share with people the horror of what had happened.

I set up the lights, and then Yoko arranged John's glasses on a windowsill that overlooked Central Park. She also set down a glass of water that was half full, or half empty, depending on your viewpoint. The meaning of the image was perspective—

seeing Central Park through the glasses, through the window, through various lenses that focus the reality differently. At the same moment, there were all these different viewpoints, all presenting differing realities.

I set up the camera and handed it to Yoko. It was important to her that she take the shot herself.

When people saw Yoko's picture on the cover of her *Season of Glass* album, they were horrified. But in a way, it was also brilliant. People would ask, "How's Yoko feeling?" and anyone who knew her could say, "Oh, she's feeling terrible" and complete a polite, contained conversation. But showing people what the glasses looked like on December 8th brought home a little bit of the horror and the sickness Yoko was going through. If you could feel that upset just by looking at a broken pair of glasses, you could begin to understand Yoko's pain.

ON MOTHER'S DAY, I went to the Dakota at 3:30 or so in the morning to hear the final version of *Season of Glass*. At around 5:30, while we were finishing listening to the record, Sean woke up, came down the hall, and snuggled into his mom's bed. I was so used to seeing them in intimate situations, it was natural for me to take my camera out and take a picture of them together.

I showed the pictures to Yoko a few days later and she commented on how odd it was that she was going to have to be the caregiver. People had never seen her that way before, and she'd never seen herself that way. After years of being put down as a weird artist in the media, now she was a sympathetic widow and mother. She said that there were many titles in life, but one thing she never wanted to be was a widow.

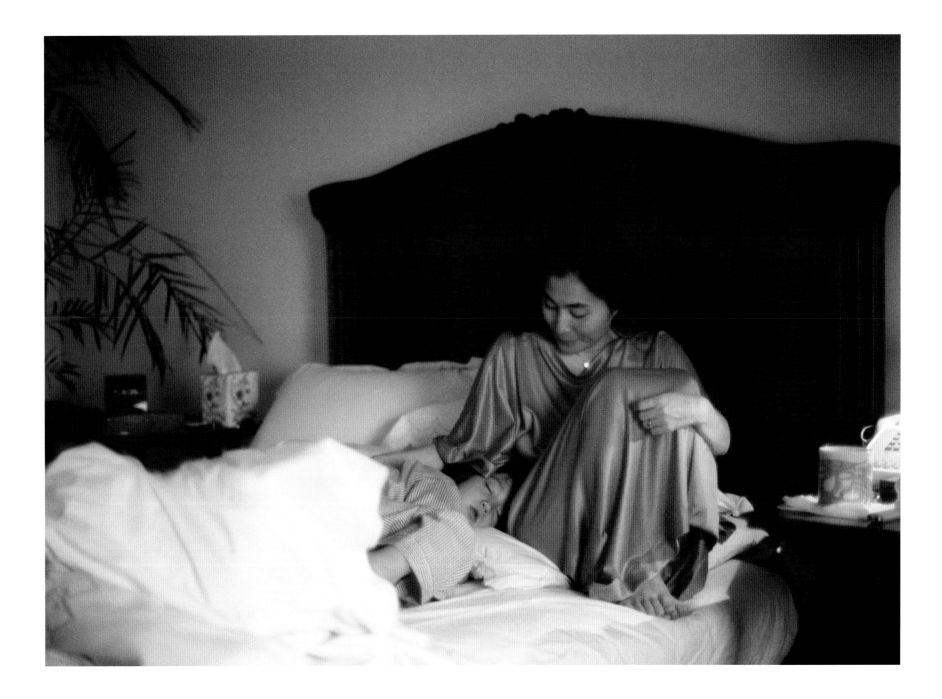

IN THE WEEKS BEFORE John died, he gave a lot of interviews, and in all of them he talked about how much he enjoyed his life—just like he'd told me on our last night together. He'd gotten rid of most of his bad habits and was clear-headed and disciplined.

John was a brilliant man and deep thinker. He spent almost five years in virtual seclusion, taking care of his son and learning what it was like to have a sober life. He emerged ready to talk openly about his new ideas of commitment and responsibility. It took him forty years to get there, and I've always wondered what would have happened if he'd had another forty years.

Not long after John died, I was downtown in a pretty bad neighborhood. I saw the words to "Imagine" written out on a wall. It was really powerful to see the lyrics written so simply, in such a rundown place.

It's hard to sum up why John means so much to so many people. Mainly I think John represented everyone's desire to better themselves and the importance of that struggle. Sometimes he fell short of the goals he set. But John Lennon always strived to do better, to be better, and encouraged people to imagine a better world.

Bob Gruen + John Lennon

N.Y.C. 8/74

ACKNOWLEDGMENTS

I'D LIKE TO THANK John Lennon and Yoko Ono, and their son, Sean; my wife, Elizabeth Gregory; my son, Kris; my mom and family; and all the people who have helped me and made this book possible, especially Virginia Lohle, Mandi A. Newall, Nadya Lublin, Jonathan Takami, Karla Merrifield, Linda Rowe. Thanks, too, to David Hazan, Phil South, Alec Friedman, Alec Horihan, and James Kim at Picturehouse. I'd also like to thank Leslie Stoker, Beth Huseman, Ron Longe, and Andrea Glickson at Stewart, Tabori & Chang, and my team at becker&mayer!—text editor Jenna Free, editor Adrienne Wiley, designers Joanna Price and Kasey Clark, researcher Shayna Ian, and production coordinator Sheila Hackler.

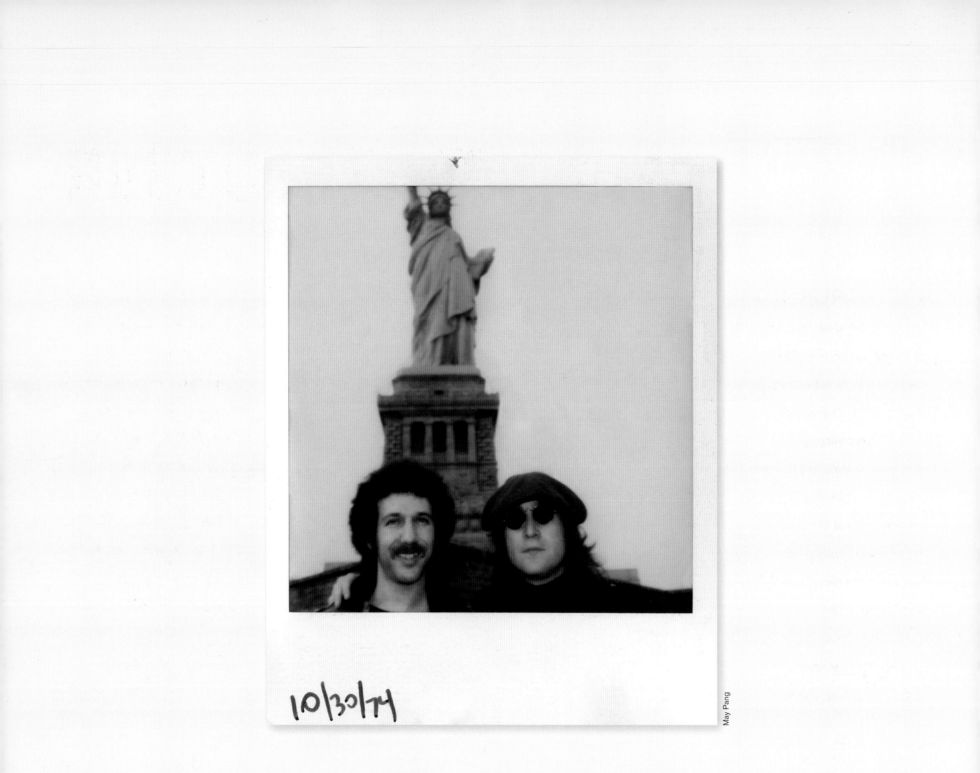

10/30/74

May Pang

ABOUT THE AUTHOR

BOB GRUEN is one of the most well-known and respected photographers in rock-and-roll. From Muddy Waters to The Rolling Stones, Elvis to Madonna, Bob Dylan to Bob Marley, he has captured the music scene for over forty years, and today his work is known around the world. In June 2004, Bob was presented with *MOJO* magazine's prestigious Honours List Award for Classic Image, in London.

As chief photographer for *Rock Scene* in the '70s, Gruen specialized in candid, you-are-there photo features. He toured extensively with bands of the punk and new wave scenes, including the New York Dolls, Sex Pistols, Clash, Ramones, The Patti Smith Group, and Blondie. Gruen has also worked with countless major rock attractions, including Led Zeppelin, The Who, David Bowie, Tina Turner, Elton John, Aerosmith, Kiss, and Alice Cooper. In 1989, he documented Ozzy Osbourne, Motley Crue, and Bon Jovi on their epic trip to Russia for the Moscow Music Peace Festival. For years, Gruen was also the official photographer for the New York New Music Seminar, covering dozens of aspiring new bands in the course of a summer week. In 1994, he organized a photography workshop for the seminar.

More recently, in 2004, Gruen has photographed the New York Dolls reunion, Jesse Malin, Green Day, Ryan Adams, Courtney Love, and other new popular artists. His current work can be found on his Web site, www.bobgruen.com.

Gruen's work has been featured in numerous photo exhibits highlighting his historic journey, most notably at A Gallery For Fine Photography in New Orleans, Fahey/Klein in Los Angeles, Morrison Hotel Gallery in New York, The Govinda Gallery in Washington, D.C., The Special Photographers Gallery in London, and the Mitsukoshi Gallery in Tokyo. His photo *Sid Vicious with Hot Dog* was acquired in 1999 by The National Portrait Gallery, London, for their permanent collection.

Gruen is a frequent presenter and writer, and has given numerous slide talks at sites including The Smithsonian Institute in Washington, D.C., New York University, the Savannah College of Art and Design, the Rock and Roll Hall of Fame and Museum, and the Eastman Kodak New York headquarters. His books include *The Clash*, *Crossfire Hurricane—25 Years of the Rolling Stones*, and *Chaos: The Sex Pistols*.

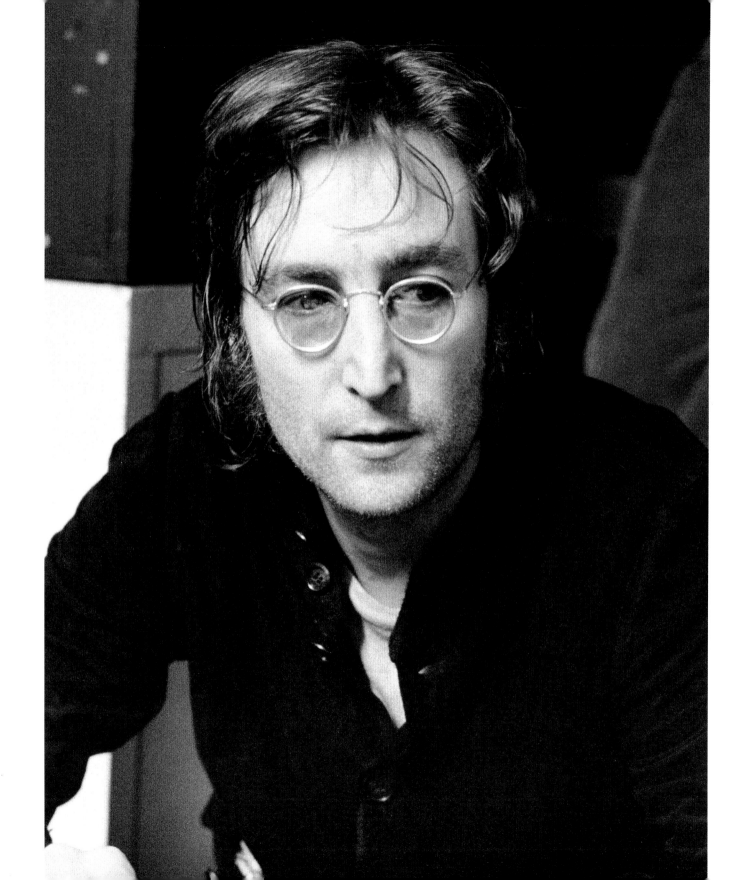